Oliver Byrne's Elements of Euclid

The First Six Books with Coloured Diagrams and Symbols

Read & Co.

Copyright © 2022 Art Meets Science

This edition is published by Art Meets Science,
an imprint of Read & Co.

This book is copyright and may not be reproduced or copied in any way without the express permission of the publisher in writing.

British Library Cataloguing-in-Publication Data
A catalogue record for this book is available
from the British Library.

Read & Co. is part of Read Books Ltd.
For more information visit
www.readandcobooks.co.uk

'Segnius irritant animos demissa per aurem,
Quam quae sunt oculis subjecta fidelibus'

– Horace

'A feebler impress through the ear is made,
Than what is by the faithful eye conveyed.'

– Oliver Byrne

PREFACE.

The Geometric Masterpiece of Oliver Byrne

Despite being printed over a century ago, Oliver Byrne's stunning edition of Euclid's *Elements* continues to be one of the most beautiful expositions in the world of mathematical publishing. Scattered across each page in brilliant reds, yellows and blues are triangles, squares and circles in a myriad of combinations with intersecting lines and numbers. These intricate figures express the mathematical proofs of many iconic geometric equations that form the bedrock of mathematical study.

First published in 1847 and uniquely beautiful in its presentation, Byrne's edition of *The First Six Books of the Elements of Euclid* was the first attempt to illustrate the classic books of mathematical theorems written by ancient Greek mathematician Euclid of Alexandria, originally penned around 300BC. Euclid's original treatise on geometry and mathematical theory laid the foundation for the modern study of geometry and have since become cornerstone works in the history of mathematics. They have proved influential in the sciences, used by Galileo Galilei, Albert Einstein, and Sir Isaac Newton, who implemented the theories within *Elements* to aid their discoveries. The thirteen books of Euclid's *Elements* continue to be considered a masterpiece in the practice and application of mathematics.

While the artfully compact diagrams within this volume can be appreciated as artworks in their own right, Byrne's intention surpassed the visual, aiming to aid the mind

in attaining such complex mathematical knowledge. The visual, educational elements in Byrne's nineteenth-century edition encouraged learning by physical example, provided in the colourful compounds formed of shapes, angles, and edges. This stunning example of numerical visual study has influenced the history of mathematics the world over; however, it has also proven to be an indispensable inspiration for twentieth-century art movements. With avant-garde groups like De Stijl and The Bauhaus using Byrne's iconic colour, line work and form in many of their works.

Translated from Greek, Euclid means 'renowned' or 'glorious' – a fitting name for the legacy to which the scholar is attributed, now often named 'the father of geometry'. The thirteen books produced by Euclid in 300BC equated to a comprehensive geometrical system that was, for many following centuries, considered the only geometry possible. Euclid deduced many theorems of geometry, mathematical proofs, and number theory within the works, and although many theorems originated from earlier mathematicians, Euclid's *Elements* was pioneering in its age because of how the hypotheses were presented. The single, logical framework was easy to reference as it included a system of rigorous mathematical proofs to help aid the reader. His work included the now-famous geometry theorems like Pythagoras and circular theory, which have become integral to the logical development of subjects like mathematics and science. Euclid's axiomatic approach of application and proof of geometry has enabled his work to remain the basis of mathematical study for over 2000 years. In the modern age, this ancient system is often referred to as Euclidean geometry to separate it from

PREFACE.

other forms of non-Euclidean geometry discovered from the nineteenth century onwards. When Oliver Byrne's edition was published in 1847, Euclid's *Elements* was still used as the basis for geometric study in the classroom.

Oliver Byrne was a mathematician, civil engineer, and prolific author, born in Ireland at the beginning of the nineteenth century. He wrote numerous works on mathematics, geometry, and engineering; however, he is most famous for his creative adaptation of Euclid's *Elements* – illustrating the first six books in his edition: *The First Six Books of the Elements of Euclid in Which Coloured Diagrams and Symbols Are Used Instead of Letters for the Greater Ease of Learners*. With little about his early life being known, Byrne first appeared on record in Dublin aged twenty with the publication of his first book, *A Treatise on Diophantine Algebra*, 1830, which was co-authored by his younger brother, John. Byrne embarked on a prolific writing career penning over forty works in his lifetime – mostly on educational subjects such as mathematics and engineering, and a well-known work on the Irish Independence of the 1850s. He was also a significant contributor to *Spon's Dictionary of Engineering*. In 1839, Byrne spent two years as Professor of Mathematics at the College for Civil Engineers in Putney, South West London.

Byrne's *Euclid* was his most ingenious educational work. By accompanying Euclid's original geometric theories with expressive, colourful proofs, Byrne turned what was already a cornerstone academic text into a pedagogical work of art. Working as an aid to understanding Euclid's complex equations, Byrne's fascinating and carefully considered graphics added an appealing visual element for

many who struggle to make sense of complex mathematics with numbers alone. The compelling explanations in vibrant red, yellow, and blue float across the book's pages, bringing the ancient theorems to life, in an attempt as he expressed: 'to teach people how to think, and not what to think.' Each wash of colour, shape, form, angle, and line were carefully contemplated to create visually stunning and easily conceivable graphics.

Byrne's mathematical masterpiece was one of the first multicolour printed books after the invention of the printing press. The multiple colours of the proofs, text, and intricate letter plates were a feat of printing technology previously unseen in the century. *The First Six Books of the Elements of Euclid* was designed and printed by Charles Whittingham of the Chiswick Press in 1847. Each page features a sophisticated initial designed by the printer's daughters to complement the typed propositions and coloured shapes. The complex nature of the illustrations must have presented a significant challenge due to the early printing methods of the time. As a consequence of the extravagant nature of the printing, Byrne's book was sold for a much higher price than other books of the time, at 25 shillings. Unfortunately, the high cost led to the book being much less successful than hoped, with only 100 copies being printed.

Despite pricing his work out of the hands of the educators for which it was intended, Byrne's vibrant geometric feat made its debut at the Great Exhibition of 1851 in London. The international exhibition aimed to showcase the work and technologies of Great Britain to cement its role as an industry leader on the world stage. *The First Six Books of the Elements of Euclid* was celebrated for its

elegance and artistry within the printing world, with the fascinating intricacies of Byrne's illustrations proving as evocative in the Victorian age as they are today.

The influence of Byrne's work on the classroom is apparent; however, his illustrations have created a legacy within the art world. The colour and form of Byrne's original illustrations profoundly affected the world of art and design after they were picked up by art groups in the early twentieth century. Their influence can be seen in the avant-garde work of the Bauhaus School and art group De Stijl (meaning 'the style' in Dutch), responsible for pushing aesthetic boundaries and creating minimalist, abstract works. The order and conformity of Byrne's geometric proofs appealed to these groups in the wake of the First World War – they were committed to rebelling against the chaos and destruction of the war, looking for a 'return to order'. The neat squares of primary colours produced by Dutch pioneers like Piet Mondrian, and other leading artists in the De Stijl movement like Theo Van Doesburg, are a short leap from the delicate shapes and stark lines of Byrne's *Euclid*. His influence can also be seen later in the twentieth century in the colourful intersectional work of Wassily Kandinsky, whose combinations of shapes and lines hark back to the geometric constructions first created by Byrne in the mid-1800s. In more recent times, Byrne's pioneering visual work has been the subject of study in graphic design, featuring in many contemporary works on the subject.

While Euclid's original theorems stand alone as the foundation of modern mathematics and continue to be used as a practical mathematical guide, it is through Byrne's enchanting illustrations that this work continues

to intrigue readers centuries on. Republished by Read & Co. Books for our Art Meets Science imprint, a facsimile edition of this legacy work has been painstakingly restored for a new generation to enjoy. Taking special care to conserve the colours, shapes, and text as they were printed on publication in the hope to recapture the magic of this beautiful volume for future readers, both inside and outside of the classroom.

Read & Co.
Bristol, 2022

BYRNE'S EUCLID

THE FIRST SIX BOOKS OF
THE ELEMENTS OF EUCLID
WITH COLOURED DIAGRAMS
AND SYMBOLS

THE FIRST SIX BOOKS OF
THE ELEMENTS OF EUCLID

IN WHICH COLOURED DIAGRAMS AND SYMBOLS

ARE USED INSTEAD OF LETTERS FOR THE

GREATER EASE OF LEARNERS

BY OLIVER BYRNE

SURVEYOR OF HER MAJESTY'S SETTLEMENTS IN THE FALKLAND ISLANDS
AND AUTHOR OF NUMEROUS MATHEMATICAL WORKS

LONDON
WILLIAM PICKERING
1847

TO THE

RIGHT HONOURABLE THE EARL FITZWILLIAM,

ETC. ETC. ETC.

THIS WORK IS DEDICATED

BY HIS LORDSHIP'S OBEDIENT

AND MUCH OBLIGED SERVANT,

OLIVER BYRNE.

INTRODUCTION.

HE arts and sciences have become so extensive, that to facilitate their acquirement is of as much importance as to extend their boundaries. Illustration, if it does not shorten the time of study, will at least make it more agreeable. THIS WORK has a greater aim than mere illustration; we do not introduce colours for the purpose of entertainment, or to amuse *by certain combinations of tint and form*, but to assist the mind in its researches after truth, to increase the facilities of instruction, and to diffuse permanent knowledge. If we wanted authorities to prove the importance and usefulness of geometry, we might quote every philosopher since the days of Plato. Among the Greeks, in ancient, as in the school of Pestalozzi and others in recent times, geometry was adopted as the best gymnastic of the mind. In fact, Euclid's Elements have become, by common consent, the basis of mathematical science all over the civilized globe. But this will not appear extraordinary, if we consider that this sublime science is not only better calculated than any other to call forth the spirit of inquiry, to elevate the mind, and to strengthen the reasoning faculties, but also it forms the best introduction to most of the useful and important vocations of human life. Arithmetic, land-surveying, mensuration, engineering, navigation, mechanics, hydrostatics, pneumatics, optics, physical astronomy, &c. are all dependent on the propositions of geometry.

INTRODUCTION.

Much however depends on the first communication of any science to a learner, though the best and most easy methods are seldom adopted. Propositions are placed before a student, who though having a sufficient understanding, is told just as much about them on entering at the very threshold of the science, as gives him a prepossession most unfavourable to his future study of this delightful subject; or " the formalities and paraphernalia of rigour are so ostentatiously put forward, as almost to hide the reality. Endless and perplexing repetitions, which do not confer greater exactitude on the reasoning, render the demonstrations involved and obscure, and conceal from the view of the student the consecution of evidence." Thus an aversion is created in the mind of the pupil, and a subject so calculated to improve the reasoning powers, and give the habit of close thinking, is degraded by a dry and rigid course of instruction into an uninteresting exercise of the memory. To raise the curiosity, and to awaken the listless and dormant powers of younger minds should be the aim of every teacher; but where examples of excellence are wanting, the attempts to attain it are but few, while eminence excites attention and produces imitation. The object of this Work is to introduce a method of teaching geometry, which has been much approved of by many scientific men in this country, as well as in France and America. The plan here adopted forcibly appeals to the eye, the most sensitive and the most comprehensive of our external organs, and its pre-eminence to imprint it subject on the mind is supported by the incontrovertible maxim expressed in the well known words of Horace :—

Segnius irritant animos demissa per aurem
Quàm quæ sunt oculis subjecta fidelibus.
A feebler impress through the ear is made,
Than what is by the faithful eye conveyed.

INTRODUCTION.

All language confifts of reprefentative figns, and thofe figns are the beft which effect their purpofes with the greateft precifion and difpatch. Such for all common purpofes are the audible figns called words, which are ftill confidered as audible, whether addreffed immediately to the ear, or through the medium of letters to the eye. Geometrical diagrams are not figns, but the materials of geometrical fcience, the object of which is to fhow the relative quantities of their parts by a procefs of reafoning called Demonftration. This reafoning has been generally carried on by words, letters, and black or uncoloured diagrams; but as the ufe of coloured fymbols, figns, and diagrams in the linear arts and fciences, renders the procefs of reafoning more precife, and the attainment more expeditious, they have been in this inftance accordingly adopted.

Such is the expedition of this enticing mode of communicating knowledge, that the Elements of Euclid can be acquired in lefs than one third the time ufually employed, and the retention by the memory is much more permanent; thefe facts have been afcertained by numerous experiments made by the inventor, and feveral others who have adopted his plans. The particulars of which are few and obvious; the letters annexed to points, lines, or other parts of a diagram are in fact but arbitrary names, and reprefent them in the demonftration; inftead of thefe, the parts being differently coloured, are made to name themfelves, for their forms in correfponding colours reprefent them in the demonftration.

In order to give a better idea of this fyftem, and of the advantages gained by its adoption, let us take a right

INTRODUCTION.

angled triangle, and express some of its properties both by colours and the method generally employed.

Some of the properties of the right angled triangle ABC, expressed by the method generally employed.

1. The angle BAC, together with the angles BCA and ABC are equal to two right angles, or twice the angle ABC.

2. The angle CAB added to the angle ACB will be equal to the angle ABC.

3. The angle ABC is greater than either of the angles BAC or BCA.

4. The angle BCA or the angle CAB is less than the angle ABC.

5. If from the angle ABC, there be taken the angle BAC, the remainder will be equal to the angle ACB.

6. The square of AC is equal to the sum of the squares of AB and BC.

The same properties expressed by colouring the different parts.

1.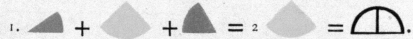

That is, the red angle added to the yellow angle added to the blue angle, equal twice the yellow angle, equal two right angles.

2.

Or in words, the red angle added to the blue angle, equal the yellow angle.

3.

The yellow angle is greater than either the red or blue angle.

INTRODUCTION.

4.

Either the red or blue angle is less than the yellow angle.

5.

In other terms, the yellow angle made less by the blue angle equal the red angle.

6.

That is, the square of the yellow line is equal to the sum of the squares of the blue and red lines.

In oral demonstrations we gain with colours this important advantage, the eye and the ear can be addressed at the same moment, so that for teaching geometry, and other linear arts and sciences, in classes, the system is the best ever proposed, this is apparent from the examples just given.

Whence it is evident that a reference from the text to the diagram is more rapid and sure, by giving the forms and colours of the parts, or by naming the parts and their colours, than naming the parts and letters on the diagram. Besides the superior simplicity, this system is likewise conspicuous for concentration, and wholly excludes the injurious though prevalent practice of allowing the student to commit the demonstration to memory; until reason, and fact, and proof only make impressions on the understanding.

Again, when lecturing on the principles or properties of figures, if we mention the colour of the part or parts referred to, as in saying, the red angle, the blue line, or lines, &c. the part or parts thus named will be immediately seen by all in the class at the same instant; not so if we say the angle ABC, the triangle PFQ, the figure EGKt, and so on;

xii *INTRODUCTION.*

for the letters muſt be traced one by one before the ſtudents arrange in their minds the particular magnitude referred to, which often occaſions confuſion and error, as well as loſs of time. Alſo if the parts which are given as equal, have the ſame colours in any diagram, the mind will not wander from the object before it; that is, ſuch an arrangement preſents an ocular demonſtration of the parts to be proved equal, and the learner retains the data throughout the whole of the reaſoning. But whatever may be the advantages of the preſent plan, if it be not ſubſtituted for, it can always be made a powerful auxiliary to the other methods, for the purpoſe of introduction, or of a more ſpeedy reminiſcence, or of more permanent retention by the memory.

The experience of all who have formed ſyſtems to impreſs facts on the underſtanding, agree in proving that coloured repreſentations, as pictures, cuts, diagrams, &c. are more eaſily fixed in the mind than mere ſentences unmarked by any peculiarity. Curious as it may appear, poets ſeem to be aware of this fact more than mathematicians; many modern poets allude to this viſible ſyſtem of communicating knowledge, one of them has thus expreſſed himſelf:

> Sounds which addreſs the ear are loſt and die
> In one ſhort hour, but theſe which ſtrike the eye,
> Live long upon the mind, the faithful ſight
> Engraves the knowledge with a beam of light.

This perhaps may be reckoned the only improvement which plain geometry has received ſince the days of Euclid, and if there were any geometers of note before that time, Euclid's ſucceſs has quite eclipſed their memory, and even occaſioned all good things of that kind to be aſſigned to him; like Æſop among the writers of Fables. It may alſo be worthy of remark, as tangible diagrams afford the only medium through which geometry and other linear

INTRODUCTION. xiii

arts and sciences can be taught to the blind, this visible system is no less adapted to the exigencies of the deaf and dumb.

Care must be taken to show that colour has nothing to do with the lines, angles, or magnitudes, except merely to name them. A mathematical line, which is length without breadth, cannot possess colour, yet the junction of two colours on the same plane gives a good idea of what is meant by a mathematical line; recollect we are speaking familiarly, such a junction is to be understood and not the colour, when we say the black line, the red line or lines, &c.

Colours and coloured diagrams may at first appear a clumsy method to convey proper notions of the properties and parts of mathematical figures and magnitudes, however they will be found to afford a means more refined and extensive than any that has been hitherto proposed.

We shall here define a point, a line, and a surface, and demonstrate a proposition in order to show the truth of this assertion.

A point is that which has position, but not magnitude; or a point is position only, abstracted from the consideration of length, breadth, and thickness. Perhaps the following description is better calculated to explain the nature of a mathematical point to those who have not acquired the idea, than the above specious definition.

Let three colours meet and cover a portion of the paper, where they meet is not blue, nor is it yellow, nor is it red, as it occupies no portion of the plane, for if it did, it would belong to the blue, the red, or the yellow part; yet it exists, and has position without magnitude, so that with a little reflection, this junc-

INTRODUCTION.

tion of three colours on a plane, gives a good idea of a mathematical point.

A line is length without breadth. With the assistance of colours, nearly in the same manner as before, an idea of a line may be thus given:—

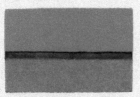

Let two colours meet and cover a portion of the paper; where they meet is not red, nor is it blue; therefore the junction occupies no portion of the plane, and therefore it cannot have breadth, but only length: from which we can readily form an idea of what is meant by a mathematical line. For the purpose of illustration, one colour differing from the colour of the paper, or plane upon which it is drawn, would have been sufficient; hence in future, if we say the red line, the blue line, or lines, &c. it is the junctions with the plane upon which they are drawn are to be understood.

Surface is that which has length and breadth without thickness.

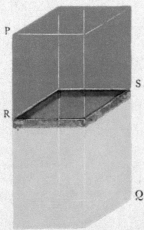

When we consider a solid body (PQ), we perceive at once that it has three dimensions, namely:— length, breadth, and thickness; suppose one part of this solid (PS) to be red, and the other part (QR) yellow, and that the colours be distinct without commingling, the blue surface (RS) which separates these parts, or which is the same thing, that which divides the solid without loss of material, must be without thickness, and only possesses length and breadth;

INTRODUCTION.

this plainly appears from reasoning, similar to that just employed in defining, or rather describing a point and a line.

The proposition which we have selected to elucidate the manner in which the principles are applied, is the fifth of the first Book.

In an isosceles triangle ABC, the internal angles at the base ABC, ACB are equal, and when the sides AB, AC are produced, the external angles at the base BCE, CBD are also equal.

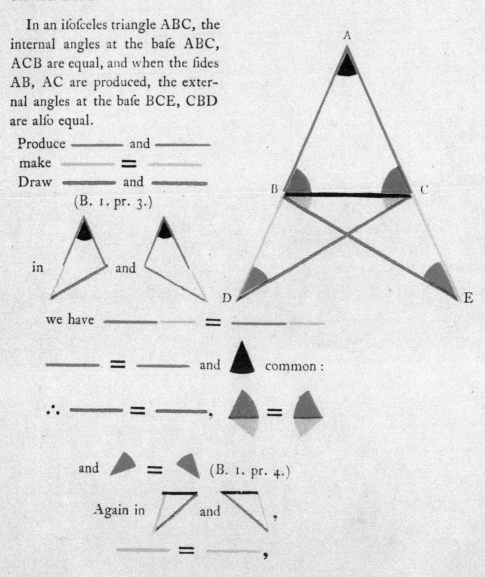

Produce ——— and ———
make ═══ ═ ═══
Draw ——— and ———
(B. 1. pr. 3.)

in ▲ and ▲

we have ——— ═ ———

——— ═ ——— and ▲ common :

∴ ——— ═ ———, ◄ ═ ►

and ▲ ═ ◄ (B. 1. pr. 4.)

Again in ◺ and ◿ ,

——— ═ ——— ,

xvi INTRODUCTION.

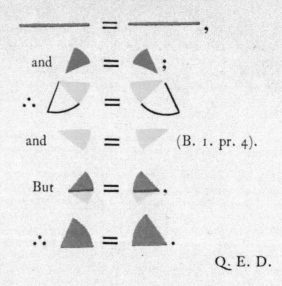

(B. 1. pr. 4).

Q. E. D.

By annexing Letters to the Diagram.

LET the equal sides AB and AC be produced through the extremities BC, of the third side, and in the produced part BD of either, let any point D be assumed, and from the other let AE be cut off equal to AD (B. 1. pr. 3). Let the points E and D, so taken in the produced sides, be connected by straight lines DC and BE with the alternate extremities of the third side of the triangle.

In the triangles DAC and EAB the sides DA and AC are respectively equal to EA and AB, and the included angle A is common to both triangles. Hence (B. 1. pr. 4.) the line DC is equal to BE, the angle ADC to the angle AEB, and the angle ACD to the angle ABE; if from the equal lines AD and AE the equal sides AB and AC be taken, the remainders BD and CE will be equal. Hence in the triangles BDC and CEB, the sides BD and DC are respectively equal to CE and EB, and the angles D and E included by those sides are also equal. Hence (B. 1. pr. 4.)

the angles DBC and ECB, which are those included by the third side BC and the productions of the equal sides AB and AC are equal. Also the angles DCB and EBC are equal if those equals be taken from the angles DCA and EBA before proved equal, the remainders, which are the angles ABC and ACB opposite to the equal sides, will be equal.

Therefore in an isosceles triangle, &c.

Q. E. D.

Our object in this place being to introduce the system rather than to teach any particular set of propositions, we have therefore selected the foregoing out of the regular course. For schools and other public places of instruction, dyed chalks will answer to describe diagrams, &c. for private use coloured pencils will be found very convenient.

We are happy to find that the Elements of Mathematics now forms a considerable part of every sound female education, therefore we call the attention of those interested or engaged in the education of ladies to this very attractive mode of communicating knowledge, and to the succeeding work for its future developement.

We shall for the present conclude by observing, as the senses of sight and hearing can be so forcibly and instantaneously addressed alike with one thousand as with one, *the million* might be taught geometry and other branches of mathematics with great ease, this would advance the purpose of education more than any thing that *might* be named, for it would teach the people how to think, and not what to think; it is in this particular the great error of education originates.

THE ELEMENTS OF EUCLID.

BOOK I.

DEFINITIONS.

I.
A *point* is that which has no parts.

II.
A *line* is length without breadth.

III.
The extremities of a line are points.

IV.
A ſtraight or right line is that which lies evenly between its extremities.

V.
A ſurface is that which has length and breadth only.

VI.
The extremities of a ſurface are lines.

VII.
A plane ſurface is that which lies evenly between its extremities.

VIII.
A plane angle is the inclination of two lines to one another, in a plane, which meet together, but are not in the ſame direction.

IX.

A plane rectilinear angle is the inclination of two ſtraight lines to one another, which meet together, but are not in the ſame ſtraight line.

BOOK I. DEFINITIONS. xix

X.

When one ſtraight line ſtanding on another ſtraight line makes the adjacent angles equal, each of theſe angles is called a *right angle*, and each of theſe lines is ſaid to be *perpendicular* to the other.

XI.

An obtuſe angle is an angle greater than a right angle.

XII.

An acute angle is an angle leſs than a right angle.

XIII.

A term or boundary is the extremity of any thing.

XIV.

A figure is a ſurface encloſed on all ſides by a line or lines.

XV.

A circle is a plane figure, bounded by one continued line, called its circumference or periphery; and having a certain point within it, from which all ſtraight lines drawn to its circumference are equal.

XVI.

This point (from which the equal lines are drawn) is called the centre of the circle.

XVII.

A diameter of a circle is a straight line drawn through the centre, terminated both ways in the circumference.

XVIII.

A semicircle is the figure contained by the diameter, and the part of the circle cut off by the diameter.

XIX.

A segment of a circle is a figure contained by a straight line, and the part of the circumference which it cuts off.

XX.

A figure contained by straight lines only, is called a rectilinear figure.

XXI.

A triangle is a rectilinear figure included by three sides.

XXII.

A quadrilateral figure is one which is bounded by four sides. The straight lines and ─── connecting the vertices of the opposite angles of a quadrilateral figure, are called its diagonals.

XXIII.

A polygon is a rectilinear figure bounded by more than four sides.

XXIV.

A triangle whose three sides are equal, is said to be equilateral.

XXV.

A triangle which has only two sides equal is called an isosceles triangle.

XXVI.

A scalene triangle is one which has no two sides equal.

XXVII.

A right angled triangle is that which has a right angle.

XXVIII.

An obtuse angled triangle is that which has an obtuse angle.

XXIX.

An acute angled triangle is that which has three acute angles.

XXX.

Of four-sided figures, a square is that which has all its sides equal, and all its angles right angles.

XXXI.

A rhombus is that which has all its sides equal, but its angles are not right angles.

XXXII.

An oblong is that which has all its angles right angles, but has not all its sides equal.

BOOK I. POSTULATES.

XXXIII.

A rhomboid is that which has its oppoſite ſides equal to one another, but all its ſides are not equal, nor its angles right angles.

XXXIV.

All other quadrilateral figures are called trapeziums.

XXXV.

Parallel ſtraight lines are ſuch as are in the ſame plane, and which being produced continually in both directions, would never meet.

POSTULATES.

I.

Let it be granted that a ſtraight line may be drawn from any one point to any other point.

II.

Let it be granted that a finite ſtraight line may be produced to any length in a ſtraight line.

III.

Let it be granted that a circle may be deſcribed with any centre at any diſtance from that centre.

AXIOMS.

I.

Magnitudes which are equal to the ſame are equal to each other.

II.

If equals be added to equals the ſums will be equal.

BOOK I. AXIOMS.

III.
If equals be taken away from equals the remainders will be equal.

IV.
If equals be added to unequals the sums will be unequal.

V.
If equals be taken away from unequals the remainders will be unequal.

VI.
The doubles of the same or equal magnitudes are equal.

VII.
The halves of the same or equal magnitudes are equal.

VIII.
Magnitudes which coincide with one another, or exactly fill the same space, are equal.

IX.
The whole is greater than its part.

X.
Two straight lines cannot include a space.

XI.
All right angles are equal.

XII.
If two straight lines (▬▬▬) meet a third straight line (———) so as to make the two interior angles (◖ and ◗) on the same side less than two right angles, these two straight lines will meet if they be produced on that side on which the angles are less than two right angles.

xxiv BOOK I. ELUCIDATIONS.

The twelfth axiom may be expressed in any of the following ways:

1. Two diverging straight lines cannot be both parallel to the same straight line.

2. If a straight line intersect one of the two parallel straight lines it must also intersect the other.

3. Only one straight line can be drawn through a given point, parallel to a given straight line.

Geometry has for its principal objects the exposition and explanation of the properties of *figure*, and figure is defined to be the relation which subsists between the boundaries of space. Space or magnitude is of three kinds, *linear*, *superficial*, and *solid*.

Angles might properly be considered as a fourth species of magnitude. Angular magnitude evidently consists of parts, and must therefore be admitted to be a species of quantity. The student must not suppose that the magnitude of an angle is affected by the length of the straight lines which include it, and of whose mutual divergence it is the measure. The *vertex* of an angle is the point where the *sides* or the *legs* of the angle meet, as A.

An angle is often designated by a single letter when its legs are the only lines which meet together at its vertex. Thus the red and blue lines form the yellow angle, which in other systems would be called the angle A. But when more than two lines meet in the same point, it was necessary by former methods, in order to avoid confusion, to employ three letters to designate an angle about that point,

the letter which marked the vertex of the angle being always placed in the middle. Thus the black and red lines meeting together at C, form the blue angle, and has been usually denominated the angle FCD or DCF The lines FC and CD are the legs of the angle; the point C is its vertex. In like manner the black angle would be designated the angle DCB or BCD. The red and blue angles added together, or the angle HCF added to FCD, make the angle HCD; and so of other angles.

When the legs of an angle are produced or prolonged beyond its vertex, the angles made by them on both sides of the vertex are said to be *vertically opposite* to each other: Thus the red and yellow angles are said to be vertically opposite angles.

Superposition is the process by which one magnitude may be conceived to be placed upon another, so as exactly to cover it, or so that every part of each shall exactly coincide.

A line is said to be *produced*, when it is extended, prolonged, or has its length increased, and the increase of length which it receives is called its *produced part*, or its *production*.

The entire length of the line or lines which enclose a figure, is called its *perimeter*. The first six books of Euclid treat of plain figures only. A line drawn from the centre of a circle to its circumference, is called a *radius*. The lines which include a figure are called its *sides*. That side of a right angled triangle, which is opposite to the right angle, is called the *hypotenuse*. An *oblong* is defined in the second book, and called a *rectangle*. All the lines which are considered in the first six books of the Elements are supposed to be in the same plane.

The *straight-edge* and *compasses* are the only instruments,

the use of which is permitted in Euclid, or plain Geometry. To declare this restriction is the object of the *postulates*.

The *Axioms* of geometry are certain general propositions, the truth of which is taken to be self-evident and incapable of being established by demonstration.

Propositions are those results which are obtained in geometry by a process of reasoning. There are two species of propositions in geometry, *problems* and *theorems*.

A *Problem* is a proposition in which something is proposed to be done; as a line to be drawn under some given conditions, a circle to be described, some figure to be constructed, &c.

The *solution* of the problem consists in showing how the thing required may be done by the aid of the rule or straight-edge and compasses.

The *demonstration* consists in proving that the process indicated in the solution really attains the required end.

A *Theorem* is a proposition in which the truth of some principle is asserted. This principle must be deduced from the axioms and definitions, or other truths previously and independently established. To show this is the object of demonstration.

A *Problem* is analogous to a postulate.

A *Theorem* resembles an axiom.

A *Postulate* is a problem, the solution of which is assumed.

An *Axiom* is a theorem, the truth of which is granted without demonstration.

A *Corollary* is an inference deduced immediately from a proposition.

A *Scholium* is a note or observation on a proposition not containing an inference of sufficient importance to entitle it to the name of a *corollary*.

A *Lemma* is a proposition merely introduced for the purpose of establishing some more important proposition.

SYMBOLS AND ABBREVIATIONS.

∴ expresses the word *therefore*.
∵ *because*.
= *equal*. This sign of equality may be read *equal to*, or *is equal to*, or *are equal to*; but any discrepancy in regard to the introduction of the auxiliary verbs *is*, *are*, &c. cannot affect the geometrical rigour.
≠ means the same as if the words '*not equal*' were written.
⊐ signifies *greater than*.
⊏ *less than*.
⊉ *not greater than*.
⊈ *not less than*.
+ is read *plus* (*more*), the sign of addition; when interposed between two or more magnitudes, signifies their sum.
− is read *minus* (*less*), signifies subtraction; and when placed between two quantities denotes that the latter is to be taken from the former.
× this sign expresses the product of two or more numbers when placed between them in arithmetic and algebra; but in geometry it is generally used to express a *rectangle*, when placed between " two straight lines which contain one of its right angles." A *rectangle* may also be represented by placing a point between two of its conterminous sides.
: :: : expresses an *analogy* or *proportion*; thus, if A, B, C and D, represent four magnitudes, and A has to B the same ratio that C has to D, the proposition is thus briefly written,
$$A : B :: C : D,$$
$$A : B = C : D,$$
$$\text{or } \frac{A}{B} = \frac{C}{D}.$$
This equality or sameness of ratio is read,

SYMBOLS AND ABBREVIATIONS.

as A is to B, so is C to D;
or A is to B, as C is to D.

∥ signifies *parallel to*.
⊥ *perpendicular to*.

△ . *angle*.

◳ .. *right angle*.

⌓ . *two right angles*.

⋏ or ⋏ briefly designates a *point*.
⊏, =, or ⊐ signifies *greater, equal, or less than*.

The square described on a line is concisely written thus, ——².

In the same manner twice the square of, is expressed by 2 · ——².

def. signifies *definition*.
pos. *postulate*.
ax. *axiom*.
hyp. *hypothesis*. It may be necessary here to remark, that the *hypothesis* is the condition assumed or taken for granted. Thus, the hypothesis of the proposition given in the Introduction, is that the triangle is isosceles, or that its legs are equal.
const. *construction*. The *construction* is the change made in the original figure, by drawing lines, making angles, describing circles, &c. in order to adapt it to the argument of the demonstration or the solution of the problem. The conditions under which these changes are made, are as indisputable as those contained in the hypothesis. For instance, if we make an angle equal to a given angle, these two angles are equal by construction.
Q. E. D. *Quod erat demonstrandum*.
Which was to be demonstrated.

CORRIGENDA.

Faults to be corrected before reading this Volume.

PAGE 13, line 9, *for* def. 7 *read* def. 10.

 45, last line, *for* pr. 19 *read* pr. 29.

 54, line 4 from the bottom, *for* black and red line *read* blue and red line.

 59, line 4, *for* add black line squared *read* add blue line squared.

 60, line 17, *for* red line multiplied by red and yellow line *read* red line multiplied by red, blue, and yellow line.

 76, line 11, *for* def. 7 *read* def. 10.

 81, line 10, *for* take black line *read* take blue line.

 105, line 11, *for* yellow black angle add blue angle equal red angle *read* yellow black angle add blue angle add red angle.

 129, last line, *for* circle *read* triangle.

 141, line 1, *for* Draw black line *read* Draw blue line.

 196, line 3, before the yellow magnitude insert M.

Euclid.

BOOK I.
PROPOSITION I. PROBLEM.

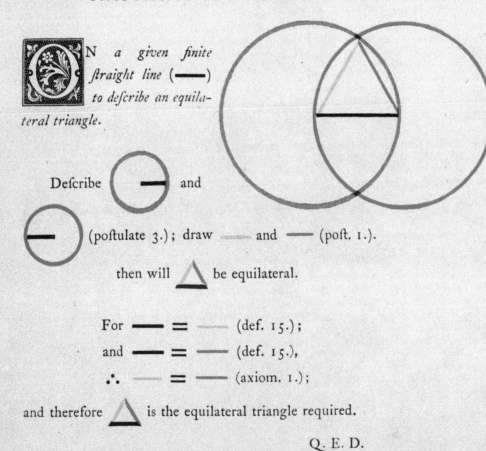

ON a given finite ſtraight line (———) to deſcribe an equilateral triangle.

Deſcribe ⊙—— and ——⊙ (poſtulate 3.); draw —— and —— (poſt. 1.).

then will △ be equilateral.

For —— = —— (def. 15.);
and —— = —— (def. 15.),
∴ —— = —— (axiom. 1.);

and therefore △ is the equilateral triangle required.

Q. E. D.

BOOK I. PROP. II. PROB.

 ROM *a given point* (————), *to draw a straight line equal to a given finite straight line* (————).

Draw ———————— (poſt. 1.), deſcribe ━━━ (pr. 1.), produce ———— (poſt. 2.), deſcribe ◯ (poſt. 3.), and ◯ (poſt. 3.); produce ———— (poſt. 2.), then ———— is the line required.

For ———— = ———— (def. 15.), and ———— = ———— (conſt.), ∴ ———— = ———— (ax. 3.), but (def. 15.) ———— = ———— = ————; ∴ ———— drawn from the given point (————), is equal the given line ————.

Q. E. D.

BOOK I. PROP. III. PROB.

ROM the greater (———......) of two given straight lines, to cut off a part equal to the less (———).

Draw ——— = ——— (pr. 2.); describe (post. 3.), then ——— = ———.

For ——— = ——— (def. 15.),
and ——— = ——— (const.);
∴ ——— = ——— (ax. 1.).

Q. E. D.

BOOK I. PROP. IV. THEOR.

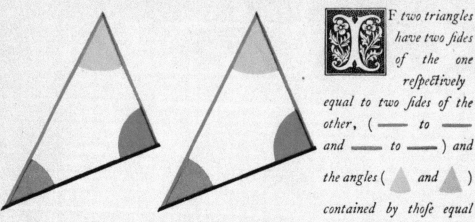

IF *two triangles have two sides of the one respectively equal to two sides of the other,* (━━ *to* ━━ *and* ━━ *to* ━━) *and the angles* (▲ *and* ▲) *contained by those equal sides also equal; then their bases or their sides* (━━ *and* ━━) *are also equal: and the remaining and their remaining angles opposite to equal sides are respectively equal* (▲ = ▲ *and* ◖ = ◖) : *and the triangles are equal in every respect.*

Let the two triangles be conceived, to be so placed, that the vertex of the one of the equal angles, ▲ or ▲ ; shall fall upon that of the other, and ━━ to coincide with ━━, then will ━━ coincide with ━━ if applied: consequently ━━ will coincide with ━━, or two straight lines will enclose a space, which is impossible (ax. 10), therefore ━━ = ━━, ▲ = ▲ and ◖ = ◖, and as the triangles △ and △ coincide, when applied, they are equal in every respect.

<div style="text-align:right;">Q. E. D.</div>

BOOK I. PROP. V. THEOR.

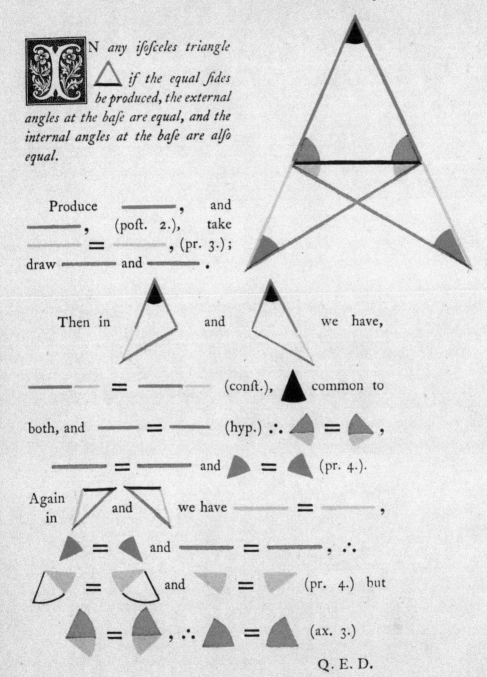

IN any isosceles triangle △ if the equal sides be produced, the external angles at the base are equal, and the internal angles at the base are also equal.

Produce ─────, and ─────, (post. 2.), take ─── = ───, (pr. 3.); draw ───── and ─────.

Then in △ and △ we have,

───── = ───── (const.), ▲ common to both, and ─── = ─── (hyp.) ∴ ◢ = ◣, ───── = ───── and ◖ = ◗ (pr. 4.).

Again in ◣ and ◢ we have ───── = ─────, ◢ = ◣ and ─── = ───, ∴ ◖ = ◗ and ▽ = ▽ (pr. 4.) but ◣ = ◢, ∴ ◣ = ◢ (ax. 3.)

Q. E. D.

BOOK I. PROP. VI. THEOR.

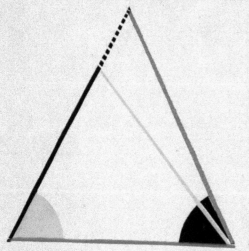

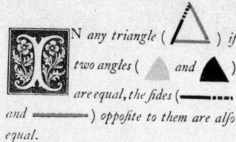 N any triangle (△) if two angles (△ and ▲) are equal, the sides (———— and ————) opposite to them are also equal.

For if the sides be not equal, let one of them ———— be greater than the other ————, and from it cut off ———— = ———— (pr. 3.), draw ————.

Then in △ and △, ———— = ————, (const.) △ = ▲ (hyp.) and ———— common, ∴ the triangles are equal (pr. 4.) a part equal to the whole, which is absurd; ∴ neither of the sides ———— or ———— is greater than the other, ∴ hence they are equal

Q. E. D.

BOOK I. PROP. VII. THEOR.

N the same base (⎯⎯), and on the same side of it there cannot be two triangles having their conterminous sides (⎯⎯ and ⎯⎯, ⎯⎯ and ⎯⎯) at both extremities of the base, equal to each other.

When two triangles stand on the same base, and on the same side of it, the vertex of the one shall either fall outside of the other triangle, or within it; or, lastly, on one of its sides.

If it be possible let the two triangles be constructed so that { ⎯⎯ = ⎯⎯ / ⎯⎯ = ⎯⎯ }, then draw ------ and,

◐ = ▽ (pr. 5.)

∴ ▽ ⊐ ▽ and

∴ ▽ ⊐ ◐ } which is absurd,

but (pr. 5.) ▽ = ◐

therefore the two triangles cannot have their conterminous sides equal at both extremities of the base.

Q. E. D.

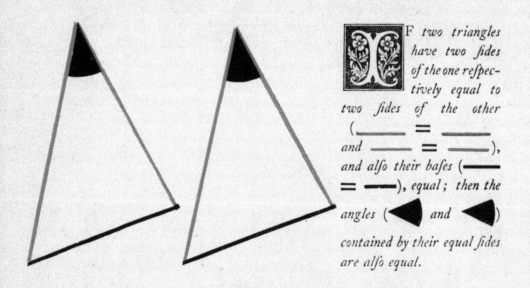

IF two triangles have two sides of the one respectively equal to two sides of the other (———— = ———— and ———— = ————), and also their bases (———— = ————), equal; then the angles (▶ and ▶) contained by their equal sides are also equal.

If the equal bases ———— and ———— be conceived to be placed one upon the other, so that the triangles shall lie at the same side of them, and that the equal sides ———— and ————, ———— and ———— be conterminous, the vertex of the one must fall on the vertex of the other; for to suppose them not coincident would contradict the last proposition.

Therefore the sides ———— and ————, being coincident with ———— and ————,

∴ ▲ = ▲.

Q. E. D.

To bisect a given rectilinear angle ().

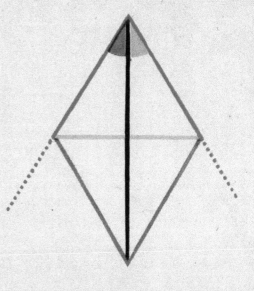

Take ─── = ─── (pr. 3.)
draw ───, upon which
describe ∨ (pr. 1.),
draw ───.

Because ─── = ─── (conſt.)
and ─── common to the two triangles
and ─── = ─── (conſt.),

∴ ◢ = ◣ (pr. 8.)

Q. E. D.

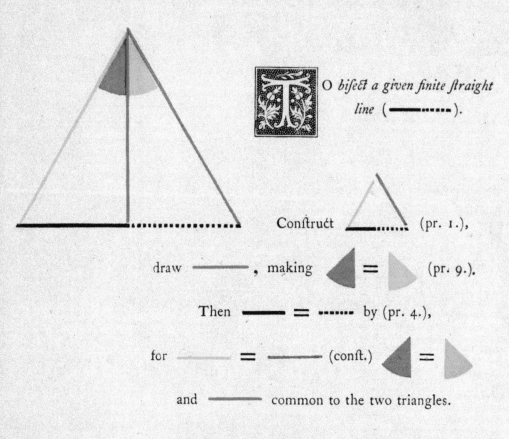

TO *bisect a given finite straight line* (━━ ⋯⋯).

Construct ▲ (pr. 1.), draw ━━, making ◀ = ▶ (pr. 9.).

Then ━━ = ⋯⋯ by (pr. 4.),

for ━━ = ━━ (conft.) ◀ = ▶

and ━━ common to the two triangles.

Therefore the given line is bisected.

Q. E. D.

BOOK I. PROP. XI. PROB.

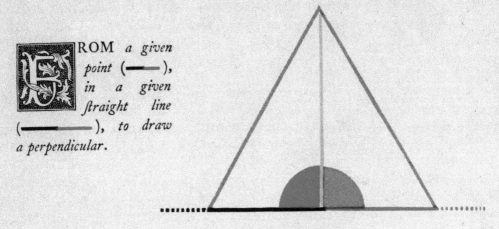

FROM a given point (———), in a given straight line (—————), to draw a perpendicular.

Take any point (———·····) in the given line,
cut off ——— = ——— (pr. 3.),

construct △ (pr. 1.),

draw ——— and it shall be perpendicular to the given line.

For ——— = ——— (conft.)
——— = ——— (conft.)
and ——— common to the two triangles.

Therefore 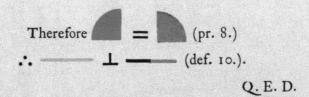 (pr. 8.)

∴ ——— ⊥ ——— (def. 10.).

Q. E. D.

BOOK I. PROP. XII. PROB.

TO draw a straight line perpendicular to a given indefinite straight line (———) from a given point (△) without.

With the given point △ as centre, at one side of the line, and any diſtance ——— capable of extending to the other ſide, deſcribe ⌣ ,

Make ——— = ——— (pr. 10.)
draw ———, ——— and ———.
then ——— ⊥ ———.

For (pr. 8.) ſince ——— = ——— (conſt.)
——— common to both,
and ——— = ——— (def. 15.)

∴ ◖ = ◗ , and
∴ ——— ⊥ ——— (def. 10.).

Q. E. D.

BOOK I. PROP. XIII. THEOR.

WHEN *a straight line* (———) *standing upon another straight line* (—————) *makes angles with it; they are either two right angles or together equal to two right angles.*

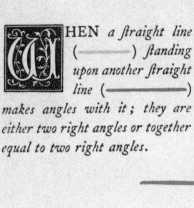

If ——— be ⟂ to ——— then,

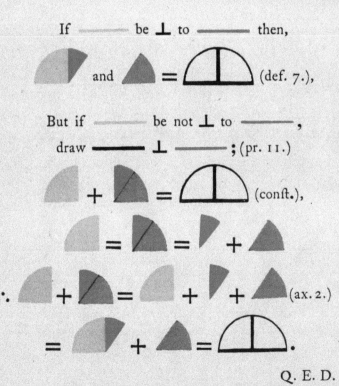

Q. E. D.

BOOK I. PROP. XIV. THEOR.

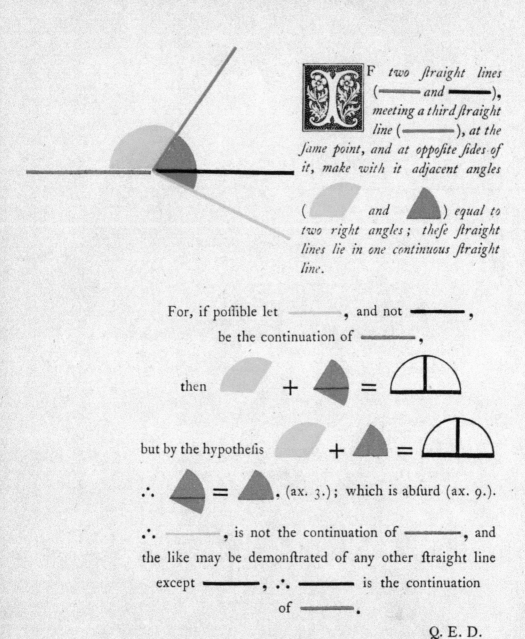

IF two straight lines (━━━ and ━━━), meeting a third straight line (━━━), at the same point, and at opposite sides of it, make with it adjacent angles (◖ and ◗) equal to two right angles; these straight lines lie in one continuous straight line.

For, if possible let ━━━, and not ━━━, be the continuation of ━━━,

then ◖ + ◗ = ◧

but by the hypothesis ◖ + ◗ = ◧

∴ ◗ = ◣. (ax. 3.); which is absurd (ax. 9.).

∴ ━━━, is not the continuation of ━━━, and the like may be demonstrated of any other straight line except ━━━, ∴ ━━━ is the continuation of ━━━.

Q. E. D.

BOOK I. PROP. XV. THEOR.

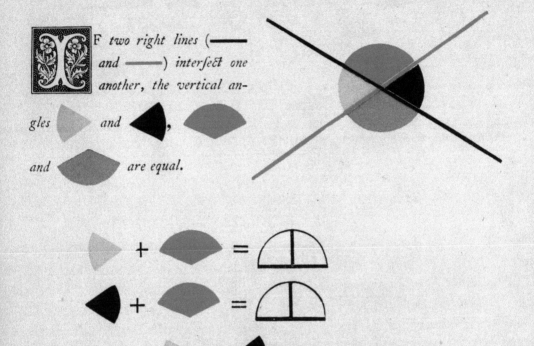

IF two right lines (———— and ————) interfect one another, the vertical angles ◐ and ◑, ◒ and ◓ are equal.

◐ + ◒ = ◗
◑ + ◒ = ◗
∴ ◐ = ◑.

In the fame manner it may be fhown that

Q. E. D.

BOOK I. PROP. XVI. THEOR.

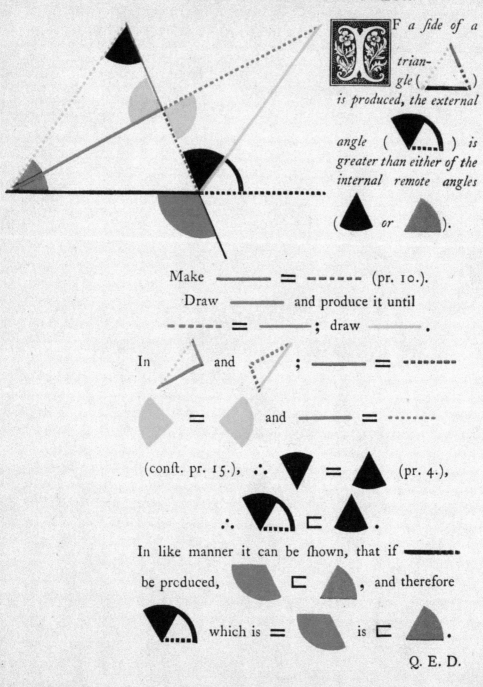

IF a side of a triangle (▬▬) is produced, the external angle (◒) is greater than either of the internal remote angles (◣ or ◣).

Make ▬▬ = ▬ ▬ ▬ (pr. 10.).
Draw ▬▬ and produce it until
▬ ▬ ▬ = ▬▬ ; draw ▬▬ .

In △ and △ ; ▬▬ = ▬ ▬ ▬

◖ = ◗ and ▬▬ = ▬ ▬ ▬

(conft. pr. 15.), ∴ ▼ = ▲ (pr. 4.),

∴ ◒ ⊏ ▲ .

In like manner it can be shown, that if ▬▬ be produced, ◖ ⊏ ◗ , and therefore ◒ which is = ◖ is ⊏ ◗ .

Q. E. D.

BOOK I. PROP. XVII. THEOR. 17

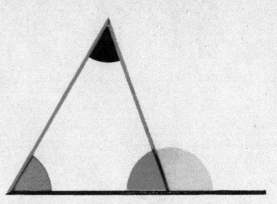

ANY *two angles of a tri-* *angle are together less than two right angles.*

Produce ———, then will

But ◧ ⊏ ▲ (pr. 16.)

∴ ◧ + ▲ ⊐ ◐ ,

and in the same manner it may be shown that any other two angles of the triangle taken together are less than two right angles.

<div align="right">Q. E. D.</div>

BOOK I. PROP. XVIII. THEOR.

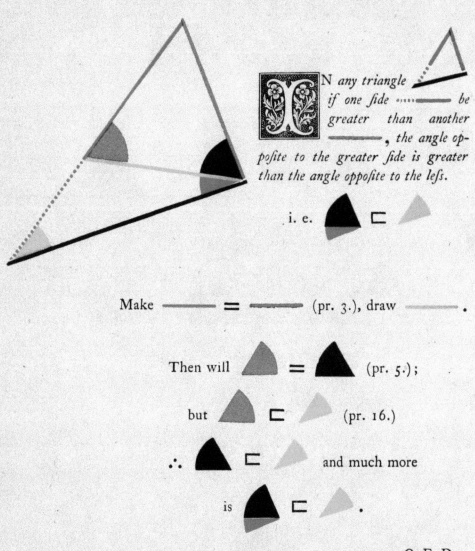

N any triangle if one side ····· —— be greater than another ———, the angle opposite to the greater side is greater than the angle opposite to the less.

Q. E. D.

BOOK I. PROP. XIX. THEOR.

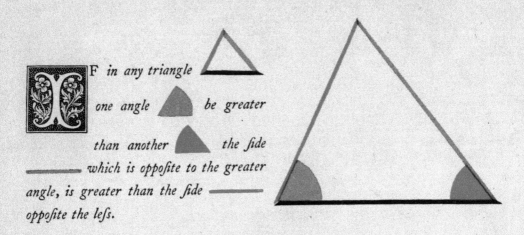

IF in any triangle ▲ one angle ▲ be greater than another ▲ the side ▬▬ which is oppofite to the greater angle, is greater than the fide ▬▬ oppofite the lefs.

If ▬▬ be not greater than ▬▬ then muft ▬▬ = or ⊐ ▬▬.

If ▬▬ = ▬▬ then ▲ = ▲ (pr. 5.);

which is contrary to the hypothefis.

▬▬ is not lefs than ▬▬ ; for if it were,

▲ ⊐ ▲ (pr. 18.)

which is contrary to the hypothefis:

∴ ▬▬ ⊏ ▬▬.

Q. E. D.

BOOK I. PROP. XX. THEOR.

 NY *two sides* ———— *and* ———— *of a triangle* *taken together are greater than the third side* (————).

Produce ————, and make ------ = ———— (pr. 3.);
draw ————.

Then becaufe ------ = ———— (conft.),

◣ = ◢ (pr. 5.)

∴ ◣ ⊏ ◢ (ax. 9.)

∴ ———— + ------ ⊏ ———— (pr. 19.)

and ∴ ———— + ———— ⊏ ————.

Q. E. D

BOOK I. PROP. XXI. THEOR.

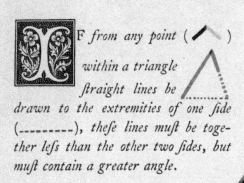

IF from any point (▬) within a triangle ſtraight lines be drawn to the extremities of one ſide (┄┄┄┄), theſe lines muſt be together leſs than the other two ſides, but muſt contain a greater angle.

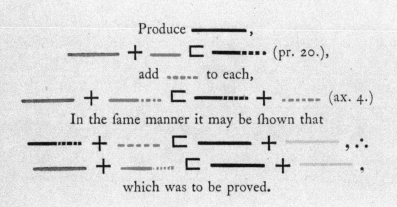

Produce ▬▬,
▬▬ + ▬▬ ⊏ ▬▬┄ (pr. 20.),
add ┄┄ to each,
▬▬ + ▬▬ ⊏ ▬▬ + ┄┄ (ax. 4.)
In the ſame manner it may be ſhown that
▬▬ + ▬▬ ⊏ ▬▬ + ▬▬, ∴
▬▬ + ▬▬ ⊏ ▬▬ + ▬▬;
which was to be proved.

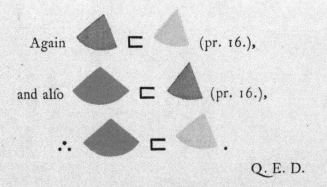

Q. E. D.

BOOK I. PROP. XXII. THEOR.

IVEN *three right lines* { ▬▬▬▬▬ / ▬ ▬ ▬ ▬ / ▭ ▭ ▭ ▭ ▭ } *the sum of any two greater than the third, to construct a triangle whose sides shall be respectively equal to the given lines.*

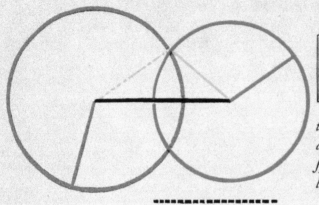

Assume ▬▬▬ = ▭▭▭ (pr. 3.).
Draw ▬▬ = ▭▭ }
and ▬▬ = ▭▭ } (pr. 2.).

With ▬▬ and ▬▬ as radii,

describe ◯ and ◯ (post. 3.);

draw ▭▭▭ and ▬▬▬,

then will △ be the triangle required.

For ▬▬▬ = ▭▭▭,

▬▬ = ▬▬ = ▭▭, }
and ▭▭ = ▬▬ = ▭▭. } (const.)

Q. E. D.

BOOK I. PROP. XXIII. PROB.

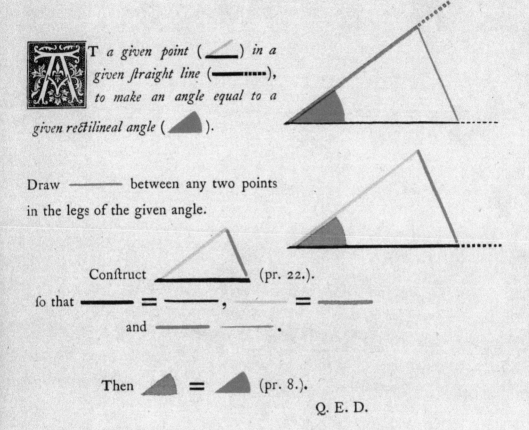

T a given point (▱) in a given ſtraight line (━━▬▬), to make an angle equal to a given rectilineal angle (◢).

Draw ━━ between any two points in the legs of the given angle.

Conſtruct ◸ (pr. 22.).

ſo that ━━ = ━━, ━━ = ━━,

and ━━ ━━ .

Then ◢ = ◢ (pr. 8.).

<div style="text-align: right">Q. E. D.</div>

BOOK I. PROP. XXIV. THEOR.

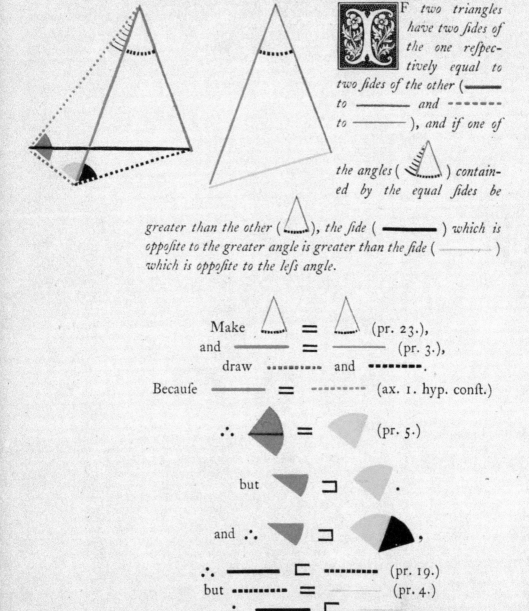

IF two triangles have two sides of the one respectively equal to two sides of the other (———— to ———— and ·········· to ————), and if one of the angles (△) contained by the equal sides be greater than the other (△), the side (————) which is opposite to the greater angle is greater than the side (··········) which is opposite to the less angle.

Make △ = △ (pr. 23.),
and ———— = ———— (pr. 3.),
draw ·········· and ··········.

Because ———— = ·········· (ax. 1. hyp. conft.)

∴ ◖ = ◗ (pr. 5.)

but ◖ ⊐ ◗.

and ∴ ◖ ⊐ ◗,

∴ ———— ⊏ ·········· (pr. 19.)
but ·········· = ══ (pr. 4.)
∴ ———— ⊏ ══.

Q. E. D.

BOOK I. PROP. XXV. THEOR.

IF two triangles have two sides (———— and ————) of the one respectively equal to two sides (———— and ————) of the other, but their bases unequal, the angle subtended by the greater base (————) of the one, must be greater than the angle subtended by the less base (————) of the other.

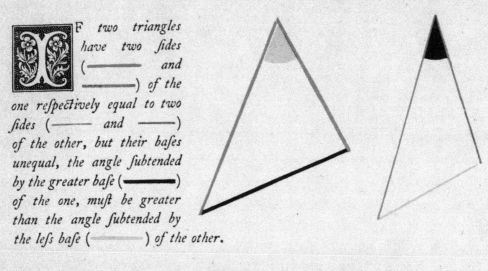

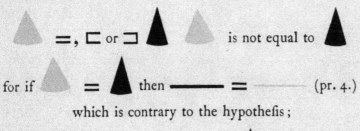

which is contrary to the hypothesis;

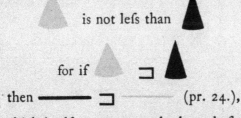

which is also contrary to the hypothesis:

Q. E. D.

BOOK I. PROP. XXVI. THEOR.

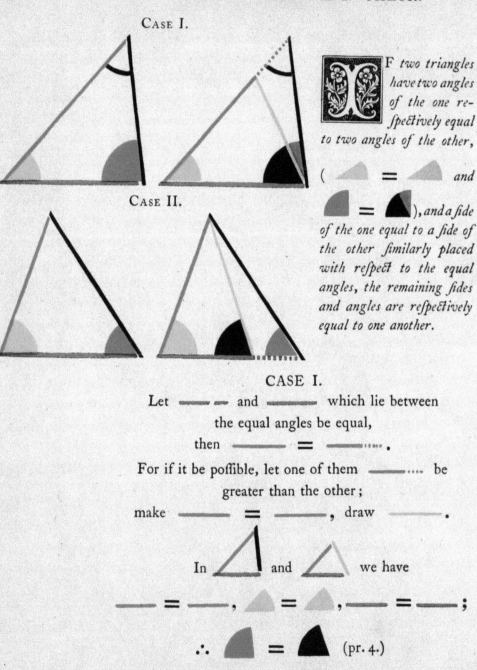

IF *two triangles have two angles of the one respectively equal to two angles of the other,* (▲ = ▲ *and* ▲ = ▲), *and a side of the one equal to a side of the other similarly placed with respect to the equal angles, the remaining sides and angles are respectively equal to one another.*

CASE I.

Let ▬▬ and ▬▬ which lie between the equal angles be equal,

then ▬▬ = ▬▬ .

For if it be possible, let one of them ▬▬ be greater than the other;

make ▬▬ = ▬▬ , draw ▬▬ .

In △ and △ we have

▬▬ = ▬▬ , ▲ = ▲ , ▬▬ = ▬▬ ;

∴ ▲ = ▲ (pr. 4.)

BOOK I. PROP. XXVI. THEOR.

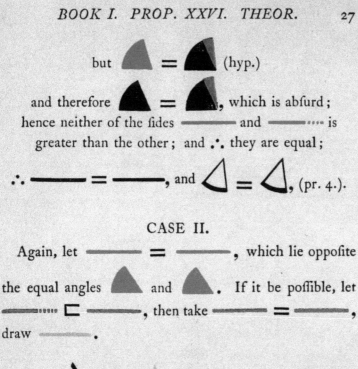

CASE II.

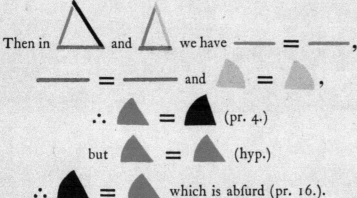

∴ ▲ = ▲ which is abſurd (pr. 16.).

Conſequently, neither of the ſides ▬▬ or ▬▬ is greater than the other, hence they muſt be equal. It follows (by pr. 4.) that the triangles are equal in all reſpects.

Q. E. D.

BOOK I. PROP. XXVII. THEOR.

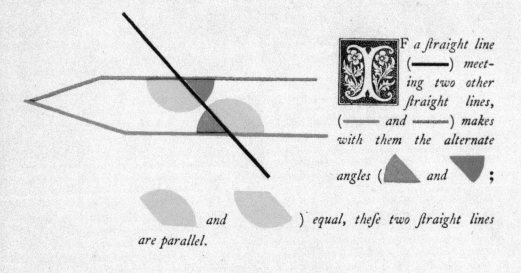

IF a straight line (———) meeting two other straight lines, (——— and ———) makes with them the alternate angles (▲ and ▼); and ▼ and ▲) equal, these two straight lines are parallel.

If ——— be not parallel to ——— they shall meet when produced.

If it be possible, let those lines be not parallel, but meet when produced; then the external angle ▼ is greater than ▲ (pr. 16), but they are also equal (hyp.), which is absurd: in the same manner it may be shown that they cannot meet on the other side; ∴ they are parallel.

Q. E. D.

BOOK I. PROP. XXVIII. THEOR.

IF *a straight line* (———), *cutting two other straight lines* (——— *and* ———), *makes the external equal to the internal and opposite angle, at the same side of the cutting line* (namely,

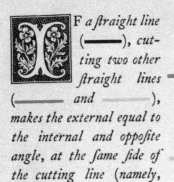

= 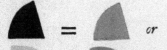), *or if it makes the two internal angles at the same side* (▰ *and* ▰, *or* ▰ *and* ▰) *together equal to two right angles, those two straight lines are parallel.*

First, if ▰ = ▰ , then ▰ = ▰ (pr. 15.),

∴ ▰ = ▰ ∴ ——— || ——— (pr. 27.).

Secondly, if ▰ + ▰ = ◠ ,

then ▰ + ▰ = ◠ (pr. 13.),

∴ ▰ + ▰ = ▰ + ▰ (ax. 3.)

∴ ▰ = ▰

∴ ——— || ——— (pr. 27.)

Q. E. D.

BOOK I. PROP. XXIX. THEOR.

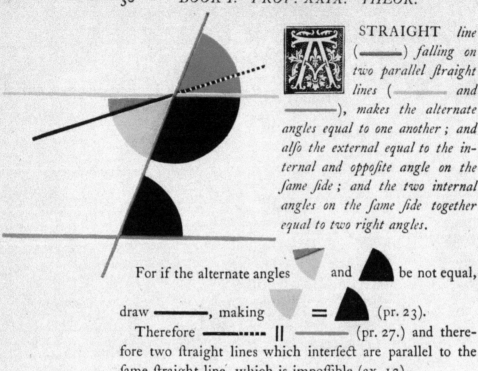

A STRAIGHT *line* (———) *falling on two parallel straight lines* (——— *and* ———), *makes the alternate angles equal to one another; and also the external equal to the internal and opposite angle on the same side; and the two internal angles on the same side together equal to two right angles.*

For if the alternate angles ▽ and ◢ be not equal, draw ———, making ▽ = ◢ (pr. 23).

Therefore ——— ∥ ——— (pr. 27.) and therefore two straight lines which interfect are parallel to the same straight line, which is impossible (ax. 12).

Hence the alternate angles ▽ and ◢ are not unequal, that is, they are equal: ▽ = ◢ (pr. 15);

∴ ◢ = ◢, the external angle equal to the internal and opposite on the same side: if ◗ be added to both, then ◢ + ◗ = ◓ = ◖ (pr. 13).

That is to say, the two internal angles at the same side of the cutting line are equal to two right angles.

Q. E. D.

BOOK I. PROP. XXX. THEOR.

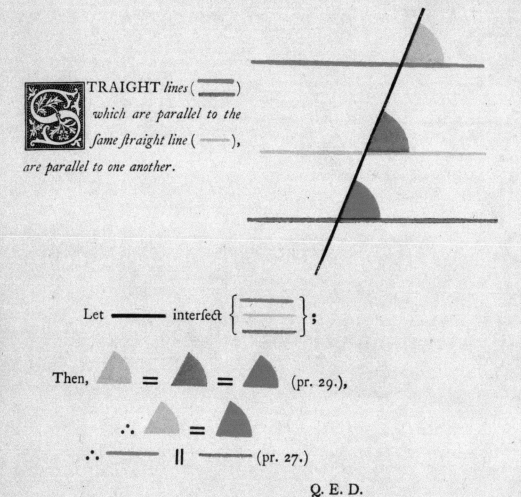

STRAIGHT *lines* (═══) *which are parallel to the same straight line* (───), *are parallel to one another.*

Let ─── interfect { ═══ };

Then, ▲ = ▲ = ▲ (pr. 29.),

∴ ▲ = ▲

∴ ─── ∥ ─── (pr. 27.)

Q. E. D.

BOOK I. PROP. XXXI. PROB.

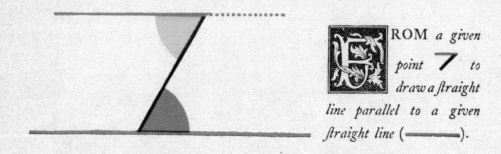

FROM a given point 7 to draw a straight line parallel to a given straight line (———).

Draw ——— from the point 7 to any point ∠ in ———,

make ▽ = ▲ (pr. 23.),

then ——-—— ∥ ——— (pr. 27.).

Q. E. D.

BOOK I. PROP. XXXII. THEOR. 33

IF any side (———) of a triangle be produced, the external angle () is equal to the sum of the two internal and opposite angles (), and the three internal angles of every triangle taken together are equal to two right angles.

Through the point ◢ draw ——— ∥ ——— (pr. 31.).

Then { ▲ = ▲ } { ▼ = ▼ } (pr. 29.),

∴ ▲ + ▲ = ▼ (ax. 2.),

and therefore

▲ + ▲ + ▲ = ◐ = ◖ (pr. 13.).

Q. E. D.

BOOK I. PROP. XXXIII. THEOR.

STRAIGHT *lines* (———— *and* ————) *which join the adjacent extremities of two equal and parallel straight lines* (———— *and* ┄┄┄┄), *are themselves equal and parallel.*

Draw ———— the diagonal.

———— = ┄┄┄┄ (hyp.)

▼ = ▲ (pr. 29.)

and ———— common to the two triangles;

∴ ———— = ————, and ▼ = ▲ (pr. 4.);

and ∴ ———— ∥ ———— (pr. 27.).

Q. E. D.

BOOK I. PROP. XXXIV. THEOR.

HE *opposite sides and angles of any parallelogram are equal, and the diagonal* (———) *divides it into two equal parts.*

Since $\left\{\vcenter{}\right\}$ (pr. 29.)

and ——— common to the two triangles.

∴ $\left\{\vcenter{}\right\}$ (pr. 26.)

and ▲ = ▲ (ax.):

Therefore the opposite sides and angles of the parallelogram are equal: and as the triangles ◣ and ◤ are equal in every respect (pr. 4,), the diagonal divides the parallelogram into two equal parts.

Q. E. D.

BOOK I. PROP. XXXV. THEOR.

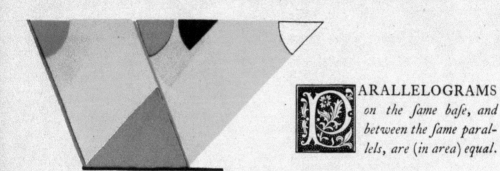

PARALLELOGRAMS on the same base, and between the same parallels, are (in area) equal.

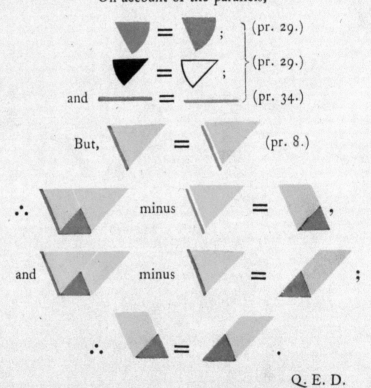

Q. E. D.

BOOK I. PROP. XXXVI. THEOR.

PARALLELO-GRAMS

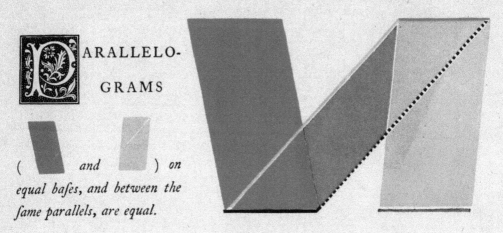

(▬ and ▬) on equal bafes, and between the fame parallels, are equal.

Draw ──── and ┅┅┅,

▬ = ──── = ────, by (pr. 34, and hyp.);

∴ ▬ = and ∥ ────;

∴ ──── = and ∥ ┅┅┅┅ (pr. 33.)

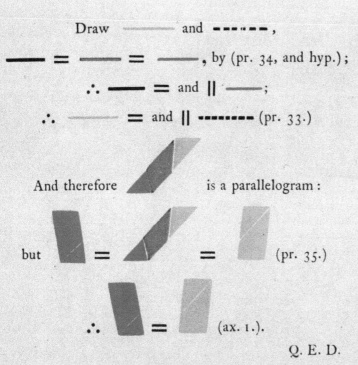

And therefore ▬ is a parallelogram:

but ▬ = ▬ = ▬ (pr. 35.)

∴ ▬ = ▬ (ax. 1.).

Q. E. D.

BOOK I. PROP. XXXVII. THEOR.

TRIANGLES and on the same base (———) and between the same parallels are equal.

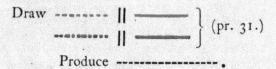 (pr. 31.)

Produce ------------------- .

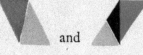 and 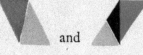 are parallelograms on the same base, and between the same parallels, and therefore equal. (pr. 35.)

∴ (pr. 34.)

∴ .

Q. E. D.

BOOK I. PROP. XXXVIII. THEOR. 39

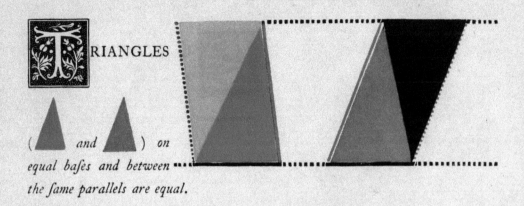

TRIANGLES (△ and △) on equal bases and between the same parallels are equal.

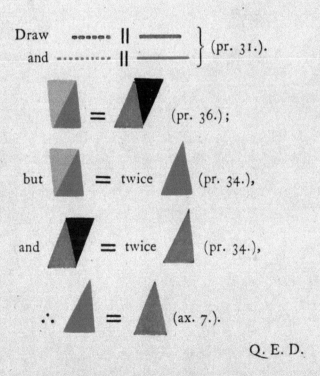

Q. E. D.

BOOK I. PROP. XXXIX. THEOR.

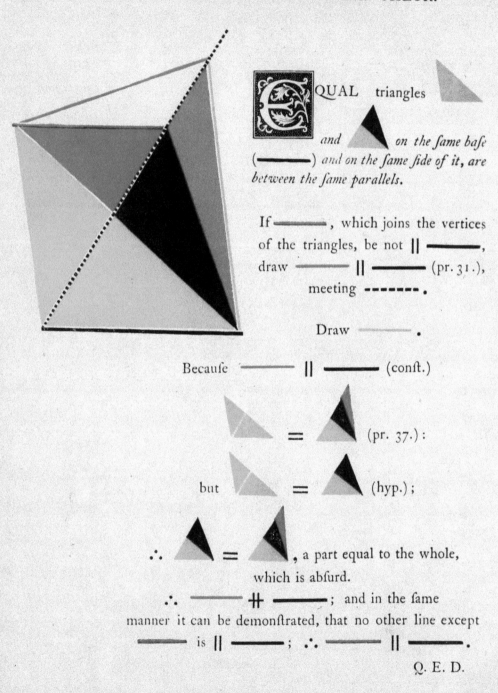

EQUAL triangles ▲ and ▲ on the same base (———) and on the same side of it, are between the same parallels.

If ———, which joins the vertices of the triangles, be not ∥ ———, draw ——— ∥ ——— (pr. 31.), meeting ------.

Draw ———.

Because ——— ∥ ——— (conft.)

▲ = ▲ (pr. 37.):

but ▲ = ▲ (hyp.);

∴ ▲ = ▲, a part equal to the whole, which is abfurd.

∴ ——— ∦ ———; and in the same manner it can be demonftrated, that no other line except ——— is ∥ ———; ∴ ——— ∥ ———.

Q. E. D.

BOOK I. PROP. XL. THEOR. 41

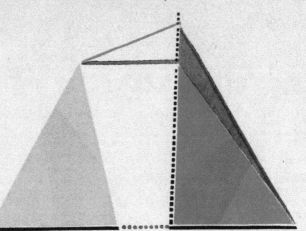

EQUAL triangles (and) on equal bafes, and on the fame fide, are between the fame parallels.

If ▬▬ which joins the vertices of triangles be not ∥ ▬▬▬▬,

draw ▬▬ ∥ ▬▬▬▬ (pr. 31.),

meeting ┄┄┄┄.

Draw ▬▬.

Becaufe ▬▬ ∥ ▬▬▬▬ (conft.)

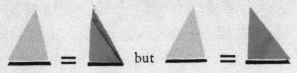

∴ ▲ = ▲ , a part equal to the whole, which is abfurd.

∴ ▬▬ ∦ ▬▬ : and in the fame manner it can be demonftrated, that no other line except ▬▬ is ∥ ▬▬ : ∴ ▬▬ ∥ ▬▬.

Q. E. D.

BOOK I. PROP. XLI. THEOR.

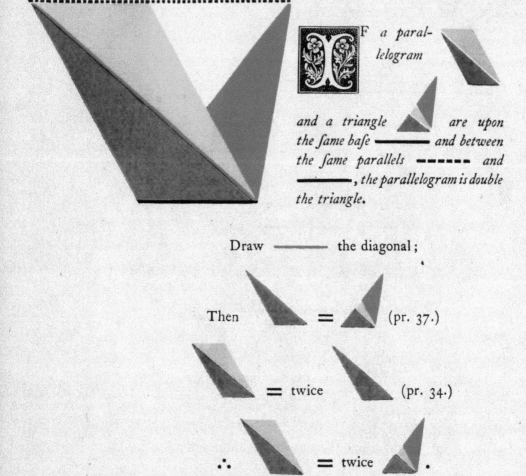

IF a parallelogram and a triangle are upon the same base ——— and between the same parallels -------- and ———, the parallelogram is double the triangle.

Draw ——— the diagonal;

Then ◣ = ◣ (pr. 37.)

= twice ◣ (pr. 34.)

∴ ◢ = twice ◣.

Q. E. D.

BOOK I. PROP. XLII. THEOR.

TO construct a parallelogram equal to a given triangle and having an angle equal to a given rectilinear angle .

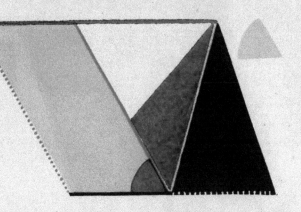

Make ———— = ------ (pr. 10.)

Draw 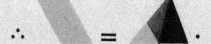 .

Make ▲ = ▲ (pr. 23.)

Draw { ---- ∥ ——— } (pr. 31.)
 { ——— ∥ ——— }

▱ = twice ▲ (pr. 41.)

but ▲ = ▲ (pr. 38.)

∴ ▱ = ▲ .

Q. E. D.

BOOK I. PROP. XLIII. THEOR.

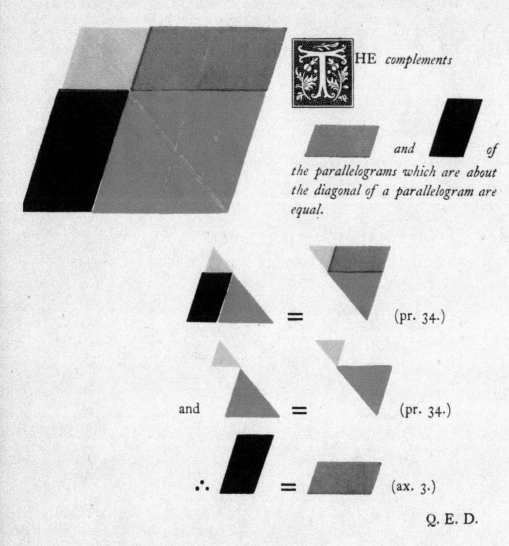

THE *complements* and of *the parallelograms which are about the diagonal of a parallelogram are equal.*

= (pr. 34.)

and = (pr. 34.)

∴ = (ax. 3.)

Q. E. D.

BOOK I. PROP. XLIV. PROB.

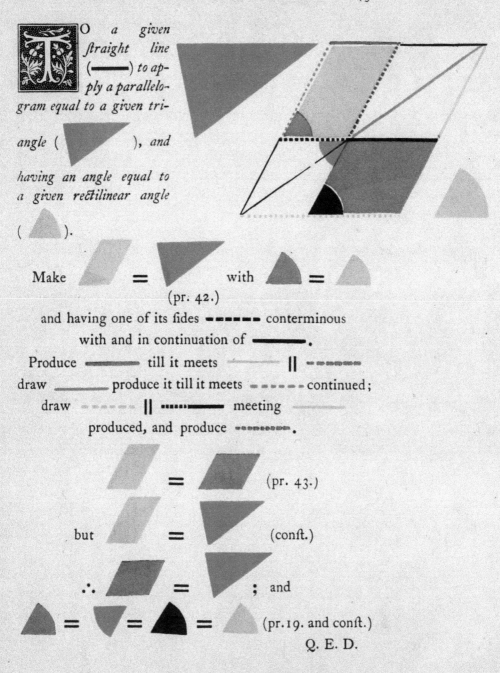

To a given straight line (———) to apply a parallelogram equal to a given triangle (▲), and having an angle equal to a given rectilinear angle (◭).

Make ▰ = ▲ with ◭ = ◭ (pr. 42.)

and having one of its sides ▬▬▬ conterminous with and in continuation of ———.

Produce ——— till it meets ▬▬ ∥ ▬▬▬
draw ——— produce it till it meets ▬▬▬ continued;
draw ▬▬ ∥ ▬▬▬ meeting ——— produced, and produce ▬▬▬.

▰ = ▰ (pr. 43.)

but ▰ = ▲ (const.)

∴ ▰ = ▲ ; and

◮ = ◭ = ◭ = ◭ (pr. 19. and const.)

Q. E. D.

BOOK I. PROP. XLV. PROB.

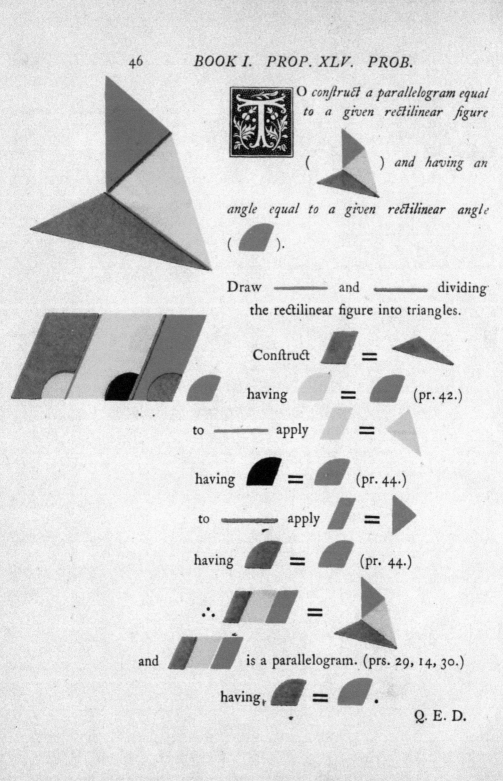

TO *construct a parallelogram equal to a given rectilinear figure* () *and having an angle equal to a given rectilinear angle* ().

Draw ——— and ——— dividing the rectilinear figure into triangles.

Construct ▱ = ◣
having ◗ = ◗ (pr. 42.)
to ——— apply ▱ = ◣
having ◗ = ◗ (pr. 44.)
to ——— apply ▱ = ▶
having ◗ = ◗ (pr. 44.)

∴ ▱▱ = ◣◣

and ▱▱▱ is a parallelogram. (prs. 29, 14, 30.)
having ◗ = ◗.

Q. E. D.

BOOK I. PROP. XLVI. PROB. 47

UPON *a given straight line* (———) *to construct a square.*

Draw ——— ⊥ and = ———
(pr. 11. and 3.)

Draw ——— ∥ ———, and meeting ——— drawn ∥ ———.

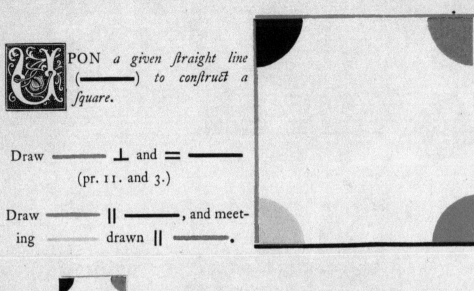

In ——— = ——— (conſt.)

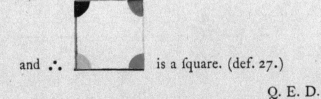 = a right angle (conſt.)

∴ = = a right angle (pr. 29.), and the remaining ſides and angles muſt be equal, (pr. 34.)

and ∴ is a ſquare. (def. 27.)

Q. E. D.

BOOK I. PROP. XLVII. THEOR.

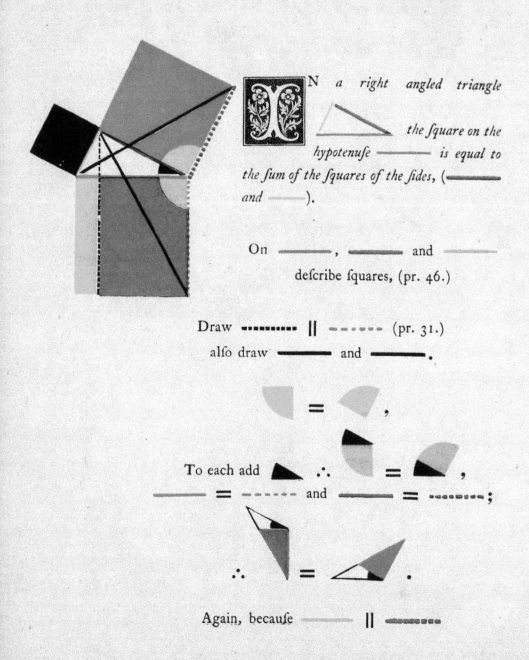

IN a right angled triangle the square on the hypotenuse ──── is equal to the sum of the squares of the sides, (──── and ────).

On ────, ──── and ──── describe squares, (pr. 46.)

Draw ········ ∥ ------ (pr. 31.) also draw ──── and ────.

▲ = ▲,

To each add ▲ ∴ ◢ = ◣,

──── = ------ and ──── = ········ ;

∴ ◣ = ◢ .

Again, becauſe ──── ∥ ········

BOOK I. PROP. XLVII. THEOR. 49

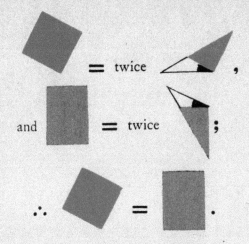

In the fame manner it may be fhown

Q. E. D.

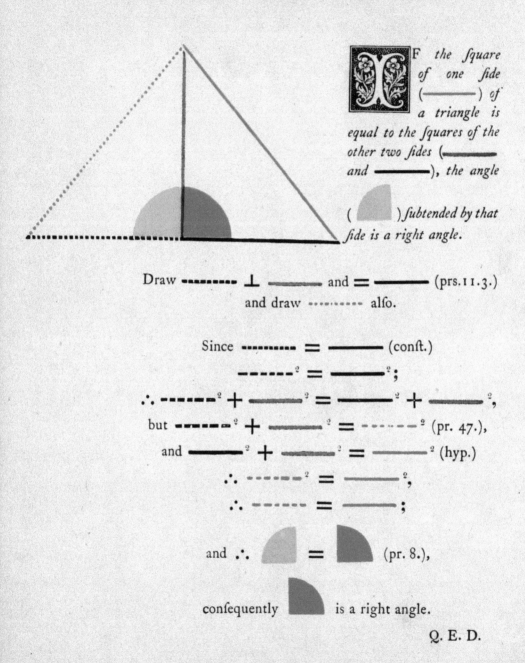

Q. E. D.

BOOK II.

DEFINITION I.

A RECTANGLE or a right angled parallelogram is said to be contained by any two of its adjacent or conterminous sides.

Thus: the right angled parallelogram is said to be contained by the sides ───── and ─────; or it may be briefly designated by ───── · ─────.

If the adjacent sides are equal; i. e. ───── = ─────, then ───── · ───── which is the expression for the rectangle under ───── and ───── is a square, and

is equal to $\begin{cases} \text{─────} \cdot \text{─────} \text{ or } \text{─────}^2 \\ \text{─────} \cdot \text{─────} \text{ or } \text{─────}^2 \end{cases}$

DEFINITION II.

IN a parallelogram, the figure composed of one of the parallelograms about the diagonal, together with the two complements, is called a *Gnomon*.

Thus and are called Gnomons.

BOOK II. PROP. I. PROB.

HE rectangle contained by two straight lines, one of which is divided into any number of parts,

is equal to the sum of the rectangles contained by the undivided line, and the several parts of the divided line.

Draw ▬▬ ⊥ ▬▬ and ═ ▬▬ (prs. 2. 3. B. 1.); complete the parallelograms, that is to say,

Draw { ▬▬ ∥ ▬▬
▬▬ ∥ ▬▬ } (pr. 31. B. 1.)

▤ = ▤ + ▮ + ▮

▤ = ▬ · ▬

▮ = ▬ · ▬ , ▮ = ▬ · ▬ ,

▮ = ▬ · ▬

∴ ▬ · ▬ = ▬ · ▬ + ▬ · ▬ + ▬ · ▬

Q. E. D.

BOOK II. PROP. II. THEOR.

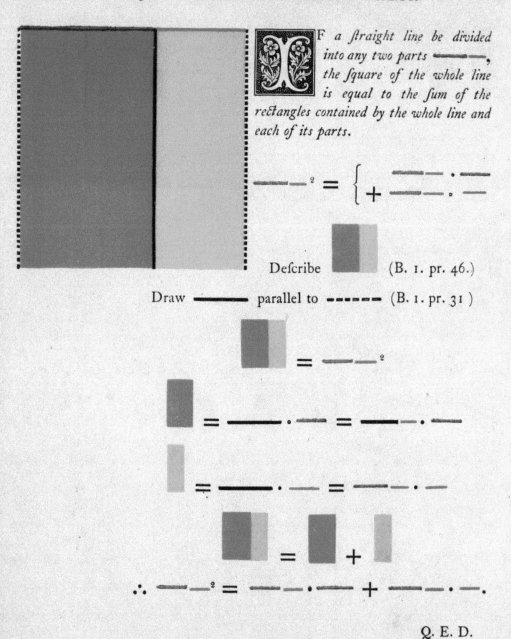

IF a straight line be divided into any two parts ———, the square of the whole line is equal to the sum of the rectangles contained by the whole line and each of its parts.

Q. E. D.

BOOK II. PROP. III. THEOR.

F a straight line be divided into any two parts ——, the rectangle contained by the whole line and either of its parts, is equal to the square of that part, together with the rectangle under the parts.

—— · — = —² + —— · —, or,
—— · — = —² + —— · —.

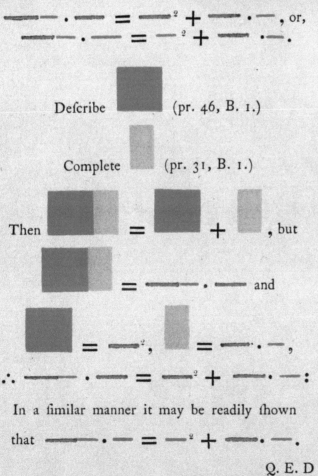

Describe ▪ (pr. 46, B. 1.)

Complete ▪ (pr. 31, B. 1.)

Then ▪ = ▪ + ▪ , but

▪ = —— · —— and

▪ = —² , ▪ = —— · — ,

∴ —— · — = —² + —— · — :

In a similar manner it may be readily shown that —— · — = —² + —— · —.

Q. E. D

BOOK II. PROP. IV. THEOR.

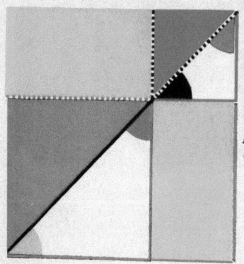

F a straight line be divided into any two parts ━━━ ━━, the square of the whole line is equal to the squares of the parts, together with twice the rectangle contained by the parts.

━━━━━2 = ━━2 + ━━2 +
twice ━━ · ━━.

Describe ▢ (pr. 46, B. 1.)

draw ━━━━━ ┅┅┅┅ (post. 1.),

and { ━━━ ┅┅ ‖ ━━ ━━ } (pr. 31, B. 1.)
 ┅┅┅ ━━━ ‖ ━━ ━━

◢ = ◢ (pr. 5, B. 1.),

◢ = ◢ (pr. 29, B. 1.)

∴ ◢ = ◢

BOOK II. PROP. IV. THEOR. 57

∴ by (prs. 6, 29, 34. B. 1.) ▨ is a square = ──².

For the fame reafons ◪ is a square = ──²,

▬ = ▮ = ── · ── (pr. 43, b. 1.)

but ▦ = ◪ + ▬ + ▮ + ◪,

∴ ──── ² = ──² + ──² +

twice ── · ──.

Q. E. D.

BOOK II. PROP. V. PROB.

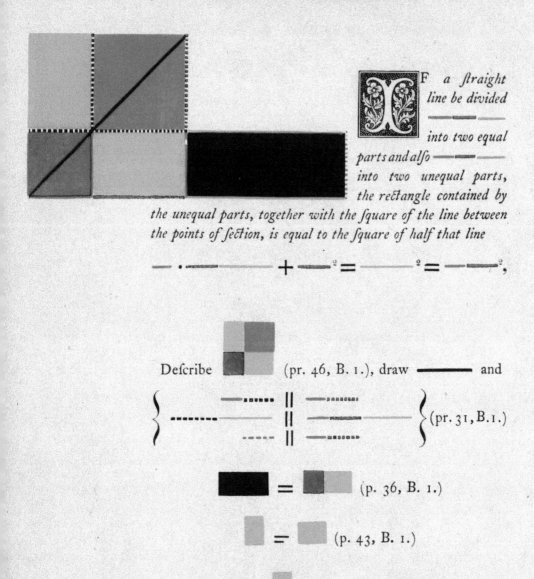

IF a straight line be divided into two equal parts and also into two unequal parts, the rectangle contained by the unequal parts, together with the square of the line between the points of section, is equal to the square of half that line.

BOOK II. PROP. V. THEOR. 59

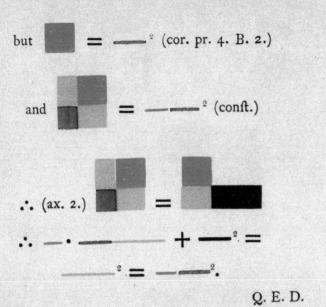

Q. E. D.

BOOK II. PROP. VI. THEOR.

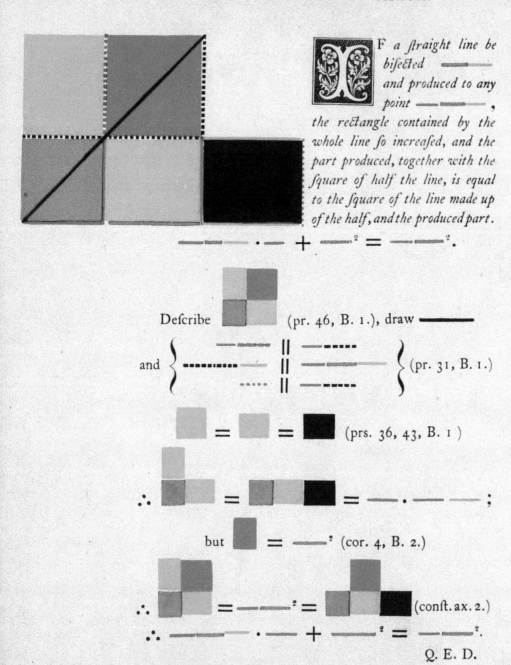

IF a straight line be bisected ▬▬ and produced to any point ▬▬▬, the rectangle contained by the whole line so increased, and the part produced, together with the square of half the line, is equal to the square of the line made up of the half, and the produced part.

▬▬▬ · ▬▬ + ▬▬² = ▬▬².

Describe ▢ (pr. 46, B. 1.), draw ▬▬

and { ▬▬ ∥ ▬▬ ▬▬ ∥ ▬▬ ▬▬ ∥ ▬▬ } (pr. 31, B. 1.)

▢ = ▢ = ▢ (prs. 36, 43, B. 1)

∴ ▢ = ▢ = ▬▬ · ▬▬ ;

but ▢ = ▬▬² (cor. 4, B. 2.)

∴ ▢ = ▬▬² = ▢ (const. ax. 2.)

∴ ▬▬ · ▬▬ + ▬▬² = ▬▬².

Q. E. D.

BOOK II. PROP. VII. THEOR.

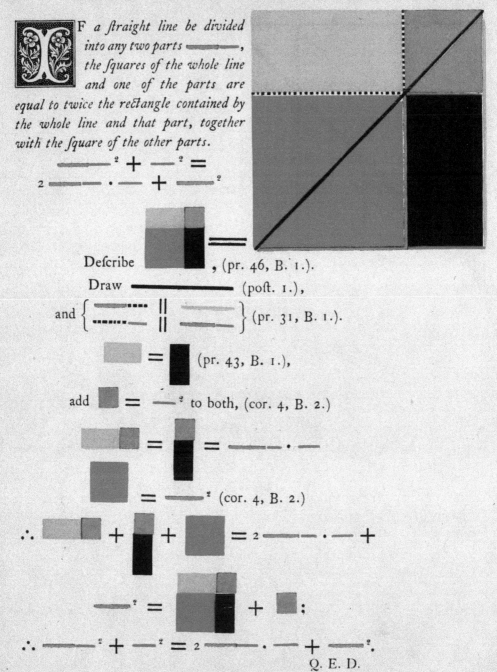

IF a straight line be divided into any two parts ———, the squares of the whole line and one of the parts are equal to twice the rectangle contained by the whole line and that part, together with the square of the other parts.

——² + —² = 2 ——— · — + —²

Describe ▊ , (pr. 46, B. I.).

Draw ——— (post. 1.),

and { ···· ∥ —— ∥ —— } (pr. 31, B. 1.).

▊ = ▊ (pr. 43, B. 1.),

add ▊ = —² to both, (cor. 4, B. 2.)

▊ = ▊ = ——— · —

▊ = —² (cor. 4, B. 2.)

∴ ▊ + ▊ + ▊ = 2 ——— · — +

—² = ▊ + ▊ :

∴ ——² + —² = 2 ——— · — + —².

Q. E. D.

BOOK II. PROP. VIII. THEOR.

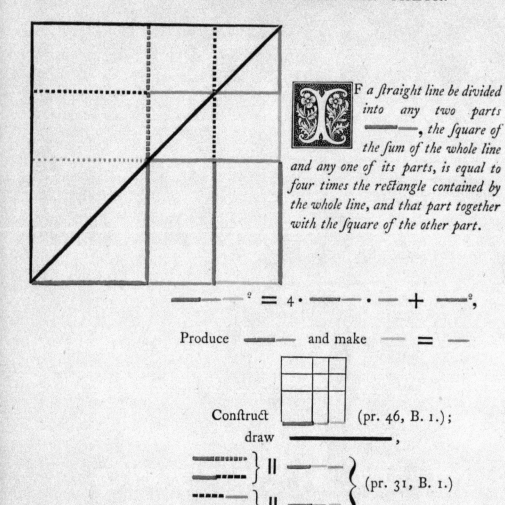

IF a straight line be divided into any two parts ▬▬ ▬▬, the square of the sum of the whole line and any one of its parts, is equal to four times the rectangle contained by the whole line, and that part together with the square of the other part.

▬▬▬² = 4 · ▬▬▬ · ▬ + ▬².

Produce ▬▬▬ and make ▬ = ▬

Construct ▦ (pr. 46, B. 1.);

draw ▬▬▬▬▬,

▭ } ∥ ▬▬
▭ } ∥ ▬▬ } (pr. 31, B. 1.)

▬▬▬² = ▬² + ▬▬² + 2 · ▬▬ · ▬
(pr. 4, B. II.)

but ▬² + ▬▬² = 2 · ▬▬ · ▬ + ▬²
(pr. 7, B. II.)

∴ ▬▬▬² = 4 · ▬▬ · ▬ + ▬².

Q. E. D.

BOOK II. PROP. IX. THEOR.

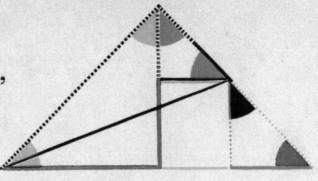

F a straight line be divided into two equal parts ▬▬▬, and also into two unequal parts ▬▬▬, the squares of the unequal parts are together double the squares of half the line, and of the part between the points of section.

▬² + ▬² = 2 ▬² + 2 ▬².

Make ▬▬ ⊥ and = ▬▬ or ▬▬,
Draw ▬▬▬ and ▬▬▬,
▬▬ ∥ ▬▬, ▬ ∥ ▬▬, and draw ▬▬.

◣ = ◣ (pr. 5, B. 1.) = half a right angle.
(cor. pr. 32, B. 1.)

◣ = ◣ (pr. 5, B. 1.) = half a right angle.
(cor. pr. 32, B. 1.)

∴ ◣ = a right angle.

◣ = ◣ = ◣ = ◣
(prs. 5, 29, B. 1.).

hence ▬▬ = ▬▬, ▬▬ = ▬▬ = ▬▬
(prs. 6, 34, B. 1.)

▬² = { ▬² + ▬², or + ▬²
{ ▬▬² = 2 ▬²
(pr. 47, B. 1.)
{ ▬▬² = 2 ▬²

∴ ▬² + ▬² = 2 ▬² + 2 ▬².

Q. E. D.

BOOK II. PROP. X. THEOR.

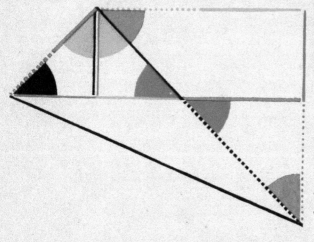

IF a straight line be bisected and produced to any point, the squares of the whole produced line, and of the produced part, are together double of the squares of the half line, and of the line made up of the half and produced part.

Make ▬▬ ⊥ and = to ▬▬ or ▬▬,
draw ▬▬ and ▬▬,
and { ▬▬ ∥ ▬▬ ∥ } (pr. 31, B. 1.);
draw ▬▬ also.

◣ = ◣ (pr. 5, B. 1.) = half a right angle.
(cor. pr. 32, B. 1.)

◣ = ◣ (pr. 5, B. 1.) = half a right angle
(cor. pr. 32, B. 1.)

∴ ◣ = a right angle.

BOOK II. PROP. X. THEOR.

half a right angle (prs. 5, 32, 29, 34, B. 1.),

and ▬▬ = ┈┈┈ , ▬▬ = ┈┈┈ = ┈┈┈ , (prs. 6, 34, B. 1.). Hence by (pr. 47, B. 1.)

$$\underline{\quad}^2 = \begin{cases} \underline{\quad}^2 + \underline{\quad}^2 \text{ or } \underline{\quad}^2 \\ \{ + \underline{\quad}^2 = 2\underline{\quad}^2 \\ \phantom{\{} + \underline{\quad}^2 = 2\underline{\quad}^2 \end{cases}$$

$\therefore \underline{\quad}^2 + \underline{\quad}^2 = 2\underline{\quad}^2 + 2\underline{\quad}^2.$

Q. E. D.

BOOK II. PROP. XI. PROB.

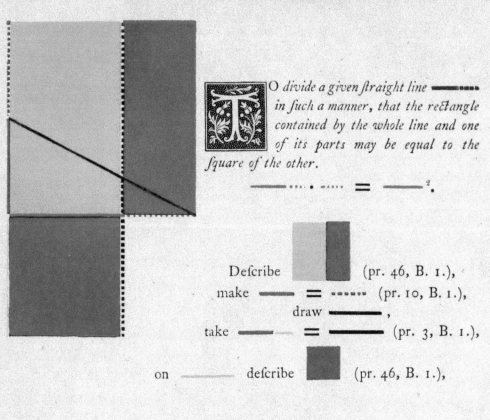

To divide a given straight line ▬▬▬▬ in such a manner, that the rectangle contained by the whole line and one of its parts may be equal to the square of the other.

▬▬▬ · ▬▬▬ = ▬▬▬².

Describe ▭ (pr. 46, B. 1.),
make ▬▬ = ▬▬▬ (pr. 10, B. 1.),
draw ▬▬▬,
take ▬▬ = ▬▬▬ (pr. 3, B. 1.),
on ▬▬▬ describe ▪ (pr. 46, B. 1.),

Produce ▬ ▬ ▬ ▬ (post. 2.).

Then, (pr. 6, B. 2.) ▬▬▬ · ▬▬▬ +
▬▬² = ▬▬² = ▬▬² = ▬▬² +
▬▬² ∴ ▬▬▬ · ▬▬▬ = ▬▬▬², or,

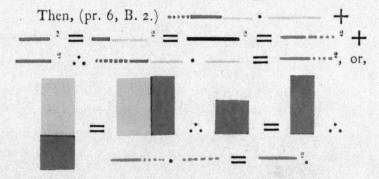

▬▬▬ · ▬▬▬ = ▬▬▬².

Q. E. D.

BOOK II. PROP. XII. THEOR.

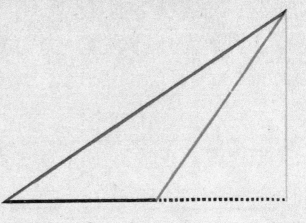

N any obtuſe angled triangle, the ſquare of the ſide ſubtending the obtuſe angle exceeds the ſum of the ſquares of the ſides containing the obtuſe angle, by twice the rectangle contained by either of theſe ſides and the produced parts of the ſame from the obtuſe angle to the perpendicular let fall on it from the oppoſite acute angle.

———² ⊏ ———² + ———² by 2 ——— · ·······.

By pr. 4, B. 2.

———² = ———² + ·······² + 2 ——— · ·······:

add ———² to both

———² + ———² = ———² (pr. 47, B. 1.)

= 2 · ——— · ······· + ———² + { ·······² }² or

+ ———² (pr. 47, B. 1.). Therefore,

———² = 2 · ——— · ······· + ———² + ———²: hence ———² ⊏ ———² + ———² by 2 · ——— · ·······.

Q. E. D.

BOOK II. PROP. XIII. THEOR.

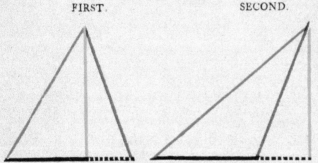

N any triangle, the square of the side subtending an acute angle, is less than the sum of the squares of the sides containing that angle, by twice the rectangle contained by either of these sides, and the part of it intercepted between the foot of the perpendicular let fall on it from the opposite angle, and the angular point of the acute angle.

FIRST.

$$\rule{1cm}{0.4pt}^2 \sqsupset \rule{1cm}{0.4pt}^2 + \rule{1cm}{0.4pt}^2 \text{ by } 2 \cdot \rule{2cm}{0.4pt} \cdot \rule{1cm}{0.4pt}.$$

SECOND.

$$\rule{1cm}{0.4pt}^2 \sqsupset \rule{1cm}{0.4pt}^2 + \rule{1cm}{0.4pt}^2 \text{ by } 2 \cdot \rule{1cm}{0.4pt} \cdot \rule{2cm}{0.4pt}.$$

First, suppose the perpendicular to fall within the triangle, then (pr. 7, B. 2.)

$$\rule{1.5cm}{0.4pt}^2 + \rule{1cm}{0.4pt}^2 = 2 \cdot \rule{1.5cm}{0.4pt} \cdot \rule{1cm}{0.4pt} + \rule{1.5cm}{0.4pt}^2,$$

add to each $\rule{1cm}{0.4pt}^2$ then,

$$\rule{1.5cm}{0.4pt}^2 + \rule{1cm}{0.4pt}^2 + \rule{1cm}{0.4pt}^2 = 2 \cdot \rule{1.5cm}{0.4pt} \cdot \rule{1cm}{0.4pt} + \rule{1.5cm}{0.4pt}^2 + \rule{1cm}{0.4pt}^2$$

∴ (pr. 47, B. 1.)

$$\rule{1.5cm}{0.4pt}^2 + \rule{1cm}{0.4pt}^2 = 2 \cdot \rule{1.5cm}{0.4pt} \cdot \rule{1cm}{0.4pt} + \rule{1cm}{0.4pt}^2,$$

and ∴ ──² ⊐ ────² + ──² by 2 · ────· ──.

Next suppose the perpendicular to fall without the triangle, then (pr. 7, B. 2.)

────² + ──² = 2 · ────· ── + ────²,

add to each ──² then

────² + ──² + ──² = 2 · ────· ── + ────² + ──² ∴ (pr. 47, B. 1.),

──² + ──² = 2 · ────· ── + ──²,

∴ ──² ⊐ ──² + ──² by 2 · ────· ──.

Q. E. D.

BOOK II. PROP. XIV. PROB.

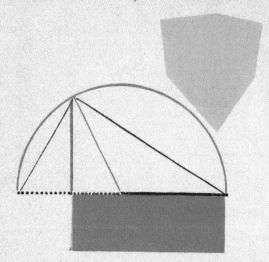

T O draw a right line of which the square shall be equal to a given rectilinear figure.

To draw ─────── such that,

───2 =

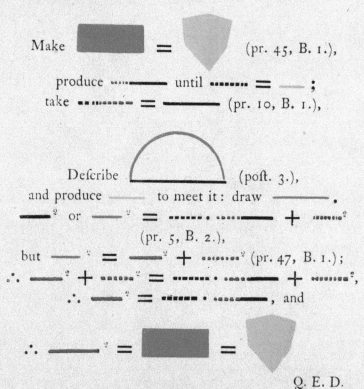

Make ▬▬ = ◆ (pr. 45, B. 1.),

produce ·····──── until ········ = ───;
take ·········· = ──────── (pr. 10, B. 1.),

Describe ⌒ (poſt. 3.),
and produce ───── to meet it: draw ─────.
───2 or ───2 = ········· · ········ + ·········2
(pr. 5, B. 2.),
but ───2 = ───2 + ·······2 (pr. 47, B. 1.);
∴ ───2 + ·····2 = ······· · ······· + ·······2,
∴ ───2 = ······· · ·······, and

∴ ───2 = ▬▬ = ◆

Q. E. D.

BOOK III.

DEFINITIONS.

I.

EQUAL circles are those whose diameters are equal.

II.

A right line is said to touch a circle when it meets the circle, and being produced does not cut it.

III.

Circles are said to touch one another which meet but do not cut one another.

IV.

Right lines are said to be equally distant from the centre of a circle when the perpendiculars drawn to them from the centre are equal.

V.

And the straight line on which the greater perpendicular falls is said to be farther from the centre.

VI.

A segment of a circle is the figure contained by a straight line and the part of the circumference it cuts off.

VII.

An angle in a segment is the angle contained by two straight lines drawn from any point in the circumference of the segment to the extremities of the straight line which is the base of the segment.

VIII.

An angle is said to stand on the part of the circumference, or the arch, intercepted between the right lines that contain the angle.

IX.

A sector of a circle is the figure contained by two radii and the arch between them.

DEFINITIONS.

X.

Similar segments of circles are those which contain equal angles.

Circles which have the same centre are called *concentric circles*.

BOOK III. PROP. I. PROB.

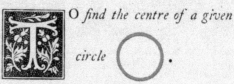 O *find the centre of a given circle* ◯.

Draw within the circle any straight line ———, make ═══ ═ ┄┄┄, draw ─── ⊥ ┄┄┄; bisect ───, and the point of bisection is the centre.

For, if it be possible, let any other point as the point of concourse of ───, ┄┄┄ and ┄┄┄ be the centre.

Because in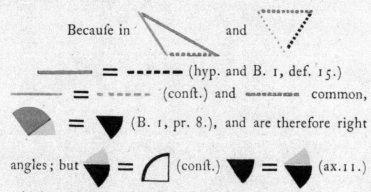

─── = ┄┄┄ (hyp. and B. 1, def. 15.)

─── = ┄┄┄ (const.) and ─── common,

◔ = ▼ (B. 1, pr. 8.), and are therefore right angles; but ▼ = ◜ (const.) ▼ = ▼ (ax. 11.)

which is abfurd; therefore the affumed point is not the centre of the circle; and in the fame manner it can be proved that no other point which is not on ─── is the centre, therefore the centre is in ───, and therefore the point where ─── is bifected is the centre.

<div align="right">Q. E. D.</div>

BOOK III. PROP. II. THEOR. 75

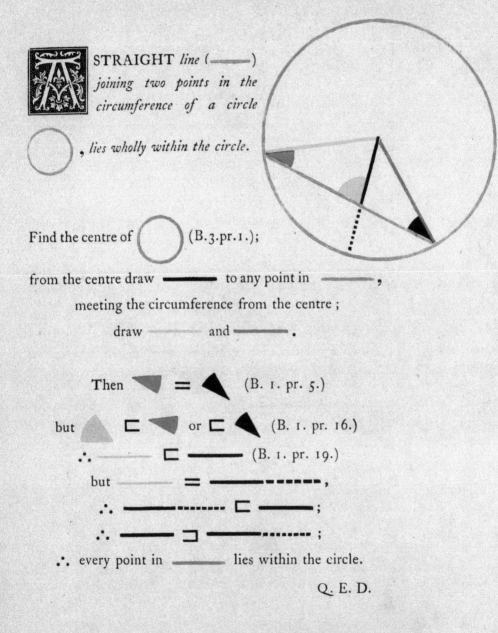

A STRAIGHT *line* (———) *joining two points in the circumference of a circle* ◯ , *lies wholly within the circle.*

Find the centre of ◯ (B. 3. pr. 1.);

from the centre draw ——— to any point in ———, meeting the circumference from the centre; draw ——— and ———.

Then ◣ = ◢ (B. 1. pr. 5.)

but ▲ ⊏ ◣ or ⊏ ◢ (B. 1. pr. 16.)

∴ ——— ⊏ ——— (B. 1. pr. 19.)

but ——— = ———-----,

∴ ———-------- ⊏ ———;

∴ ——— ⊐ ———-------- ;

∴ every point in ——— lies within the circle.

Q. E. D.

BOOK III. PROP. III. THEOR.

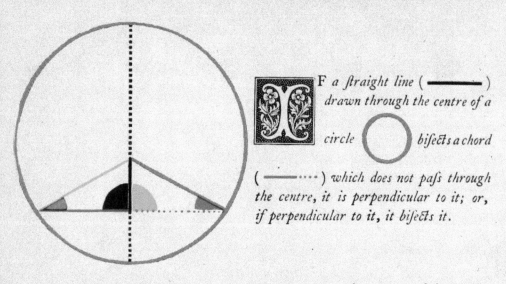

IF a ſtraight line (━━) drawn through the centre of a circle ◯ biſects a chord (━ ⋯) which does not paſs through the centre, it is perpendicular to it; or, if perpendicular to it, it biſects it.

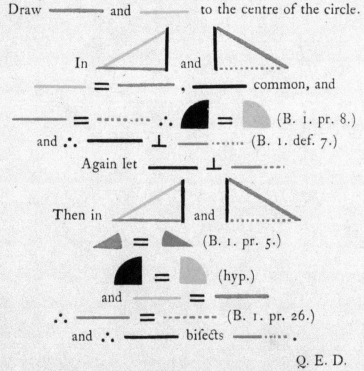

Draw ━━ and ━━ to the centre of the circle.

In △ and △
━ = ━, ━ common, and
━ = ⋯ ∴ ◨ = ◨ (B. 1. pr. 8.)
and ∴ ━ ⊥ ━ ⋯ (B. 1. def. 7.)

Again let ━ ⊥ ━⋯

Then in △ and △
◣ = ◣ (B. 1. pr. 5.)
◨ = ◨ (hyp.)
and ━ = ━
∴ ━ = ⋯ (B. 1. pr. 26.)
and ∴ ━ biſects ━⋯.

Q. E. D.

BOOK III. PROP. IV. THEOR.

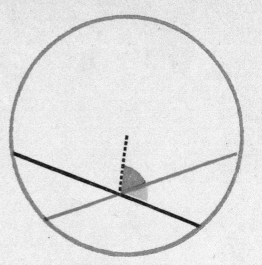

F *in a circle two straight lines cut one another, which do not both pass through the centre, they do not bisect one another.*

If one of the lines pass through the centre, it is evident that it cannot be bisected by the other, which does not pass through the centre.

But if neither of the lines ▬▬ or ▬▬ pass through the centre, draw ▬ ▬ ▬ from the centre to their intersection.

If ▬▬ be bisected, ▬ ▬ ▬ ⊥ to it (B. 3. pr. 3.)

∴ ◐ = ◑ and if ▬▬ be bisected, ▬ ▬ ▬ ⊥ ▬▬ (B. 3. pr. 3.)

∴ ◐ = ◑

and ∴ ◐ = ◐ ; a part equal to the whole, which is absurd:

∴ ▬▬ and ▬▬ do not bisect one another.

Q. E. D.

BOOK III. PROP. V. THEOR.

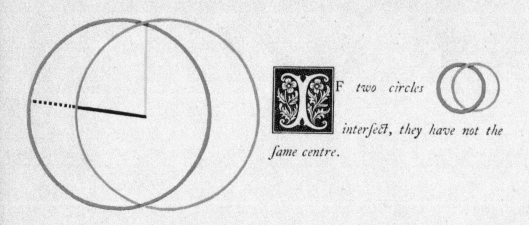

IF *two circles intersect, they have not the same centre.*

Suppose it possible that two intersecting circles have a common centre; from such supposed centre draw ———— to the intersecting point, and ——————•••••• meeting the circumferences of the circles.

Then ———— = ———— (B. 1. def. 15.)

and ———— = ——————•••••• (B. 1. def. 15.)

∴ ———— = ——————••••••; a part equal to the whole, which is absurd:

∴ circles supposed to intersect in any point cannot have the same centre.

Q. E. D.

BOOK III. PROP. VI. THEOR. 79

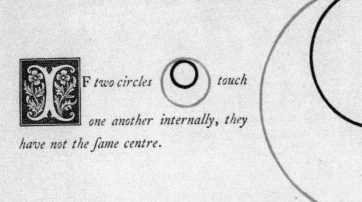

IF *two circles* ⊙ *touch one another internally, they have not the same centre.*

For, if it be possible, let both circles have the same centre; from such a supposed centre draw ——— cutting both circles, and ——— to the point of contact.

Then ——— = ------ (B. 1. def. 15.)
and ——— = ------ (B. 1. def. 15.)
∴ ------ = ------ ; a part equal to the whole, which is absurd; therefore the assumed point is not the centre of both circles; and in the same manner it can be demonstrated that no other point is.

Q. E. D.

BOOK III. PROP. VII. THEOR.

FIGURE I.

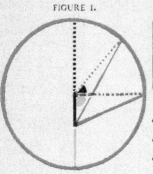

 IF *from any point within a circle*
which is not the centre, lines
are drawn to the circumference; the greatest of those lines is that (⸺⸺) which passes through the centre, and the least is the remaining part (⸺) of the diameter.

Of the others, that (⸺) which is nearer to the line passing through the centre, is greater than that (⸺) which is more remote.

FIGURE II.

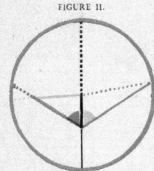

Fig. 2. The two lines (⸺⸺ and ⸺) which make equal angles with that passing through the centre, on opposite sides of it, are equal to each other; and there cannot be drawn a third line equal to them, from the same point to the circumference.

FIGURE I.

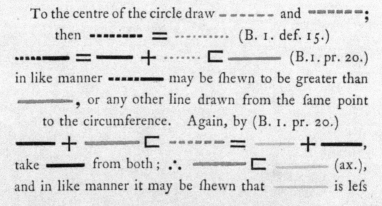

To the centre of the circle draw ⸺⸺ and ⸺⸺;
then ⸺⸺ = ⸺⸺ (B. 1. def. 15.)
⸺⸺ = ⸺ + ⸺ ⊏ ⸺ (B.1. pr. 20.)
in like manner ⸺⸺ may be shewn to be greater than ⸺⸺, or any other line drawn from the same point to the circumference. Again, by (B. 1. pr. 20.)
⸺ + ⸺ ⊏ ⸺⸺ = ⸺ + ⸺,
take ⸺ from both; ∴ ⸺ ⊏ ⸺ (ax.),
and in like manner it may be shewn that ⸺ is less

than any other line drawn from the same point to the circumference. Again, in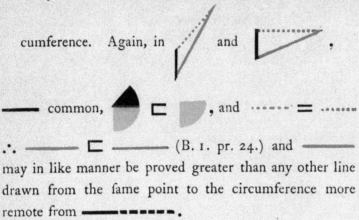

▬▬ common, ◐ ⊏ ◑, and ┈┈ = ┈┈
∴ ▬▬ ⊏ ▬▬ (B. 1. pr. 24.) and ▬▬ may in like manner be proved greater than any other line drawn from the same point to the circumference more remote from ▬▬┈▬▬.

FIGURE II.

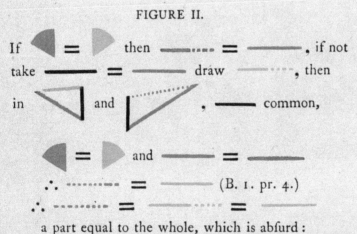

If ◀ = ▶ then ▬▬ = ▬▬, if not take ▬▬ = ▬▬ draw ┈┈, then in △ and △, ▬▬ common,

◀ = ▶ and ▬▬ = ▬▬
∴ ┈┈ = ▬▬ (B. 1. pr. 4.)
∴ ┈┈ = ▬▬ = ▬▬

a part equal to the whole, which is absurd:
∴ ▬▬ = ▬▬; and no other line is equal to ▬▬ drawn from the same point to the circumference; for if it were nearer to the one passing through the centre it would be greater, and if it were more remote it would be less.

Q. E. D.

82 BOOK III. PROP. VIII. THEOR.

The original text of this propofition is here divided into three parts.

I.

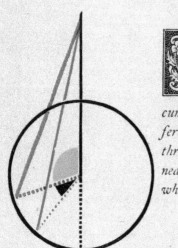

IF from a point without a circle, ftraight lines are drawn to the circumference; of thofe falling upon the concave circumference the greateft is that (━━━━) which paffes through the centre, and the line (━━━━) which is nearer the greateft is greater than that (━━━━) which is more remote.

Draw ┈┈┈ and ┈┈┈ to the centre.

Then, ━━━━ which paffes through the centre, is greateft; for fince ┈┈┈ = ┈┈┈ , if ━━━━ be added to both, ━━━━ = ━━━━ + ┈┈┈ ; but ⊏ ━━━━ (B. 1. pr. 20.) ∴ ━━━━ is greater than any other line drawn from the fame point to the concave circumference.

Again in

BOOK III. PROP. VIII. THEOR.

and ──── common, but ,

∴ ──── ⊏ ──── (B. 1. pr. 24.);
and in like manner ──── may be shewn ⊏ than any other line more remote from ────·······.

II.

Of those lines falling on the convex circumference the least is that (··········) which being produced would pass through the centre, and the line which is nearer to the least is less than that which is more remote.

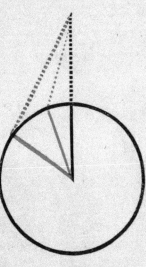

For, since ──── + ········ ⊏ ──────── (B. 1. pr. 20.)
and ──── = ────,
∴ ········ ⊏ ·········· (ax. 5.)

And again, since ──── + ········ ⊏
──── + ········ (B. 1. pr. 21.),
and ──── = ────,
∴ ········ ⊐ ·······. And so of others.

III.

Also the lines making equal angles with that which passes through the centre are equal, whether falling on the concave or convex circumference; and no third line can be drawn equal to them from the same point to the circumference.

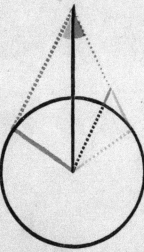

For if ········ ⊏ ········, but making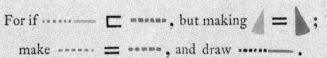

BOOK III. PROP. VIII. THEOR.

Then in 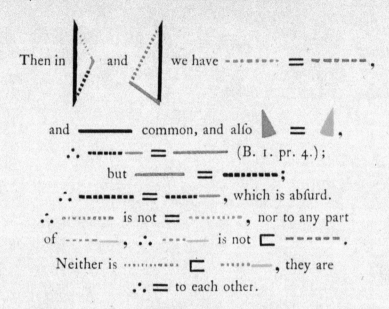 and we have ⋯⋯ = ⎯ ⎯ ⎯,

and ⎯⎯⎯ common, and also ◣ = ◤.

∴ ⋯⋯ = ⎯⎯⎯ (B. 1. pr. 4.);
but ⎯⎯ = ⋯⋯⋯;
∴ ⋯⋯⋯ = ⋯⎯⎯, which is absurd.
∴ ⋯⋯⋯ is not = ⋯⋯⋯, nor to any part
of ⋯⋯⋯, ∴ ⋯⋯ is not ⊏ ⎯⎯⎯.
Neither is ⋯⋯⋯ ⊏ ⋯⋯⎯, they are
∴ = to each other.

And any other line drawn from the same point to the circumference muſt lie at the same ſide with one of theſe lines, and be more or leſs remote than it from the line paſſing through the centre, and cannot therefore be equal to it.

Q. E. D.

BOOK III. PROP. IX. THEOR. 85

IF *a point be taken within a circle* (○) *, from which more than two equal straight lines* (─── , ─── , ───) *can be drawn to the circumference, that point must be the centre of the circle.*

For, if it be supposed that the point ◬ in which more than two equal straight lines meet is not the centre, some other point ▬ must be; join these two points by ───, and produce it both ways to the circumference.

Then since more than two equal straight lines are drawn from a point which is not the centre, to the circumference, two of them at least must lie at the same side of the diameter ───; and since from a point ◬, which is not the centre, straight lines are drawn to the circumference; the greatest is ───, which passes through the centre: and ─── which is nearer to ───, ⊏ ─── which is more remote (B. 3. pr. 8.); but ─── = ─── (hyp.) which is absurd.

The same may be demonstrated of any other point, different from ◬, which must be the centre of the circle.

<div style="text-align: right">Q. E. D.</div>

BOOK III. PROP. X. THEOR.

ONE circle ◯ cannot intersect another ◯ in more points than two.

For, if it be possible, let it intersect in three points; from the centre of ◯ draw ──, ── and ── to the points of intersection;

∴ ── = ── = ── (B. 1. def. 15.),

but as the circles intersect, they have not the same centre (B. 3. pr. 5.):

∴ the assumed point is not the centre of ◯, and

∴ as ──, ── and ── are drawn from a point not the centre, they are not equal (B. 3. prs. 7, 8); but it was shewn before that they were equal, which is absurd; the circles therefore do not intersect in three points.

Q. E. D.

BOOK III. PROP. XI. THEOR.

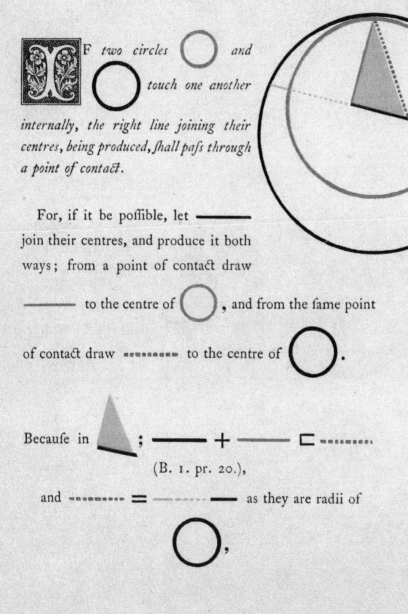

IF *two circles* ◯ *and* ◯ *touch one another internally*, the right line joining their centres, being produced, shall pass through a point of contact.

For, if it be possible, let ─── join their centres, and produce it both ways; from a point of contact draw ─── to the centre of ◯, and from the same point of contact draw ▬▬▬ to the centre of ◯.

Because in ▲; ─── + ─── ⊏ ▬▬▬
(B. 1. pr. 20.),
and ▬▬▬ = ─── as they are radii of ◯,

BOOK III. PROP. XI. THEOR.

but ▬▬ + ▬▬▬ ⊏ ▬▬▬▬▬ ; take away ▬▬▬▬ which is common, and ▬▬▬ ⊏ ▭▭▭▭ ; but ▬▬▬ = ▭▭▭ ,

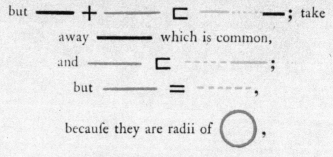

because they are radii of ◯,

and ∴ ▭▭▭ ⊏ ▭▭▭ a part greater than the whole, which is absurd.

The centres are not therefore so placed, that a line joining them can pass through any point but a point of contact.

<div style="text-align: right">Q. E. D.</div>

BOOK III. PROP. XII. THEOR.

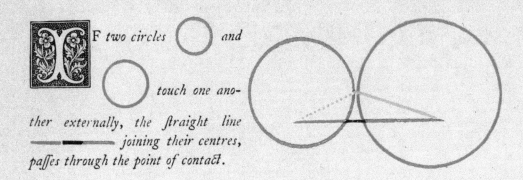

IF *two circles* ⬭ *and* ⬭ *touch one another externally, the straight line* ▬▬ *joining their centres, passes through the point of contact.*

If it be possible, let ▬▬▬ join the centres, and not pass through a point of contact; then from a point of contact draw ┄┄┄ and ▬▬▬ to the centres.

Because ┄┄┄ ✛ ▬▬▬ ⊏ ▬▬▬ (B. 1. pr. 20.),

and ▬▬▬ = ┄┄┄ (B. 1. def. 15.),

and ▬▬▬ = ▬▬▬ (B. 1. def. 15.),

∴ ▬▬ ✛ ▬▬ ⊏ ▬▬▬▬, a part greater than the whole, which is absurd.

The centres are not therefore so placed, that the line joining them can pass through any point but the point of contact.

<div align="right">Q. E. D.</div>

BOOK III. PROP. XIII. THEOR.

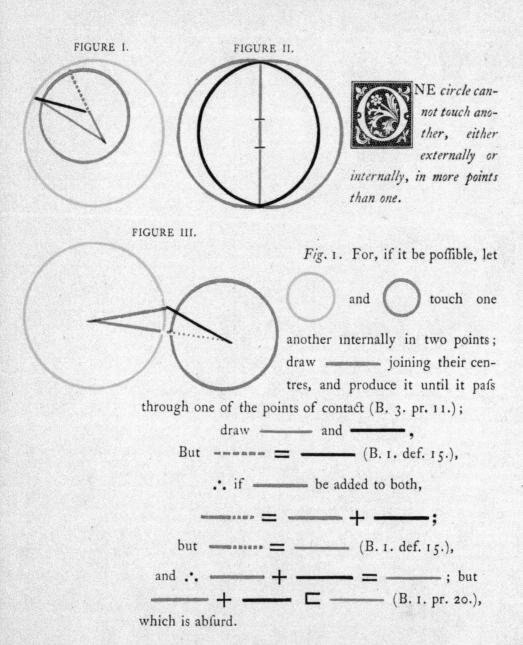

FIGURE I.

FIGURE II.

FIGURE III.

ONE *circle cannot touch another, either externally or internally, in more points than one.*

Fig. 1. For, if it be possible, let ―― and ―― touch one another internally in two points; draw ―― joining their centres, and produce it until it pass through one of the points of contact (B. 3. pr. 11.);

draw ―― and ――,

But ------ = ―― (B. 1. def. 15.),

∴ if ―― be added to both,

――― = ―― + ――;

but ―····― = ―― (B. 1. def. 15.),

and ∴ ―― + ―― = ――; but ―― + ―― ⊏ ―― (B. 1. pr. 20.), which is abfurd.

BOOK III. PROP. XIII. THEOR. 91

Fig. 2. But if the points of contact be the extremities of the right line joining the centres, this ftraight line muft be bifected in two different points for the two centres; becaufe it is the diameter of both circles, which is abfurd.

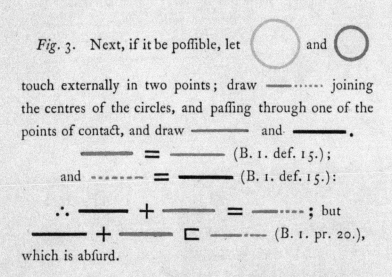

Fig. 3. Next, if it be poffible, let ◯ and ◯ touch externally in two points; draw ———⋯⋯ joining the centres of the circles, and paffing through one of the points of contact, and draw ——— and ———.

——— = ——— (B. 1. def. 15.);
and ⋯⋯ = ——— (B. 1. def. 15.):
∴ ——— + ——— = ———⋯; but
——— + ——— ⊏ ———⋯ (B. 1. pr. 20.),

which is abfurd.

There is therefore no cafe in which two circles can touch one another in two points.

<div style="text-align: right;">Q E. D.</div>

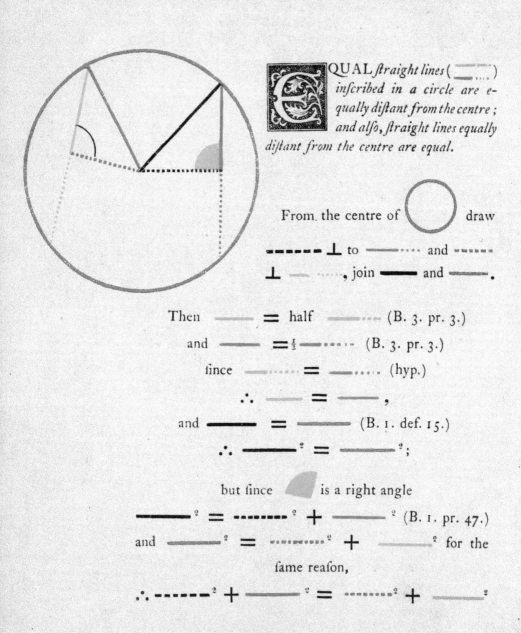

BOOK III. PROP. XIV. THEOR.

$$\therefore \text{------}^2 = \text{------}^2,$$

$$\therefore \text{------} = \text{------}.$$

Also, if the lines ——— and ——— be equally distant from the centre; that is to say, if the perpendiculars ——— and ——— be given equal, then ——— = ———.

For, as in the preceding case,

$$\text{------}^2 + \text{------}^2 = \text{------}^2 + \text{------}^2;$$

but $\text{------}^2 = \text{------}^2$:

$$\therefore \text{------}^2 = \text{------}^2,$$ and the doubles of these ——— and ——— are also equal.

<div style="text-align: right;">Q. E. D.</div>

94 BOOK III. PROP. XV. THEOR.

FIGURE I.

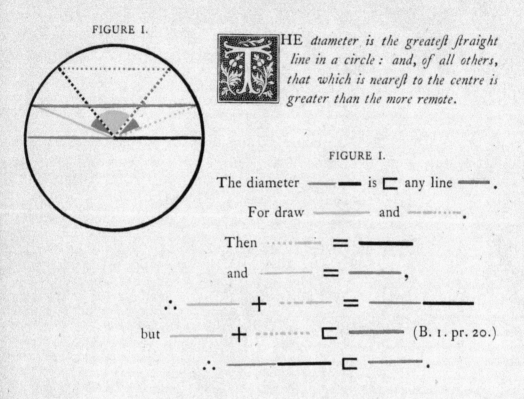

THE *diameter is the greatest straight line in a circle: and, of all others, that which is nearest to the centre is greater than the more remote.*

FIGURE I.

The diameter —— is ⊏ any line ——.

For draw ——— and ———.

Then ······ = ——

and ——— = ———,

∴ ——— + ······ = ———

but ——— + ······ ⊏ ——— (B. 1. pr. 20.)

∴ ——— ⊏ ———.

Again, the line which is nearer the centre is greater than the one more remote.

First, let the given lines be ——— and ········,
which are at the same side of the centre and do not intersect;

draw

BOOK III. PROP. XV. THEOR.

In 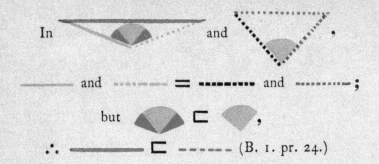 and ,

────── and ┄┄┄┄ = ━━━━━ and ┄┄┄┄;

but ◢◣ ⊏ ◢◣,

∴ ────── ⊏ ┄┄┄┄ (B. 1. pr. 24.)

FIGURE II. FIGURE II.

Let the given lines be ────── and ──────
which either are at different sides of the centre,
or intersect; from the centre draw ┄┄┄┄
and ┄┄┄┄ ⊥ ────── and ──────,
make ┄┄┄┄ = ┄┄┄┄, and
draw ────── ⊥ ┄┄┄┄.

Since ────── and ────── are equally distant from
the centre, ────── = ────── (B. 3. pr. 14.);
but ────── ⊏ ────── (Pt. 1. B. 3. pr. 15.),

∴ ────── ⊏ ──────.

Q. E. D.

BOOK III. PROP. XVI. THEOR.

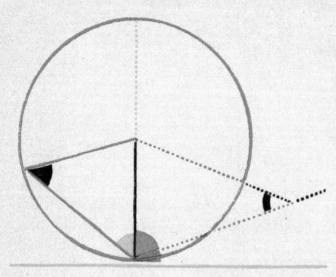

HE *straight line* ──── *drawn from the extremity of the diameter* ──── *of a circle perpendicular to it falls without the circle.*

And if any straight line ------ *be drawn from a point within that perpendicular to the point of contact, it cuts the circle.*

PART I

If it be poffible, let ────, which meets the circle again, be ⊥ ────, and draw ────.

Then, becaufe ──── = ────,

◀ = ◀ (B. 1. pr. 5.),

and ∴ each of these angles is acute. (B. 1. pr. 17.)

but ◀ = ◺ (hyp.), which is abfurd, therefore

──── drawn ⊥ ──── does not meet the circle again.

BOOK III. PROP. XVI. THEOR.

PART II.

Let ——— be ⊥ ——— and let ------ be drawn from a point between ——— and the circle, which, if it be possible, does not cut the circle.

Becaufe ◣ = ◪ ,

∴ ◣ is an acute angle; fuppofe ·········· ⊥ ········, drawn from the centre of the circle, it muft fall at the fide of ◣ the acute angle.

∴ ◩ which is fuppofed to be a right angle, is ⊏ ◣,

∴ ——— ⊏ ············;

but ········ = ——— ,

and ∴ ········ ⊏ ············, a part greater than the whole, which is abfurd. Therefore the point does not fall outfide the circle, and therefore the ftraight line ·········· cuts the circle.

<div align="right">Q. E. D.</div>

BOOK III. PROP. XVII. THEOR.

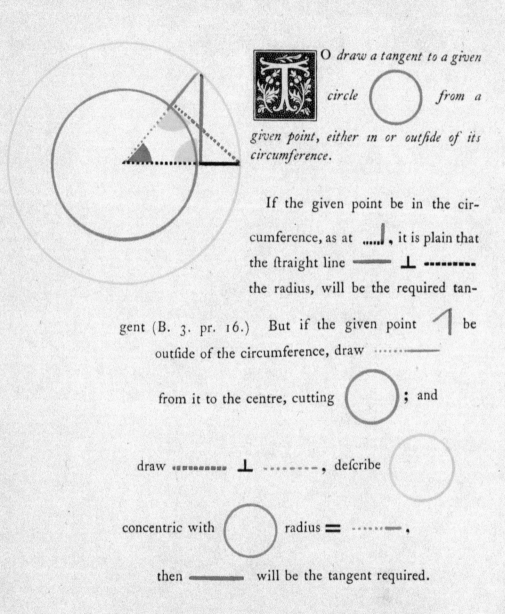

O draw a tangent to a given circle ○ from a given point, either in or outside of its circumference.

If the given point be in the circumference, as at ┅┃, it is plain that the straight line ▬ ⊥ ┅┅ the radius, will be the required tangent (B. 3. pr. 16.) But if the given point ╱ be outside of the circumference, draw ┅▬ from it to the centre, cutting ○ ; and draw ┅▬ ⊥ ┅▬ , describe ○ concentric with ○ radius ═ ┅▬ , then ▬ will be the tangent required.

BOOK III. PROP. XVII. THEOR. 99

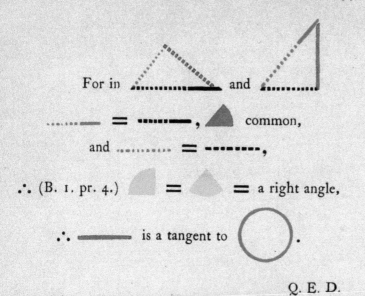

For in ▬▬▬ and ▬▬▬

▬▬ = ▬▬, ▲ common,

and ▬▬ = ▬▬,

∴ (B. 1. pr. 4.) ◗ = ◮ = a right angle,

∴ ▬▬ is a tangent to ◯.

Q. E. D.

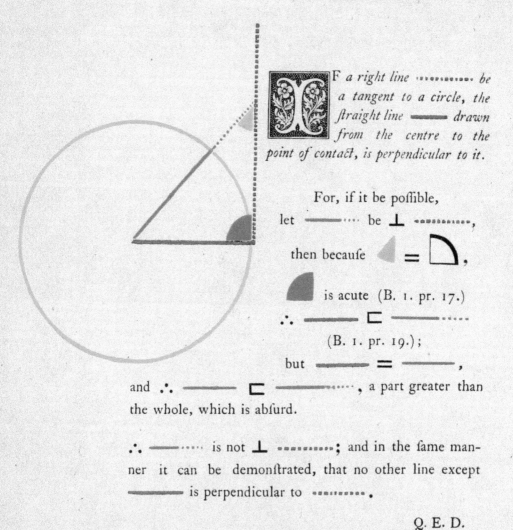

IF a right line ⋯⋯⋯ be a tangent to a circle, the straight line ▬▬ drawn from the centre to the point of contact, is perpendicular to it.

For, if it be possible,
let ▬▬⋯ be ⊥ ⋯⋯⋯,

then becaufe ◣ = ◪,

◣ is acute (B. 1. pr. 17.)

∴ ▬▬ ⊏ ▬▬⋯

(B. 1. pr. 19.);

but ▬▬ = ▬▬,

and ∴ ▬▬ ⊏ ▬▬⋯, a part greater than the whole, which is abfurd.

∴ ▬▬⋯ is not ⊥ ⋯⋯⋯; and in the fame manner it can be demonftrated, that no other line except ▬▬ is perpendicular to ⋯⋯⋯.

Q. E. D.

BOOK III. PROP. XIX. THEOR.

IF *a straight line* ——— *be a tangent to a circle, the straight line* ———, *drawn perpendicular to it from point of the contact, passes through the centre of the circle.*

For, if it be possible, let the centre be without ———, and draw ········· from the supposed centre to the point of contact.

Because ········· ⊥ ———
(B. 3. pr. 18.)

∴ ◣ = ◩, a right angle;

but ◣ = ◩ (hyp.), and ∴ ◣ = ◣,

a part equal to the whole, which is absurd.

Therefore the assumed point is not the centre; and in the same manner it can be demonstrated, that no other point without ——— is the centre.

<div align="right">Q. E. D.</div>

BOOK III. PROP. XX. THEOR.

FIGURE I

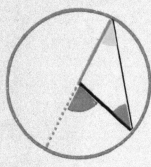

THE *angle at the centre of a circle, is double the angle at the circumference, when they have the same part of the circumference for their base.*

FIGURE I.

Let the centre of the circle be on ——— ·····

a side of ▲.

Because ——— = ———,

▲ = ◀ (B. 1. pr. 5.).

But ◣ = ▲ + ◀,

or ◣ = twice ▲ (B. 1. pr. 32).

FIGURE II.

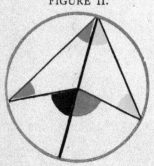

Let the centre be within ▲, the angle at the circumference; draw ——— from the angular point through the centre of the circle;

then ◀ = ▶, and ▲ = ◀,

because of the equality of the sides (B. 1. pr. 5).

BOOK III. PROP. XX. THEOR. 103

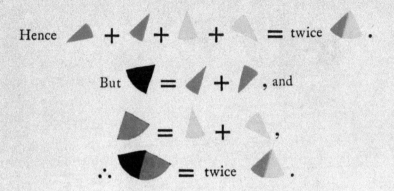

FIGURE III.

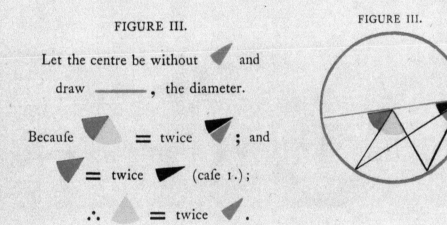

Q. E. D.

BOOK III. PROP. XXI. THEOR.

FIGURE I.

THE angles () in the same segment of a circle are equal.

FIGURE I.

Let the segment be greater than a semicircle, and draw ——— and ——— to the centre.

▰ = twice ▲ or twice = ◢ (B. 3. pr. 20.);

∴ ▲ = ◢.

FIGURE II.

FIGURE II.

Let the segment be a semicircle, or less than a semicircle, draw ——— the diameter, also draw ———.

= and = (case 1.)

∴ = .

Q. E. D.

BOOK III. PROP. XXII. THEOR.

HE *opposite angles* ▲ and ▶, ▶ and ◀ of any quadrilateral figure inscribed in a circle, are together equal to two right angles.

Draw ——— and ——— the diagonals; and because angles in the same segment are equal ▼ = ▲,

and ▼ = ◀;

add ▶ to both.

∴ ◣ + ▼ = ▶ + ▼ = ▼ = two right angles (B. 1. pr. 32.). In like manner it may be shown that,

◣ + ◀ = ⌓.

Q. E. D.

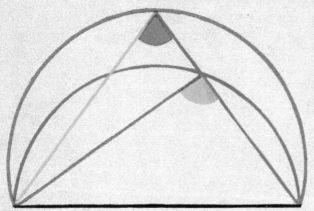

UPON the same straight line, and upon the same side of it, two similar segments of circles cannot be constructed which do not coincide.

For if it be possible, let two similar segments

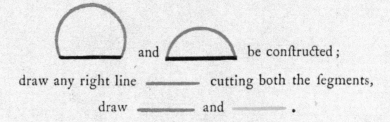

and be constructed; draw any right line ——— cutting both the segments, draw ——— and ———.

Because the segments are similar,

 = (B. 3. def. 10.),

but 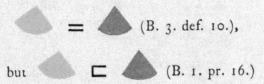 (B. 1. pr. 16.)

which is absurd: therefore no point in either of the segments falls without the other, and therefore the segments coincide.

Q. E. D.

IMILAR *segments* 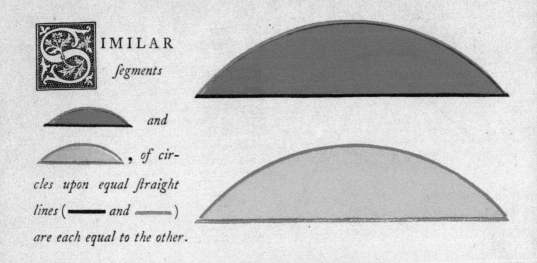 and , of circles upon equal straight lines (—— and ——) are each equal to the other.

For, if 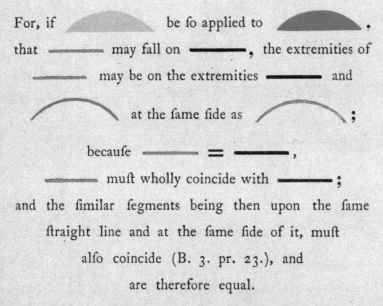 be so applied to , that —— may fall on ——, the extremities of —— may be on the extremities —— and at the same side as ;

because —— = ——, —— must wholly coincide with ——; and the similar segments being then upon the same straight line and at the same side of it, must also coincide (B. 3. pr. 23.), and are therefore equal.

Q. E. D.

BOOK III. PROP. XXV. PROB.

 SEGMENT *of a circle being given, to defcribe the circle of which it is the fegment.*

From any point in the fegment draw ———— and ———— bifect them, and from the points of bifection draw ———— ⊥ ———— and ———— ⊥ ———— where they meet is the centre of the circle.

Becaufe ———— terminated in the circle is bifected perpendicularly by ————, it paffes through the centre (B. 3. pr. 1.), likewife ———— paffes through the centre, therefore the centre is in the interfection of thefe perpendiculars.

Q. E. D.

BOOK III. PROP. XXVI. THEOR.

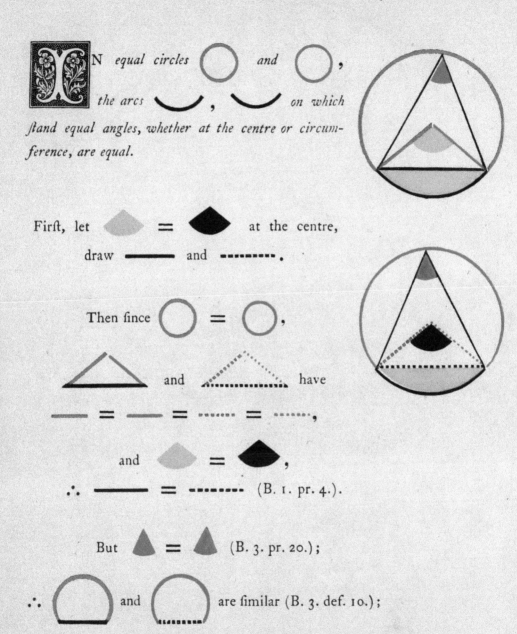

IN *equal circles* ○ *and* ○, *the arcs* ⌣, ⌣ *on which stand equal angles, whether at the centre or circumference, are equal.*

First, let ◖ = ◗ at the centre, draw —— and ------ .

Then since ○ = ○,

△ and △ have
— = — = ---- = ----,

and ◖ = ◗,

∴ —— = ------ (B. 1. pr. 4.).

But ▲ = ▲ (B. 3. pr. 20.);

∴ ◠ and ◠ are similar (B. 3. def. 10.);

they are also equal (B. 3. pr. 24.)

110 BOOK III. PROP. XXVI. THEOR.

If therefore the equal ſegments be taken from the equal circles, the remaining ſegments will be equal;

hence ▭ = ▭ (ax. 3.);

and ∴ ⌣ = ⌣.

But if the given equal angles be at the circumference, it is evident that the angles at the centre, being double of thoſe at the circumference, are alſo equal, and therefore the arcs on which they ſtand are equal.

<div align="right">Q. E. D.</div>

BOOK III. PROP. XXVII. THEOR.

N equal circles, an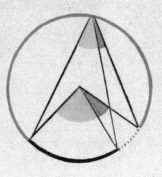

the angles and which stand upon equal arches are equal, whether they be at the centres or at the circumferences.

For if it be possible, let one of them

 be greater than the other

and make

∴ = (B. 3. pr. 26.)

but = (hyp.)

∴ = a part equal

to the whole, which is absurd; ∴ neither angle

is greater than the other, and

∴ they are equal.

Q. E. D.

BOOK III. PROP. XXVIII. THEOR.

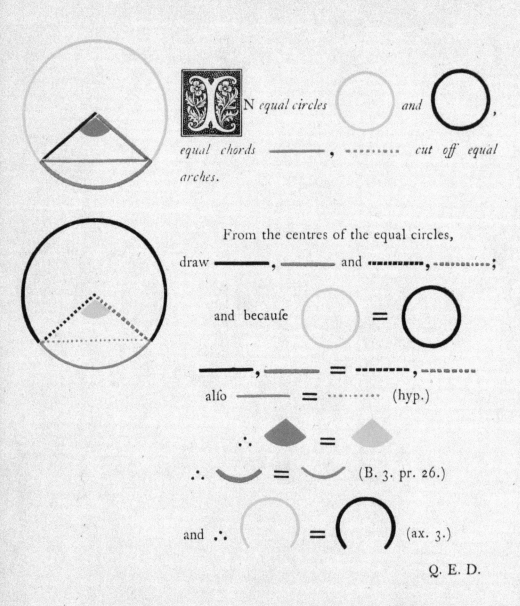

N equal circles ⬭ and ⬤, equal chords ——, ┄┄┄ cut off equal arches.

From the centres of the equal circles, draw ——, —— and ┄┄┄, ┄┄┄;

and becaufe ⬭ = ⬤

——, —— = ┄┄┄, ┄┄┄

alfo —— = ┄┄┄ (hyp.)

∴ ▲ = ▲

∴ ⌣ = ⌣ (B. 3. pr. 26.)

and ∴ ⌒ = ⌒ (ax. 3.)

Q. E. D.

BOOK III. PROP. XXIX. THEOR.

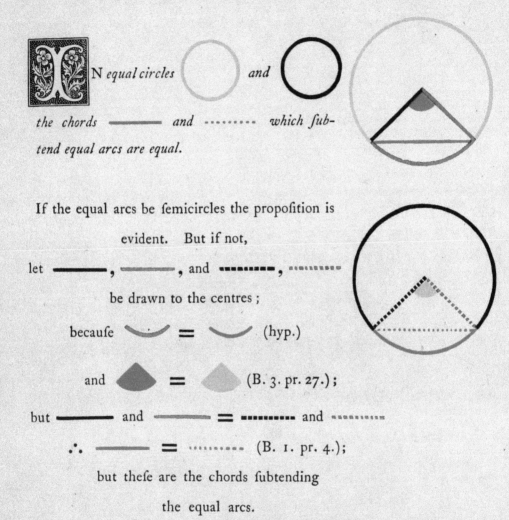

IN equal circles ———— and ⬤ the chords ———— and ········ which subtend equal arcs are equal.

If the equal arcs be semicircles the proposition is evident. But if not,

let ————, ————, and ▬▬▬▬, ▬▬▬▬ be drawn to the centres;

because ⌣ = ⌣ (hyp.)

and ◢ = ◢ (B. 3. pr. 27.);

but ———— and ———— = ▬▬▬▬ and ▬▬▬▬

∴ ———— = ········ (B. 1. pr. 4.);

but these are the chords subtending the equal arcs.

Q. E. D.

BOOK III. PROP. XXX. PROB.

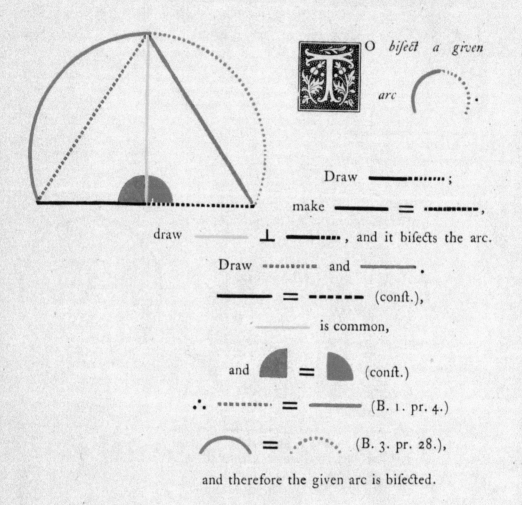

TO bifect a given arc .

Draw ———·········;

make ——— = ············,

draw ——— ⊥ ———······, and it bifects the arc.

Draw ·········· and ———.

——— = —————— (conft.),

——— is common,

and ◗ = ◖ (conft.)

∴ ············ = ——— (B. 1. pr. 4.)

⌒ = ⌢ (B. 3. pr. 28.),

and therefore the given arc is bifected.

<div style="text-align: right;">Q. E. D.</div>

BOOK III. PROP. XXXI. THEOR.

N a circle the angle in a semicircle is a right angle, the angle in a segment greater than a semicircle is acute, and the angle in a segment less than a semicircle is obtuse.

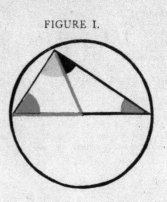

FIGURE I.

FIGURE I.

The angle in a semicircle is a right angle.

Draw ——— and ———

▲ = ▲ and ▲ = ▶ (B. 1. pr. 5.)

▲ + ▲ = ◢ = the half of two right angles = a right angle. (B. 1. pr. 32.)

FIGURE II.

The angle ▲ in a segment greater than a semicircle is acute.

Draw ——— the diameter, and ———

∴ ◢ = a right angle

∴ ▲ is acute.

FIGURE II.

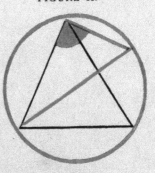

BOOK III. PROP. XXXI. THEOR.

FIGURE III.

FIGURE III.

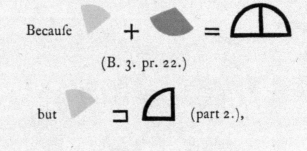

The angle ◧ in a segment less than semi-circle is obtuse.

Take in the opposite circumference any point, to which draw ——— and ———.

Because ◺ + ◧ = ◨

(B. 3. pr. 22.)

but ◺ ⊐ ◰ (part 2.),

∴ ◧ is obtuse.

Q. E. D.

BOOK III. PROP. XXXII. THEOR.

F a right line ――― be a tangent to a circle, and from the point of contact a right line ――― be drawn cutting the circle, the angle made by this line with the tangent is equal to the angle ▶ in the alterate segment of the circle.

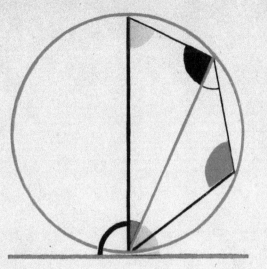

If the chord should pass through the centre, it is evident the angles are equal, for each of them is a right angle. (B. 3. prs. 16, 31.)

But if not, draw ――― ⊥ ――― from the point of contact, it must pass through the centre of the circle, (B. 3. pr. 19.)

∴ ◣ = ◔ (B. 3. pr. 31.)

▶ + ▍ = ◔ = ▶ (B. 1. pr. 32.)

∴ ▶ = ▲ (ax.).

Again ◔ = ◍ = ▶ + ◆ (B. 3. pr. 22.)

∴ ◔ = ◆, (ax.), which is the angle in the alternate segment.

Q. E. D.

BOOK III. PROP. XXXIII. PROB.

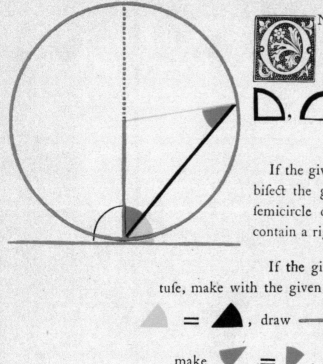

O**N** a given straight line to describe a segment of a circle that shall contain an angle equal to a given angle ▰, ◠, ▲.

If the given angle be a right angle, bisect the given line, and describe a semicircle on it, this will evidently contain a right angle. (B. 3. pr. 31.)

If the given angle be acute or obtuse, make with the given line, at its extremity,

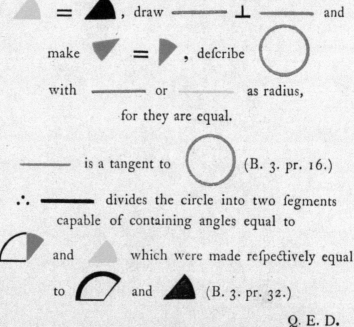

for they are equal.

―― is a tangent to ◯ (B. 3. pr. 16.)

∴ ――― divides the circle into two segments capable of containing angles equal to ◠ and ▲ which were made respectively equal to ◠ and ▲ (B. 3. pr. 32.)

Q. E. D.

BOOK III. PROP. XXXIV. PROB.

O cut off from a given circle a segment which shall contain an angle equal to a given angle .

Draw ——— (B. 3. pr. 17.), a tangent to the circle at any point; at the point of contact make

 the given angle;

and ⟣ contains an angle = the given angle.

Because ——— is a tangent, and ——— cuts it, the

angle in ⟣ = ⟢ (B. 3. pr. 32.),

but ⟢ = ⟢ (const.)

Q. E. D.

BOOK III. PROP. XXXV. THEOR.

FIGURE I.

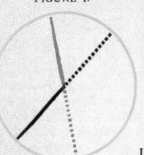

IF two chords { ──── } in a circle intersect each other, the rectangle contained by the segments of the one is equal to the rectangle contained by the segments of the other.

FIGURE I.

If the given right lines pass through the centre, they are bisected in the point of intersection, hence the rectangles under their segments are the squares of their halves, and are therefore equal.

FIGURE II.

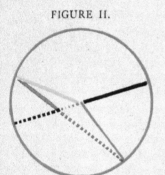

FIGURE II.

Let ────── pass through the centre, and ────── not; draw ────── and ──────.

Then ────── × ────── = ──────² −

──────² (B. 2. pr. 6.),

or ────── × ────── = ──────² − ──────².

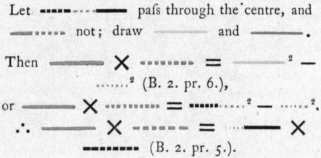

∴ ────── × ────── = ────── × ────── (B. 2. pr. 5.).

FIGURE III.

FIGURE III.

Let neither of the given lines pass through the centre, draw through their intersection a diameter ────── ──────,

and ────── × ────── = ────── × ────── (Part. 2.),

also ────── × ────── = ────── × ────── (Part. 2.);

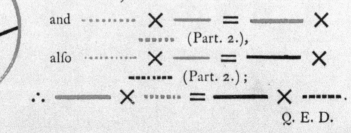

∴ ────── × ────── = ────── × ──────.

Q. E. D.

BOOK III. PROP. XXXVI. THEOR. 121

F *from a point without a circle two straight lines be drawn to it, one of which* ▬▬ *is a tangent to the circle, and the other* ▬ ▪▪▪ ▬ *cuts it; the rectangle under the whole cutting line* ▬ ▪▪▪▪ ▬ *and the external segment* ▬▬ *is equal to the square of the tangent* ▬▬.

FIGURE I.

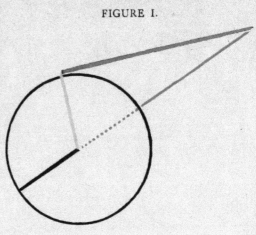

Let ▬ ▪▪▪▪ ▬ pafs through the centre; draw ▬▬ from the centre to the point of contact;

▬▬² = ▪▪▪▬² minus ▬² (B. 1. pr. 47),

or ▬▬² = ▪▪▪▬² minus ▪▪▪▪²,

∴ ▬▬² = ▬ ▪▪▪▪ ▬ × ▬▬ (B. 2. pr. 6).

FIGURE II.

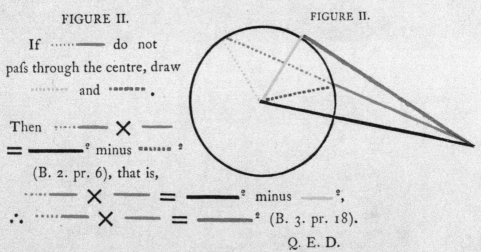

If ▪▪▪▪▬ do not pafs through the centre, draw ▪▪▪▪▬ and ▪▪▪▪▪.

Then ▪▪▪▬ × ▬ = ▬▬² minus ▬▬² (B. 2. pr. 6), that is,

▪▪▪▬ × ▬ = ▬▬² minus ▬²,

∴ ▪▪▪▬ × ▬ = ▬▬² (B. 3. pr. 18).

Q. E. D.

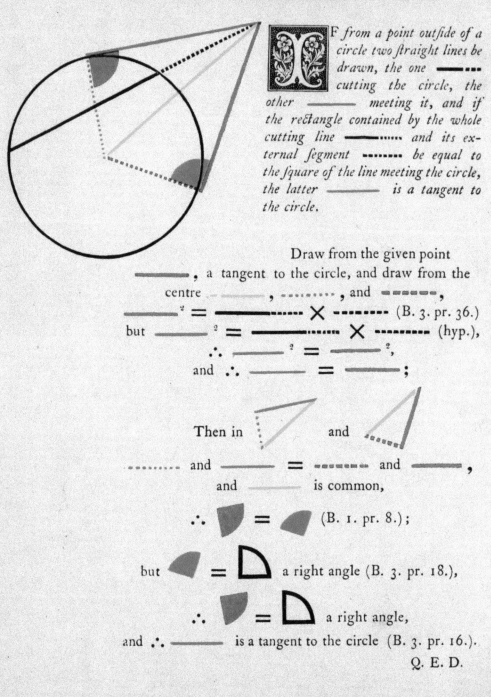

BOOK III. PROP. XXXVII. THEOR.

IF *from a point outside of a circle two straight lines be drawn, the one* ─── *cutting the circle, the other* ─── *meeting it, and if the rectangle contained by the whole cutting line* ─── *and its external segment* ─── *be equal to the square of the line meeting the circle, the latter* ─── *is a tangent to the circle.*

Draw from the given point ───, a tangent to the circle, and draw from the centre ───, ───, and ───,

───² = ─── × ─── (B. 3. pr. 36.)

but ───² = ─── × ─── (hyp.),

∴ ───² = ───²,

and ∴ ─── = ───;

Then in △ and △

─── and ─── = ─── and ───,

and ─── is common,

∴ ◣ = ◢ (B. 1. pr. 8.);

but ◣ = ◰ a right angle (B. 3. pr. 18.),

∴ ◣ = ◰ a right angle,

and ∴ ─── is a tangent to the circle (B. 3. pr. 16.).

Q. E. D.

BOOK IV.

DEFINITIONS.

I.

RECTILINEAR figure is said to be *inscribed in* another, when all the angular points of the inscribed figure are on the sides of the figure in which it is said to be inscribed.

II.

A FIGURE is said to be *described about* another figure, when all the sides of the circumscribed figure pass through the angular points of the other figure.

III.

A RECTILINEAR figure is said to be *inscribed in* a circle, when the vertex of each angle of the figure is in the circumference of the circle.

IV.

A RECTILINEAR figure is said to be *circumscribed about* a circle, when each of its sides is a tangent to the circle.

BOOK IV. DEFINITIONS.

V.

A CIRCLE is said to be *inscribed in* a rectilinear figure, when each side of the figure is a tangent to the circle.

VI.

A CIRCLE is said to be *circumscribed about* a rectilinear figure, when the circumference passes through the vertex of each angle of the figure.

 is circumscribed.

VII.

A STRAIGHT line is said to be *inscribed in* a circle, when its extremities are in the circumference.

The Fourth Book of the Elements is devoted to the solution of problems, chiefly relating to the inscription and circumscription of regular polygons and circles.

A regular polygon is one whose angles and sides are equal.

BOOK IV. PROP. I. PROB.

IN a given circle to place a straight line, equal to a given straight line (━━), not greater than the diameter of the circle.

Draw ·····━, the diameter of ◯ ;

and if ·····━ = ━━━, then the problem is solved.

But if ·····━ be not equal to ━━━,

·····━ ⊏ ━━━ (hyp.);

make ·····━ = ━━━ (B. 1. pr. 3.) with

·····━ as radius,

describe ◯, cutting ◯, and

draw ━━━, which is the line required.

For ━━━ = ·····━ = ━━━

(B. 1. def. 15. const.)

Q. E. D.

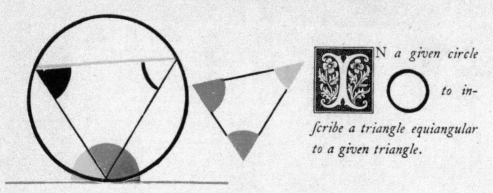

IN a given circle to inscribe a triangle equiangular to a given triangle.

To any point of the given circle draw ———, a tangent (B. 3. pr. 17.); and at the point of contact

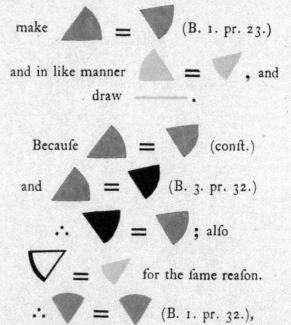

and therefore the triangle inscribed in the circle is equiangular to the given one.

Q. E. D.

BOOK IV. PROP. III. PROB.

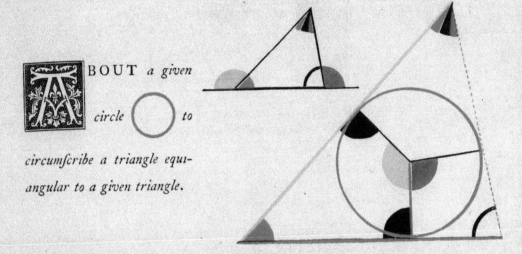

ABOUT a given circle ◯ to circumscribe a triangle equiangular to a given triangle.

Produce any side ———, of the given triangle both ways; from the centre of the given circle draw ———, any radius.

Make (B. 1. pr. 23.)

and ▮ = ◗.

At the extremities of the three radii, draw ———, ——— and ------, tangents to the given circle. (B. 3. pr. 17.)

The four angles of △, taken together, are equal to four right angles. (B. 1. pr. 32.)

BOOK IV. PROP. III. PROB.

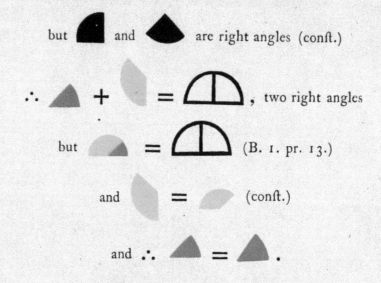

but ▰ and ◣ are right angles (conſt.)

∴ ▲ + ◖ = ⌒ , two right angles

but ◖ = ⌒ (B. 1. pr. 13.)

and ◖ = ◖ (conſt.)

and ∴ ▲ = ▲.

In the ſame manner it can be demonſtrated that

◸ = ◸ ;

∴ ◣ = ◣ (B. 1. pr. 32.)

and therefore the triangle circumſcribed about the given circle is equiangular to the given triangle.

<p style="text-align:right">Q. E. D.</p>

BOOK IV. PROP. IV. PROB.

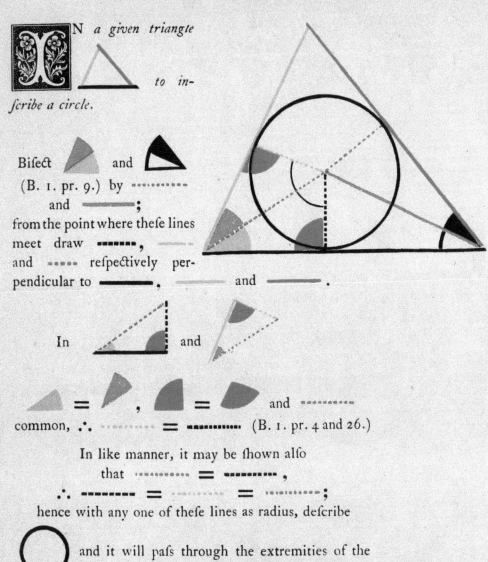

IN a given triangle ▲ to inscribe a circle.

Bisect ◣ and ◤ (B. 1. pr. 9.) by ┈┈ and ━━; from the point where these lines meet draw ┅┅, ━━ and ┄┄ respectively perpendicular to ━━, ━━ and ━━.

In ◣ and ◥ ◣ = ◥, ◣ = ◥ and ┈┈ common, ∴ ┈┈ = ━━ (B. 1. pr. 4 and 26.)

In like manner, it may be shown also that ┈┈ = ━━,

∴ ┈┈ = ━━ = ┈┈;

hence with any one of these lines as radius, describe ◯ and it will pass through the extremities of the other two; and the sides of the given triangle, being perpendicular to the three radii at their extremities, touch the circle (B. 3. pr. 16.), which is therefore inscribed in the given circle.

Q. E. D.

BOOK IV. PROP. V. PROB.

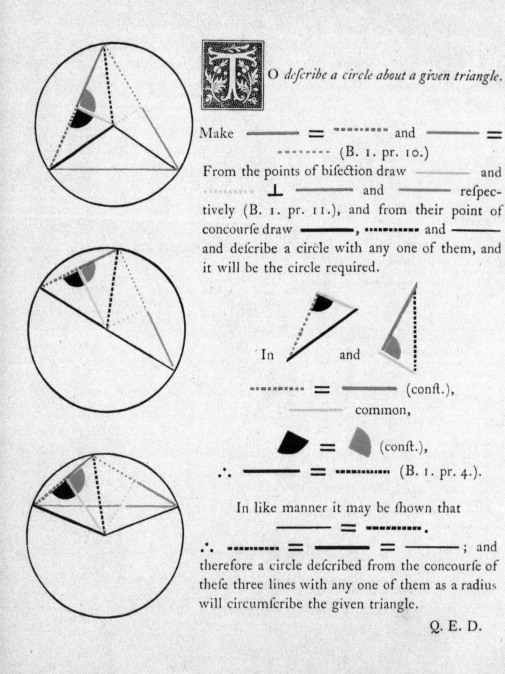

TO *describe a circle about a given triangle.*

Make ———— = ·········· and ———— = ·········· (B. 1. pr. 10.)
From the points of bisection draw ———— and ·········· ⊥ ———— and ———— respectively (B. 1. pr. 11.), and from their point of concourse draw ————, ·········· and ———— and describe a circle with any one of them, and it will be the circle required.

In ◣ and ◢

·········· = ———— (const.),
———— common,
◐ = ◐ (const.),
∴ ———— = ·········· (B. 1. pr. 4.).

In like manner it may be shown that
———— = ·········· .
∴ ·········· = ———— = ————; and therefore a circle described from the concourse of these three lines with any one of them as a radius will circumscribe the given triangle.

<div style="text-align:right">Q. E. D.</div>

BOOK IV. PROP. VI. PROB.

I N a given circle to inscribe a square.

Draw the two diameters of the circle ⊥ to each other, and draw ——, ——, —— and ——

 is a square.

For, since and are, each of them, in a semicircle, they are right angles (B. 3. pr. 31),

∴ —— ∥ —— (B. 1. pr. 28):

and in like manner —— ∥ ——.

And because = (conſt.), and

·········· = ·········· = ·········· (B. 1. def. 15).

∴ —— = —— (B. 1. pr. 4);

and since the adjacent ſides and angles of the parallelogram are equal, they are all equal (B. 1. pr. 34);

and ∴ , inſcribed in the given circle, is a ſquare.

Q. E. D.

BOOK IV. PROP. VII. PROB.

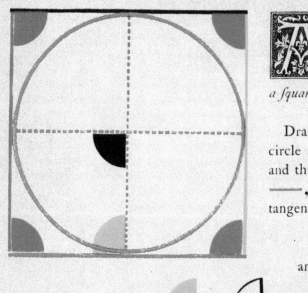

 BOUT *a given circle to circumscribe a square.*

Draw two diameters of the given circle perpendicular to each other, and through their extremities draw ——, ——, ——, and —— tangents to the circle;

and ▢ is a square.

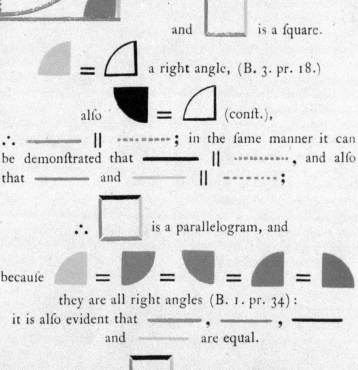

∴ ▢ is a square.

Q. E. D.

BOOK IV. PROP. VIII. PROB.

T O inscribe a circle in a given square.

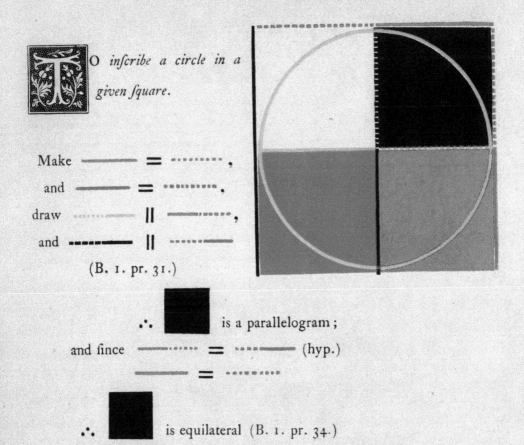

Make ▬▬▬ = ┄┄┄ ,
and ▬▬▬ = ┄┄┄ ,
draw ┄┄┄ ∥ ▬▬▬ ,
and ▬▬▬ ∥ ┄┄┄ ,
(B. 1. pr. 31.)

∴ ■ is a parallelogram;

and since ▬┄▬ = ┄▬┄ (hyp.)

▬▬▬ = ┄┄┄

∴ ■ is equilateral (B. 1. pr. 34.)

In like manner, it can be shown that

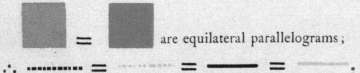

are equilateral parallelograms;

∴ ┄┄┄ = ┄┄┄ = ▬▬▬ = ▬▬▬ .

and therefore if a circle be described from the concourse of these lines with any one of them as radius, it will be inscribed in the given square. (B. 3. pr. 16.)

Q. E. D.

BOOK IV. PROP. IX. PROB.

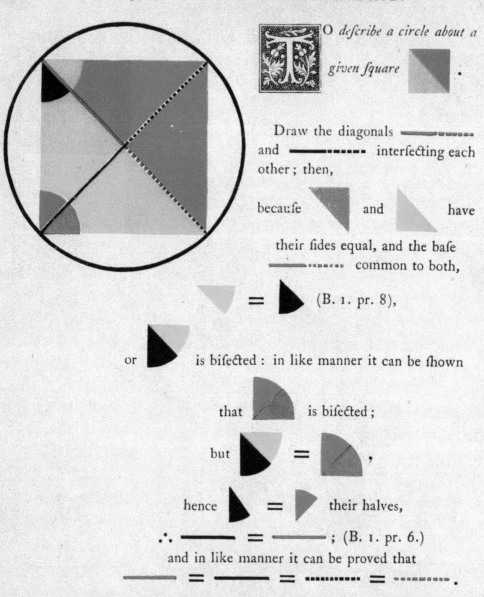

To describe a circle about a given ■.

Draw the diagonals ▬▬ ▬▬▬ and ▬▬ ▬ ▬ ▬ intersecting each other; then,

because ◣ and ◢ have their sides equal, and the base ▬▬ ▬ ▬ ▬ common to both,

◢ = ◣ (B. 1. pr. 8),

or ◣ is bisected: in like manner it can be shown that ◣ is bisected;

but ◣ = ◢,

hence ◣ = ◢ their halves,

∴ ▬▬ = ▬▬ ; (B. 1. pr. 6.)

and in like manner it can be proved that

▬▬ = ▬▬ = ▬ ▬ ▬ = ▬ ▬ ▬.

If from the confluence of these lines with any one of them as radius, a circle be described, it will circumscribe the given square.

Q. E. D.

BOOK IV. PROP. X. PROB.

O construct an isosceles triangle, in which each of the angles at the base shall be double of the vertical angle.

Take any straight line ────── ┈┈┈
and divide it so that
────── ┈┈┈ ✕ ┈┈┈ = ──────².
(B. 2. pr. 11.)

With ────── ┈┈┈ as radius, describe and place

in it from the extremity of the radius, ────── = ──────,
(B. 4. pr. 1); draw ──────.

Then △ ┈┈┈ is the required triangle.

For, draw ────── and describe

◯ about △ (B. 4. pr. 5.)

Since ────── ┈┈┈ ✕ ┈┈┈ = ──────² = ──────.

∴ ────── is a tangent to ◯ (B. 3. pr. 37.)

∴ ▲ = △ (B. 3. pr. 32),

BOOK IV. PROP. X. PROB.

add ◀ to each,

∴ ▲ + ◀ = △ + ◀ ;

but ◀ + ▲ or ◀ = ◐ (B. 1. pr. 5) :

since ——— = ———⋯ (B. 1. pr. 5.)

consequently ◐ = △ + ◀ = ◐
(B. 1. pr. 32.)

∴ ——— = ——— (B. 1. pr. 6.)

∴ ——— = ——— = ——— (const.)

∴ △ = ◀ (B. 1. pr. 5.)

∴ ◐ = ◀ = ◐ = △ + ◀ = twice △ ; and consequently each angle at the base is double of the vertical angle.

<div align="right">Q. E. D.</div>

BOOK IV. PROP. XI. PROB.

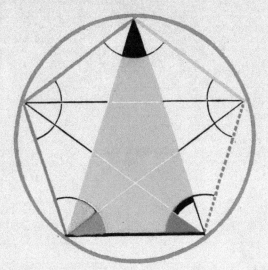

 N a given circle to inscribe an equilateral and equiangular pentagon.

Construct an isosceles triangle, in which each of the angles at the base shall be double of the angle at the vertex, and inscribe in the given circle a triangle equiangular to it; (B. 4. pr. 2.)

Bisect ▲ and ◢ (B. 1. pr. 9.)

draw ———, ———, ——— and ------.

Because each of the angles ◣, ◤, ▲, ◥ and ◸ are equal, the arcs upon which they stand are equal, (B. 3. pr. 26.) and ∴ ———, ———, ———, ——— and ------ which subtend these arcs are equal (B. 3. pr. 29.) and ∴ the pentagon is equilateral, it is also equiangular, as each of its angles stand upon equal arcs. (B. 3. pr. 27).

Q. E. D.

BOOK IV. PROP. XII. PROB.

T O describe an equilateral and equiangular pentagon about a given circle .

Draw five tangents through the vertices of the angles of any regular pentagon inscribed in the given circle (B. 3. pr. 17).

These five tangents will form the required pentagon.

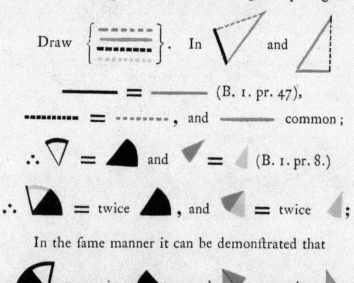

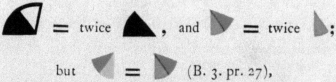

BOOK IV. PROP. XII. PROB.

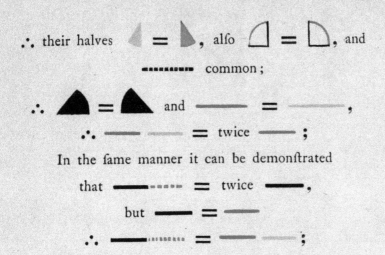

In the same manner it can be demonstrated that the other sides are equal, and therefore the pentagon is equilateral, it is also equiangular, for

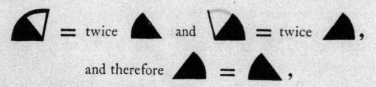

in the same manner it can be demonstrated that the other angles of the described pentagon are equal.

Q. E. D

140 BOOK IV. PROP. XIII. PROB.

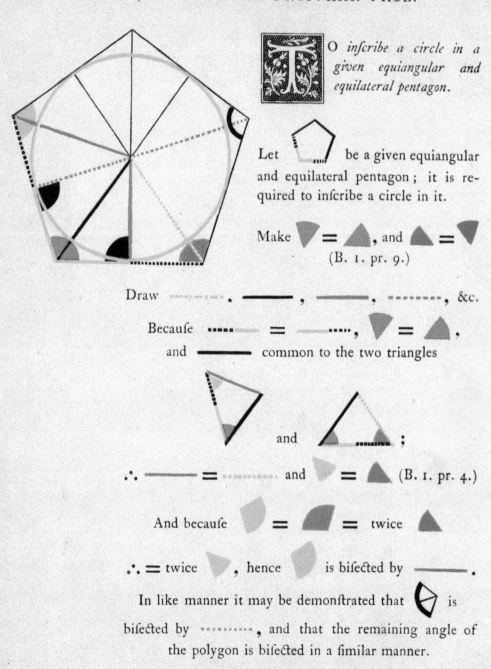

O *inſcribe a circle in a given equiangular and equilateral pentagon.*

Let ▱ be a given equiangular and equilateral pentagon; it is required to inſcribe a circle in it.

Make ▼ = ▲, and ▲ = ▼
(B. 1. pr. 9.)

Draw ·······, ———, ———, ---------, &c.

Becauſe ····· = ·····, ▼ = ▲,
and ——— common to the two triangles

and ;

∴ ——— = ········ and ◐ = ▲ (B. 1. pr. 4.)

And becauſe ◐ = ◐ = twice ▲

∴ = twice ▼, hence ◐ is biſected by ———.

In like manner it may be demonſtrated that ◭ is biſected by ---------, and that the remaining angle of the polygon is biſected in a ſimilar manner.

BOOK IV. PROP. XIII. PROB.

Draw ——— , ········· , &c. perpendicular to the sides of the pentagon.

Then in the two triangles 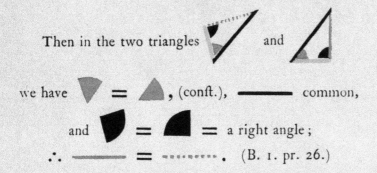 and

we have ▼ = ▲ , (const.), ——— common,

and ◗ = ◖ = a right angle;

∴ ——— = ········· . (B. 1. pr. 26.)

In the same way it may be shown that the five perpendiculars on the sides of the pentagon are equal to one another.

Describe ◯ with any one of the perpendiculars as radius, and it will be the inscribed circle required. For if it does not touch the sides of the pentagon, but cut them, then a line drawn from the extremity at right angles to the diameter of a circle will fall within the circle, which has been shown to be absurd. (B. 3. pr. 16.)

Q. E. D.

BOOK IV. PROP. XIV. PROB.

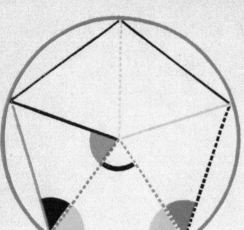

 O describe a circle about a given equilateral and equiangular pentagon.

Bisect ▼ and ◣ by and, and from the point of section, draw ——,, and ——.

▼ = ◣,

◣ = ◣, ∴ = (B. 1. pr. 6);

and since in ◣ and ◣,

—— = ——, and common,

also ▼ = ◣;

∴ —— = (B. 1. pr. 4).

In like manner it may be proved that
, and therefore = —— = = = ——:

Therefore if a circle be described from the point where these five lines meet, with any one of them as a radius, it will circumscribe the given pentagon.

Q. E. D.

BOOK IV. PROP. XV. PROB.

O *inscribe an equilateral and equiangular hexagon in a given circle* ◯.

From any point in the circumference of the given circle describe ◯ passing through its centre, and draw the diameters ──── , ──── and ──── ; draw ─ ─ ─ , ─ ─ ─ , ─ ─ ─ , &c. and the required hexagon is inscribed in the given circle.

Since ──── passes through the centres of the circles, ◁ and ▷ are equilateral triangles, hence ◖ = ◗ = one-third of two right angles; (B. 1. pr. 32) but ◖ = ◖ (B. 1. pr. 13);

∴ ◖ = ◗ = ◀ = one-third of ◖ (B. 1. pr. 32), and the angles vertically opposite to these are all equal to one another (B. 1. pr. 15), and stand on equal arches (B. 3. pr. 26), which are subtended by equal chords (B. 3. pr. 29); and since each of the angles of the hexagon is double of the angle of an equilateral triangle, it is also equiangular.

Q. E. D.

O inscribe an equilateral and equiangular quindecagon in a given circle.

Let ———— and ———— be the sides of an equilateral pentagon inscribed in the given circle, and ———— the side of an inscribed equilateral triangle.

The arc subtended by ———— and ———— $\Big\} = \frac{2}{5} = \frac{6}{15} \Big\{$ of the whole circumference.

The arc subtended by ———— $\Big\} = \frac{1}{3} = \frac{5}{15} \Big\{$ of the whole circumference.

Their difference $= \frac{1}{15}$

∴ the arc subtended by ·········· $= \frac{1}{15}$ difference of the whole circumference.

Hence if straight lines equal to ·········· be placed in the circle (B. 4. pr. 1), an equilateral and equiangular quindecagon will be thus inscribed in the circle.

<div style="text-align:right">Q. E. D.</div>

BOOK V.

DEFINITIONS.

I.

 LESS magnitude is said to be an aliquot part or submultiple of a greater magnitude, when the less measures the greater; that is, when the less is contained a certain number of times exactly in the greater.

II.

A GREATER magnitude is said to be a multiple of a less, when the greater is measured by the less; that is, when the greater contains the less a certain number of times exactly.

III.

RATIO is the relation which one quantity bears to another of the same kind, with respect to magnitude.

IV.

MAGNITUDES are said to have a ratio to one another, when they are of the same kind; and the one which is not the greater can be multiplied so as to exceed the other.

The other definitions will be given throughout the book where their aid is first required.

AXIOMS.

I.

EQUIMULTIPLES or equisubmultiples of the same, or of equal magnitudes, are equal.

If A $=$ B, then
twice A $=$ twice B, that is,
2 A $=$ 2 B;
3 A $=$ 3 B;
4 A $=$ 4 B;
&c. &c.
and $\frac{1}{2}$ of A $=$ $\frac{1}{2}$ of B;
$\frac{1}{3}$ of A $=$ $\frac{1}{3}$ of B;
&c. &c.

II.

A MULTIPLE of a greater magnitude is greater than the same multiple of a less.

Let A \sqsubset B, then
2 A \sqsubset 2 B;
3 A \sqsubset 3 B;
4 A \sqsubset 4 B;
&c. &c.

III.

THAT magnitude, of which a multiple is greater than the same multiple of another, is greater than the other.

Let 2 A \sqsubset 2 B, then
A \sqsubset B;
or, let 3 A \sqsubset 3 B, then
A \sqsubset B;
or, let m A \sqsubset m B, then
A \sqsubset B.

BOOK V. PROP. I. THEOR. 147

F any number of magnitudes be equimultiples of as many others, each of each: what multiple soever any one of the first is of its part, the same multiple shall of the first magnitudes taken together be of all the others taken together.

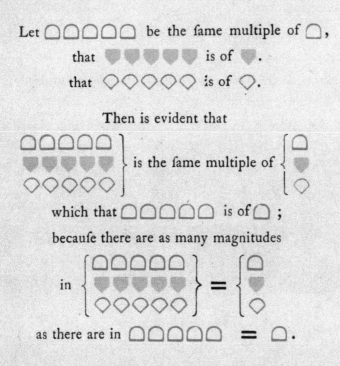

The same demonstration holds in any number of magnitudes, which has here been applied to three.

∴ If any number of magnitudes, &c.

BOOK V. PROP. II. THEOR.

F the first magnitude be the same multiple of the second that the third is of the fourth, and the fifth the same multiple of the second that the sixth is of the fourth, then shall the first, together with the fifth, be the same multiple of the second that the third, together with the sixth, is of the fourth.

Let ●●●, the first, be the same multiple of ●, the second, that ◯◯◯, the third, is of ◯, the fourth; and let ●●●●, the fifth, be the same multiple of ●, the second, that ◯◯◯◯, the sixth, is of ◯, the fourth.

Then it is evident, that $\left\{ \begin{smallmatrix} ●●● \\ ●●●● \end{smallmatrix} \right\}$, the first and fifth together, is the same multiple of ●, the second, that $\left\{ \begin{smallmatrix} ◯◯◯ \\ ◯◯◯◯ \end{smallmatrix} \right\}$, the third and sixth together, is of the same multiple of ◯, the fourth; because there are as many magnitudes in $\left\{ \begin{smallmatrix} ●●● \\ ●●●● \end{smallmatrix} \right\} = ●$ as there are in $\left\{ \begin{smallmatrix} ◯◯◯ \\ ◯◯◯◯ \end{smallmatrix} \right\} = ◯$.

∴ If the first magnitude, &c.

BOOK V. PROP. III. THEOR.

F the first of four magnitudes be the same multiple of the second that the third is of the fourth, and if any equimultiples whatever of the first and third be taken, those shall be equimultiples; one of the second, and the other of the fourth.

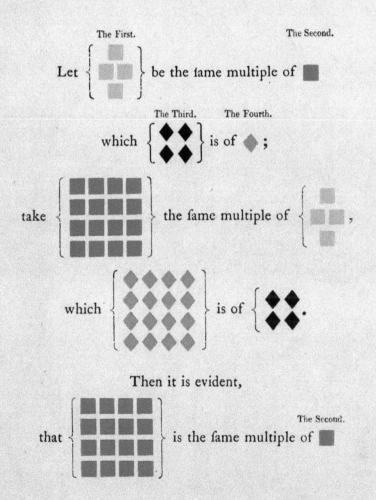

150 BOOK V. PROP. III. THEOR.

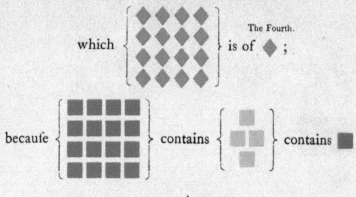

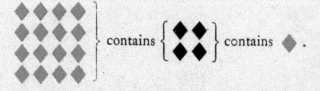

as many times as

contains contains .

The same reasoning is applicable in all cases.

∴ If the first four, &c.

DEFINITION V.

Four magnitudes, ●, ■, ◆, ▼, are said to be proportionals when every equimultiple of the first and third be taken, and every equimultiple of the second and fourth, as,

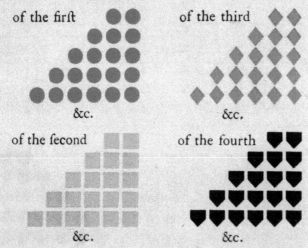

Then taking every pair of equimultiples of the first and third, and every pair of equimultiples of the second and fourth,

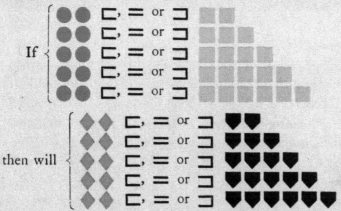

152 BOOK V. DEFINITION V.

That is, if twice the firſt be greater, equal, or leſs than twice the ſecond, twice the third will be greater, equal, or leſs than twice the fourth; or, if twice the firſt be greater, equal, or leſs than three times the ſecond, twice the third will be greater, equal, or leſs than three times the fourth, and so on, as above expreſſed.

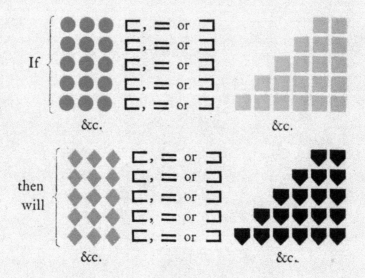

In other terms, if three times the firſt be greater, equal, or leſs than twice the ſecond, three times the third will be greater, equal, or leſs than twice the fourth; or, if three times the firſt be greater, equal, or leſs than three times the ſecond, then will three times the third be greater, equal, or leſs than three times the fourth; or if three times the firſt be greater, equal, or leſs than four times the ſecond, then will three times the third be greater, equal, or leſs than four times the fourth, and so on. Again,

BOOK V. DEFINITION V.

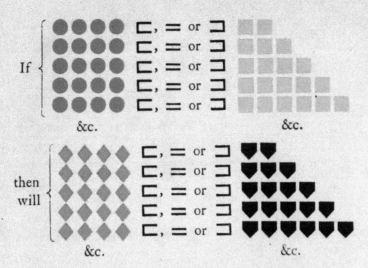

&c.

And so on, with any other equimultiples of the four magnitudes, taken in the same manner.

Euclid expresses this definition as follows:—

The first of four magnitudes is said to have the same ratio to the second, which the third has to the fourth, when any equimultiples whatsoever of the first and third being taken, and any equimultiples whatsoever of the second and fourth; if the multiple of the first be less than that of the second, the multiple of the third is also less than that of the fourth; or, if the multiple of the first be equal to that of the second, the multiple of the third is also equal to that of the fourth; or, if the multiple of the first be greater than that of the second, the multiple of the third is also greater than that of the fourth.

In future we shall express this definition generally, thus:

If M ● ⊏, = or ⊐ m ■,
when M ◆ ⊏, = or ⊐ m ▼

BOOK V. DEFINITION V.

Then we infer that ●, the firſt, has the ſame ratio to ■, the ſecond, which ♦, the third, has to ▼ the fourth: expreſſed in the ſucceeding demonſtrations thus:

● : ■ :: ♦ : ▼ ;

or thus, ● : ■ = ♦ : ▼ ;

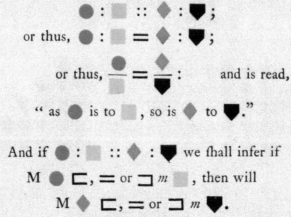

or thus, ●/■ = ♦/▼ : and is read,

" as ● is to ■, ſo is ♦ to ▼."

And if ● : ■ :: ♦ : ▼ we ſhall infer if
M ● ⊏, = or ⊐ *m* ■, then will
M ♦ ⊏, = or ⊐ *m* ▼.

That is, if the firſt be to the ſecond, as the third is to the fourth; then if M times the firſt be greater than, equal to, or leſs than *m* times the ſecond, then ſhall M times the third be greater than, equal to, or leſs than *m* times the fourth, in which M and *m* are not to be conſidered particular multiples, but every pair of multiples whatever; nor are ſuch marks as ●, ▼, ■, &c. to be conſidered any more than repreſentatives of geometrical magnitudes.

The ſtudent ſhould thoroughly underſtand this definition before proceeding further.

BOOK V. PROP. IV. THEOR.

F the firſt of four magnitudes have the ſame ratio to the ſecond, which the third has to the fourth, then any equimultiples whatever of the firſt and third ſhall have the ſame ratio to any equimultiples of the ſecond and fourth; viz., the equimultiple of the firſt ſhall have the ſame ratio to that of the ſecond, which the equimultiple of the third has to that of the fourth.

Let ● : ■ :: ◆ : ▼, then 3 ● : 2 ■ :: 3 ◆ : 2 ▼, every equimultiple of 3 ● and 3 ◆ are equimultiples of ● and ◆, and every equimultiple of 2 ■ and 2 ▼, are equimultiples of ■ and ▼ (B. 5, pr. 3.)

That is, M times 3 ● and M times 3 ◆ are equimultiples of ● and ◆, and *m* times 2 ■ and *m* 2 ▼ are equimultiples of 2 ■ and 2 ▼; but ● : ■ :: ◆ : ▼ (hyp); ∴ if M 3 ● ⊏, =, or ⊐ *m* 2 ■, then M 3 ◆ ⊏, =, or ⊐ *m* 2 ▼ (def. 5.) and therefore 3 ● : 2 ■ :: 3 ◆ : 2 ▼ (def. 5.)

The ſame reaſoning holds good if any other equimultiple of the firſt and third be taken, any other equimultiple of the ſecond and fourth.

∴ If the firſt four magnitudes, &c.

BOOK V. PROP. V. THEOR.

IF one magnitude be the same multiple of another, which a magnitude taken from the first is of a magnitude taken from the other, the remainder shall be the same multiple of the remainder, that the whole is of the whole.

Let ◇◇◇◇ = M′ ▲∎

and ◯ = M′ ∎,

∴ ◇◇◇◇ minus ◯ = M′ ▲∎ minus M′ ∎,

∴ ◇◇◇ = M′ (▲∎ minus ∎),

and ∴ ◇◇◇ = M′ ▲.

∴ If one magnitude, &c.

BOOK V. PROP. VI. THEOR.

F *two magnitudes be equimultiples of two others, and if equimultiples of thefe be taken from the firft two, the remainders are either equal to thefe others, or equimultiples of them.*

Let ◯◯◯ = M' ■ ; and ⌒⌒ = M' ▲ ;

then ◯◯◯ minus m' ■ =

M' ■ minus m' ■ = (M' minus m') ■,

and ⌒⌒ minus m' ▲ = M' ▲ minus m' ▲ = (M' minus m') ▲ .

Hence, (M' minus m') ■ and (M' minus m') ▲ are equimultiples of ■ and ▲ , and equal to ■ and ▲, when M' minus m' = 1.

∴ If two magnitudes be equimultiples, &c.

BOOK V. PROP. A. THEOR.

F the firſt of the four magnitudes has the ſame ratio to the ſecond which the third has to the fourth, then if the firſt be greater than the ſecond, the third is alſo greater than the fourth; and if equal, equal; if leſs, leſs.

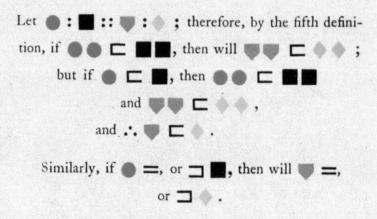

∴ If the firſt of four, &c.

DEFINITION XIV.

GEOMETRICIANS make uſe of the technical term "Invertendo," by inverſion, when there are four proportionals, and it is inferred, that the ſecond is to the firſt as the fourth to the third.

Let $A : B :: C : D$, then, by "invertendo" it is inferred $B : A :: D : C$.

BOOK V. PROP. B. THEOR.

F *four magnitudes are proportionals, they are proportionals also when taken inversely.*

Let ▼ : ⌴ :: ■ : ◆,
then, inversely, ⌴ : ▼ :: ◆ : ■.

If M ▼ ⊐ *m* ⌴, then M ■ ⊐ *m* ◆
by the fifth definition.

Let M ▼ ⊐ *m* ⌴, that is, *m* ⌴ ⊏ M ▼.
∴ M ■ ⊐ *m* ◆, or, *m* ◆ ⊏ M ■;
∴ if *m* ⌴ ⊏ M ▼, then will *m* ◆ ⊏ M ■.

In the same manner it may be shown,
that if *m* ⌴ = or ⊐ M ▼,
then will *m* ◆ =, or ⊐ M ■;
and therefore, by the fifth definition, we infer
that ⌴ : ▼ : ◆ : ■.

∴ If four magnitudes, &c.

BOOK V. PROP. C. THEOR.

F *the first be the same multiple of the second, or the same part of it, that the third is of the fourth; the first is to the second, as the third is to the fourth.*

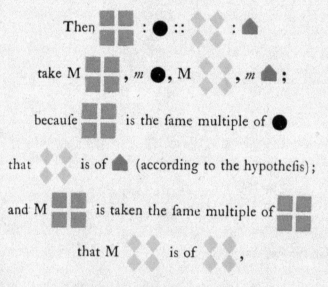

BOOK V. PROP. C. THEOR. 161

Therefore, if M ▦ be of ● a greater multiple than
m ● is, then M ◆◆ is a greater multiple of ▲ than
m ▲ is; that is, if M ▦ be greater than m ●, then
M ◆◆ will be greater than m ▲; in the same manner
it can be shewn, if M ▦ be equal m ●, then
M ◆◆ will be equal m ▲.

And, generally, if M ▦ ⊏, = or ⊐ m ●
then M ◆◆ will be ⊏, = or ⊐ m ▲;

∴ by the fifth definition,

▦ : ● :: ◆◆ : ▲.

Next, let ● be the same part of ▦
that ▲ is of ◆◆.

In this case also ● : ▦ :: ▲ : ◆◆.

For, because
● is the same part of ▦ that ▲ is of ◆◆,

162 BOOK V. PROP. C. THEOR.

therefore 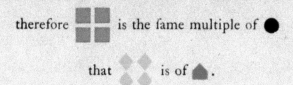 is the same multiple of ●

that 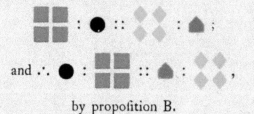 is of ▲.

Therefore, by the preceding case,

▦ : ● :: ◆◆ : ▲ ;

and ∴ ● : ▦ :: ▲ : ◆◆ ,

by proposition B.

∴ If the first be the same multiple, &c.

F *the first be to the second as the third to the fourth, and if the first be a multiple, or a part of the second; the third is the same multiple, or the same part of the fourth.*

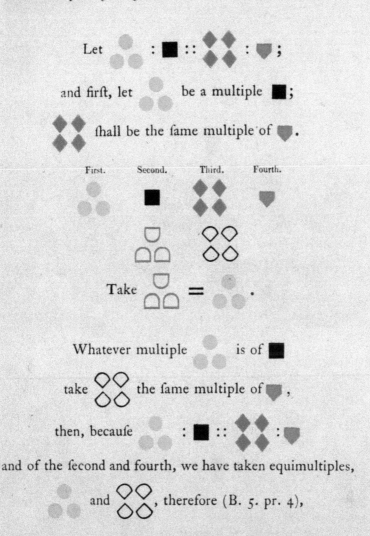

and of the second and fourth, we have taken equimultiples, and, therefore (B. 5. pr. 4),

BOOK V. PROP. D. THEOR.

● : ◐ :: ◆ : ◇, but (conft.),

● = ◐ ∴ (B. 5. pr. A.) ◆ = ◇

and ◇ is the fame multiple of ▽

that ● is of ■.

Next, let ■ : ● :: ▽ : ◆,

and alfo ■ a part of ● ;

then ▽ fhall be the fame part of ◆.

Inverfely (B. 5.), ● : ■ :: ◆ : ▽,

but ■ is a part of ● ;

that is, ● is a multiple of ■ ;

∴ by the preceding cafe, ◆ is the fame multiple of ▽

that is, ▽ is the fame part of ◆

that ■ is of ● .

∴ If the firft be to the fecond, &c.

BOOK V. PROP. VII. THEOR.

QUAL *magnitudes have the same ratio to the same magnitude, and the same has the same ratio to equal magnitudes.*

Let ● = ◆ and ■ any other magnitude;
then ● : ■ = ◆ : ■ and ■ : ● = ■ : ◆.

Because ● = ◆,

∴ M● = M◆;

∴ if M● ⊏, = or ⊐ *m* ■, then
M◆ ⊏, = or ⊐ *m* ■,
and ∴ ● : ■ = ◆ : ■ (B. 5. def. 5).

From the foregoing reasoning it is evident that,
if *m* ■ ⊏, = or ⊐ M ●, then
m ■ ⊏, = or ⊐ M ◆
∴ ■ : ● = ■ : ◆ (B. 5. def. 5).

∴ Equal magnitudes, &c.

DEFINITION VII.

When of the equimultiples of four magnitudes (taken as in the fifth definition), the multiple of the first is greater than that of the second, but the multiple of the third is not greater than the multiple of the fourth; then the first is said to have to the second a greater ratio than the third magnitude has to the fourth: and, on the contrary, the third is said to have to the fourth a less ratio than the first has to the second.

If, among the equimultiples of four magnitudes, compared as in the fifth definition, we should find

●●●●● ⊏ ■■■■ , but

◆◆◆◆◆ = or ⊐ ♥♥♥♥, or if we should find any particular multiple M′ of the first and third, and a particular multiple m′ of the second and fourth, such, that M′ times the first is ⊏ m′ times the second, but M′ times the third is not ⊏ m′ times the fourth, *i.e.* = or ⊐ m′ times the fourth; then the first is said to have to the second a greater ratio than the third has to the fourth; or the third has to the fourth, under such circumstances, a less ratio than the first has to the second: although several other equimultiples may tend to show that the four magnitudes are proportionals.

This definition will in future be expressed thus:—

If M′ ♥ ⊏ m′ ⌴, but M′ ■ = or ⊐ m′ ◆,
then ♥ : ⌴ ⊏ ■ : ◆ .

In the above general expression, M′ and m′ are to be considered particular multiples, not like the multiples M

BOOK V. DEFINITION VII. 167

and *m* introduced in the fifth definition, which are in that definition confidered to be every pair of multiples that can be taken. It muft alfo be here obferved, that ♥, ◡, ■, and the like fymbols are to be confidered merely the reprefentatives of geometrical magnitudes.

In a partial arithmetical way, this may be fet forth as follows:

Let us take the four numbers, 8, 7, 10, and 9.

Firft.	Second.	Third.	Fourth.
8	7	10	9
16	14	20	18
24	21	30	27
32	28	40	36
40	35	50	45
48	42	60	54
56	49	70	63
64	56	80	72
72	63	90	81
80	70	100	90
88	77	110	99
96	84	120	108
104	91	130	117
112	98	140	126
&c.	&c.	&c.	&c.

Among the above multiples we find 16 ⊏ 14 and 20 ⊏ 18; that is, twice the firft is greater than twice the fecond, and twice the third is greater than twice the fourth; and 16 ⊐ 21 and 20 ⊐ 27; that is, twice the firft is lefs than three times the fecond, and twice the third is lefs than three times the fourth; and among the fame multiples we can find 72 ⊏ 56 and 90 ⊏ 72; that is, 9 times the firft is greater than 8 times the fecond, and 9 times the third is greater than 8 times the fourth. Many other equimul-

tiples might be selected, which would tend to fhow that the numbers 8, 7, 10, 9, were proportionals, but they are not, for we can find a multiple of the firft ⊏ a multiple of the fecond, but the fame multiple of the third that has been taken of the firft not ⊏ the fame multiple of the fourth which has been taken of the fecond; for inftance, 9 times the firft is ⊏ 10 times the fecond, but 9 times the third is not ⊏ 10 times the fourth, that is, 72 ⊏ 70, but 90 not ⊏ 90, or 8 times the firft we find ⊏ 9 times the fecond, but 8 times the third is not greater than 9 times the fourth, that is, 64 ⊏ 63, but 80 is not ⊏ 81. When any fuch multiples as thefe can be found, the firft (8) is faid to have to the fecond (7) a greater ratio than the third (10) has to the fourth (9), and on the contrary the third (10) is faid to have to the fourth (9) a lefs ratio than the firft (8) has to the fecond (7).

BOOK V. PROP. VIII. THEOR.

F *unequal magnitudes the greater has a greater ratio to the same than the less has: and the same magnitude has a greater ratio to the less than it has to the greater.*

Let ▲■ and ■ be two unequal magnitudes, and ● any other.

We shall first prove that ▲■ which is the greater of the two unequal magnitudes, has a greater ratio to ● than ■, the less, has to ● ;

that is, ▲■ : ● ⊐ ■ : ● ;

take M' ▲■, m' ●, M' ■, and m' ● ;
such, that M' ▲ and M' ■ shall be each ⊏ ● ;
also take m' ● the least multiple of ●,
which will make m' ● ⊏ M' ■ = M' ■ ;

∴ M' ■ is not ⊏ m' ●,

but M' ▲■ is ⊏ m' ●, for,
as m' ● is the first multiple which first becomes ⊏ M'■,
than (m' minus 1) ● or m' ● minus ● is not ⊏ M' ■,
and ● is not ⊏ M' ▲,

∴ m' ● minus ● + ● must be ⊐ M' ■ + M' ▲ ;

that is, m' ● must be ⊐ M' ▲■ ;

∴ M' ▲■ is ⊏ m' ● ; but it has been shown above that

170 BOOK V. PROP. VIII. THEOR.

M′ ■ is not ⊏ m′ ●, therefore, by the seventh definition,
■ has to ● a greater ratio than ■ : ●.

Next we shall prove that ● has a greater ratio to ■, the
less, than it has to ■, the greater;

or, ● : ■ ⊏ ● : ■.

Take m′ ●, M′ ■, m′ ●, and M′ ■,
the same as in the first case, such, that
M′ ▲ and M′ ■ will be each ⊏ ●, and m′ ● the least
multiple of ●, which first becomes greater
than M′ ■ = M′ ■.

∴ m′ ● minus ● is not ⊏ M′ ■,
and ● is not ⊏ M′ ▲; consequently
m′ ● minus ● + ● is ⊐ M′ ■ + M′ ▲;

∴ m′ ● is ⊐ M′ ■, and ∴ by the seventh definition,
● has to ■ a greater ratio than ● has to ■.

∴ Of unequal magnitudes, &c.

The contrivance employed in this proposition for finding
among the multiples taken, as in the fifth definition, a multiple of the first greater than the multiple of the second, but the same multiple of the third which has been taken of the first, not greater than the same multiple of the fourth which has been taken of the second, may be illustrated numerically as follows:—

The number 9 has a greater ratio to 7 than 8 has to 7:
that is, 9 : 7 ⊏ 8 : 7; or, 8 + 1 : 7 ⊐ 8 : 7.

BOOK V. PROP. VIII. THEOR. 171

The multiple of 1, which first becomes greater than 7, is 8 times, therefore we may multiply the first and third by 8, 9, 10, or any other greater number; in this case, let us multiply the first and third by 8, and we have 64 + 8 and 64: again, the first multiple of 7 which becomes greater than 64 is 10 times; then, by multiplying the second and fourth by 10, we shall have 70 and 70; then, arranging these multiples, we have—

8 times the first.	10 times the second.	8 times the third.	10 times the fourth.
64 + 8	70	64	70

Consequently 64 + 8, or 72, is greater than 70, but 64 is not greater than 70, ∴ by the seventh definition, 9 has a greater ratio to 7 than 8 has to 7.

The above is merely illustrative of the foregoing demonstration, for this property could be shown of these or other numbers very readily in the following manner; because, if an antecedent contains its consequent a greater number of times than another antecedent contains its consequent, or when a fraction is formed of an antecedent for the numerator, and its consequent for the denominator be greater than another fraction which is formed of another antecedent for the numerator and its consequent for the denominator, the ratio of the first antecedent to its consequent is greater than the ratio of the last antecedent to its consequent.

Thus, the number 9 has a greater ratio to 7, than 8 has to 7, for $\frac{9}{7}$ is greater than $\frac{8}{7}$.

Again, 17 : 19 is a greater ratio than 13 : 15, because $\frac{17}{19} = \frac{17 \times 15}{19 \times 15} = \frac{255}{285}$, and $\frac{13}{15} = \frac{13 \times 19}{15 \times 19} = \frac{247}{285}$, hence it is evident that $\frac{255}{285}$ is greater than $\frac{247}{285}$, ∴ $\frac{17}{19}$ is greater than

$\frac{13}{15}$, and, according to what has been above shown, 17 has to 19 a greater ratio than 13 has to 15.

So that the general terms upon which a greater, equal, or less ratio exists are as follows:—

If $\frac{A}{B}$ be greater than $\frac{C}{D}$, A is said to have to B a greater ratio than C has to D; if $\frac{A}{B}$ be equal to $\frac{C}{D}$, then A has to B the same ratio which C has to D; and if $\frac{A}{B}$ be less than $\frac{C}{D}$, A is said to have to B a less ratio than C has to D.

The student should understand all up to this proposition perfectly before proceeding further, in order fully to comprehend the following propositions of this book. We therefore strongly recommend the learner to commence again, and read up to this slowly, and carefully reason at each step, as he proceeds, particularly guarding against the mischievous system of depending wholly on the memory. By following these instructions, he will find that the parts which usually present considerable difficulties will present no difficulties whatever, in prosecuting the study of this important book.

BOOK V. PROP. IX. THEOR.

AGNITUDES *which have the same ratio to the same magnitude are equal to one another; and those to which the same magnitude has the same ratio are equal to one another.*

Let ◆ : ■ :: ● : ■, then ◆ = ●.

For, if not, let ◆ ⊏ ●, then will
◆ : ■ ⊏ ● : ■ (B. 5. pr. 8),
which is absurd according to the hypothesis.

∴ ◆ is not ⊏ ●.

In the same manner it may be shown, that

● is not ⊏ ◆,

∴ ◆ = ●.

Again, let ■ : ◆ :: ■ : ●, then will ◆ = ●.

For (invert.) ◆ : ■ :: ● : ■,
therefore, by the first case, ◆ = ●.

∴ Magnitudes which have the same ratio, &c.

This may be shown otherwise, as follows:—

Let $A : B = A : C$, then $B = C$, for, as the fraction $\frac{A}{B}=$ the fraction $\frac{A}{C}$, and the numerator of one equal to the numerator of the other, therefore the denominator of these fractions are equal, that is $B = C$.

Again, if $B : A = C : A$, $B = C$. For, as $\frac{B}{A} = \frac{C}{A}$, B must $= C$.

BOOK V. PROP. X. THEOR.

THAT *magnitude which has a greater ratio than another has unto the same magnitude, is the greater of the two: and that magnitude to which the same has a greater ratio than it has unto another magnitude, is the less of the two.*

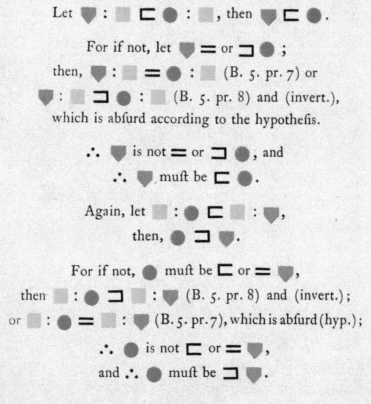

∴ That magnitude which has, &c.

BOOK V. PROP. XI. THEOR.

ATIOS *that are the same to the same ratio, are the same to each other.*

Let ◆ : ■ = ● : ▼ and ● : ▼ = ▲ : ⊙,
then will ◆ : ■ = ▲ : ⊙.

For if M ◆ ⊏, =, or ⊐ *m* ■,
then M ● ⊏, =, or ⊐ *m* ▼,
and if M ● ⊏, =, or ⊐ *m* ▼,
then M ▲ ⊏, =, or ⊐ *m* ⊙, (B. 5. def. 5);

∴ if M ◆ ⊏, =, or ⊐ *m* ■, M ▲ ⊏, =, or ⊐ *m* ⊙,
and ∴ (B. 5. def. 5) ◆ : ■ = ▲ : ⊙.

∴ Ratios that are the same, &c.

BOOK V. PROP. XII. THEOR.

F any number of magnitudes be proportionals, as one of the antecedents is to its consequent, so shall all the antecedents taken together be to all the consequents.

Let ■ : ● = ⌒ : ◇ = ◆ : ▽ = • : ▼ = ▲ : ⬤;
then will ■ : ● =
■ + ⌒ + ◆ + • + ▲ : ● + ◇ + ▽ + ▼ + ⬤.

For if M ■ ⊏ m ●, then M ⌒ ⊏ m ◇, and M ◆ ⊏ m ▽ M • ⊏ m ▼, also M ▲ ⊏ m ⬤. (B. 5. def. 5.)

Therefore, if M ■ ⊏ m ●, then will
M ■ + M ⌒ + M ◆ + M • + M ▲,
or M (■ + ⌒ + ◆ + • + ▲) be greater than m ● + m ◇ + m ▽ + m ▼ + m ⬤,
or m (● + ◇ + ▽ + ▼ + ⬤).

In the same way it may be shown, if M times one of the antecedents be equal to or less than m times one of the consequents, M times all the antecedents taken together, will be equal to or less than m times all the consequents taken together. Therefore, by the fifth definition, as one of the antecedents is to its consequent, so are all the antecedents taken together to all the consequents taken together.

∴ If any number of magnitudes, &c.

BOOK V. PROP. XIII. THEOR. 177

F the first has to the second the same ratio which the third has to the fourth, but the third to the fourth a greater ratio than the fifth has to the sixth; the first shall also have to the second a greater ratio than the fifth to the sixth.

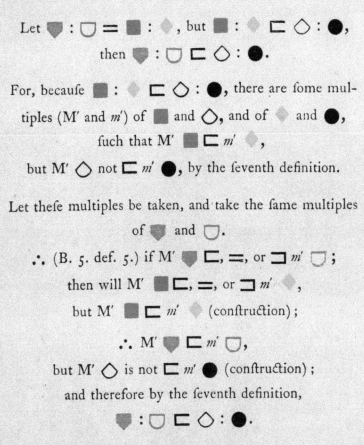

∴ If the first has to the second, &c.

178 BOOK V. PROP. XIV. THEOR.

IF *the first has the same ratio to the second which the third has to the fourth; then, if the first be greater than the third, the second shall be greater than the fourth; and if equal, equal; and if less, less.*

Let ▼ : ◡ :: ■ : ◆, and first suppose ▼ ⊏ ■, then will ◡ ⊏ ◆.

For ▼ : ◡ ⊏ ■ : ◡ (B. 5. pr. 8), and by the hypothesis, ▼ : ◡ = ■ : ◆;

∴ ■ : ◆ ⊏ ■ : ◡ (B. 5. pr. 13),

∴ ◆ ⊐ ◡ (B. 5. pr. 10.), or ◡ ⊏ ◆.

Secondly, let ▼ = ■, then will ◡ = ◆.

For ▼ : ◡ = ■ : ◡ (B. 5. pr. 7),

and ▼ : ◡ = ■ : ◆ (hyp.);

∴ ■ : ◡ = ■ : ◆ (B. 5. pr. 11),

and ∴ ◡ = ◆ (B. 5. pr. 9).

Thirdly, if ▼ ⊐ ■, then will ◡ ⊐ ◆; because ■ ⊏ ▼ and ■ : ◆ = ▼ : ◡;

∴ ◆ ⊏ ◡, by the first case,

that is, ◡ ⊐ ◆.

∴ If the first has the same ratio, &c.

BOOK V. PROP. XV. THEOR.

AGNITUDES *have the same ratio to one another which their equimultiples have.*

Let ● and ■ be two magnitudes;
then, ● : ■ :: M' ● : M' ■.

For ● : ■ = ● : ■
= ● : ■
= ● : ■

∴ ● : ■ :: 4 ● : 4 ■. (B. 5. pr. 12).

And as the same reasoning is generally applicable, we have

● : ■ :: M' ● : M' ■.

∴ Magnitudes have the same ratio, &c.

DEFINITION XIII.

The technical term permutando, or alternando, by permutation or alternately, is used when there are four proportionals, and it is inferred that the first has the same ratio to the third which the second has to the fourth; or that the first is to the third as the second is to the fourth: as is shown in the following proposition:—

Let ● : ◆ :: ▼ : ■,

by " permutando" or " alternando" it is

inferred ● : ▼ :: ◆ : ■.

It may be necessary here to remark that the magnitudes ●, ◆, ▼, ■, must be homogeneous, that is, of the same nature or similitude of kind; we must therefore, in such cases, compare lines with lines, surfaces with surfaces, solids with solids, &c. Hence the student will readily perceive that a line and a surface, a surface and a solid, or other heterogenous magnitudes, can never stand in the relation of antecedent and consequent.

BOOK V. PROP. XVI. THEOR.

F *four magnitudes of the same kind be proportionals, they are also proportionals when taken alternately.*

Let ▼ : ⌒ :: ■ : ◆, then ▼ : ■ :: ⌒ : ◆.

For M ▼ : M ⌒ :: ▼ : ⌒ (B. 5. pr. 15),

and M ▼ : M ⌒ :: ■ : ◆ (hyp.) and (B. 5. pr. 11);

also *m* ■ : *m* ◆ :: ■ : ◆ (B. 5. pr. 15);

∴ M ▼ : M ⌒ :: *m* ■ : *m* ◆ (B. 5. pr. 14),

and ∴ if M ▼ ⊏, =, or ⊐ *m* ■,

then will M ⌒ ⊏, =, or ⊐ *m* ◆ (B. 5. pr. 14);

therefore, by the fifth definition,

▼ : ■ :: ⌒ : ◆.

∴ If four magnitudes of the same kind, &c.

DEFINITION XVI.

Dividendo, by division, when there are four proportionals, and it is inferred, that the excess of the first above the second is to the second, as the excess of the third above the fourth, is to the fourth.

Let A : B :: C : D ;

by "dividendo" it is inferred

A minus B : B :: C minus D : D.

According to the above, A is supposed to be greater than B, and C greater than D ; if this be not the case, but to have B greater than A, and D greater than C, B and D can be made to stand as antecedents, and A and C as consequents, by "invertion"

B : A :: D : C ;

then, by "dividendo," we infer

B minus A : A :: D minus C : C.

BOOK V. PROP. XVII. THEOR. 183

F *magnitudes, taken jointly, be proportionals, they shall also be proportionals when taken separately: that is, if two magnitudes together have to one of them the same ratio which two others have to one of these, the remaining one of the first two shall have to the other the same ratio which the remaining one of the last two has to the other of these.*

Let ♥ + ⊍ : ⊍ :: ■ + ♦ : ♦,

then will ♥ : ⊍ :: ■ : ♦.

Take M ♥ ⊏ *m* ⊍ to each add M ⊍,

then we have M ♥ + M ⊍ ⊏ *m* ⊍ + M ⊍,

or M (♥ + ⊍) ⊏ (*m* + M) ⊍:

but because ♥ + ⊍ : ⊍ :: ■ + ♦ : ♦ (hyp.),

and M (♥ + ⊍) ⊏ (*m* + M) ⊍;

∴ M (■ + ♦) ⊏ (*m* + M) ♦ (B. 5. def. 5);

∴ M ■ + M ♦ ⊏ *m* ♦ + M ♦;

∴ M ■ ⊏ *m* ♦, by taking M ♦ from both sides:

that is, when M ♥ ⊏ *m* ⊍, then M ■ ⊏ *m* ♦.

In the same manner it may be proved, that if

M ♥ = or ⊐ *m* ⊍, then will M ■ = or ⊐ *m* ♦;

and ∴ ♥ : ⊍ :: ■ : ♦ (B. 5. def. 5).

∴ If magnitudes taken jointly, &c.

DEFINITION XV.

THE term componendo, by composition, is used when there are four proportionals; and it is inferred that the first together with the second is to the second as the third together with the fourth is to the fourth.

Let $A : B :: C : D$;

then, by the term "componendo," it is inferred that

$$A + B : B :: C + D : D.$$

By "invertion" B and D may become the first and third, A and C the second and fourth, as

$$B : A :: D : C,$$

then, by "componendo," we infer that

$$B + A : A :: D + C : C.$$

BOOK V. PROP. XVIII. THEOR.

IF *magnitudes, taken separately, be proportionals, they shall also be proportionals when taken jointly: that is, if the first be to the second as the third is to the fourth, the first and second together shall be to the second as the third and fourth together is to the fourth.*

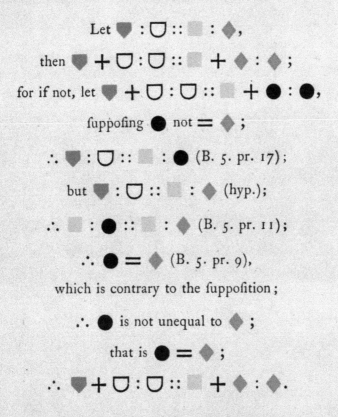

∴ If magnitudes, taken separately, &c.

F *a whole magnitude be to a whole, as a magnitude taken from the firſt, is to a magnitude taken from the other; the remainder ſhall be to the remainder, as the whole to the whole.*

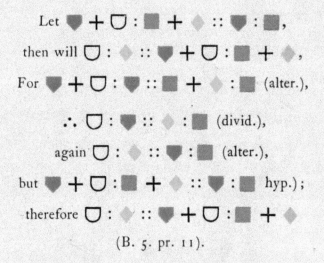

(B. 5. pr. 11).

∴ If a whole magnitude be to a whole, &c.

DEFINITION XVII.

The term "convertendo," by converſion, is made uſe of by geometricians, when there are four proportionals, and it is inferred, that the firſt is to its exceſs above the ſecond, as the third is to its exceſs above the fourth. See the following propoſition:—

BOOK V. PROP. E. THEOR.

F *four magnitudes be proportionals, they are also proportionals by conversion: that is, the first is to its excess above the second, as the third to its excess above the fourth.*

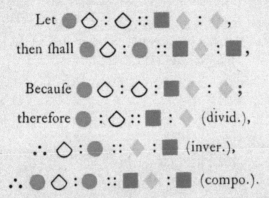

∴ If four magnitudes, &c.

DEFINITION XVIII.

"Ex æquali" (sc. distantiâ), or ex æquo, from equality of distance: when there is any number of magnitudes more than two, and as many others, such that they are proportionals when taken two and two of each rank, and it is inferred that the first is to the last of the first rank of magnitudes, as the first is to the last of the others: "of this there are the two following kinds, which arise from the different order in which the magnitudes are taken, two and two."

DEFINITION XIX.

"Ex æquali," from equality. This term is used simply by itself, when the first magnitude is to the second of the first rank, as the first to the second of the other rank; and as the second is to the third of the first rank, so is the second to the third of the other; and so on in order: and the inference is as mentioned in the preceding definition; whence this is called ordinate proportion. It is demonstrated in Book 5. pr. 22.

Thus, if there be two ranks of magnitudes,
A, B, C, D, E, F, the first rank,
and L, M, N, O, P, Q, the second,
such that A : B :: L : M, B : C :: M : N,
C : D :: N : O, D : E :: O : P, E : F :: P : Q;
we infer by the term "ex æquali" that
A : F :: L : Q.

DEFINITION XX.

"Ex æquali in proportione perturbatâ feu inordinatâ," from equality in perturbate, or diforderly proportion. This term is ufed when the firft magnitude is to the fecond of the firft rank as the laft but one is to the laft of the fecond rank; and as the fecond is to the third of the firft rank, fo is the laft but two to the laft but one of the fecond rank; and as the third is to the fourth of the firft rank, fo is the third from the laft to the laft but two of the fecond rank; and fo on in a crofs order: and the inference is in the 18th definition. It is demonftrated in B. 5. pr. 23.

Thus, if there be two ranks of magnitudes,

A, B, C, D, E, F, the firft rank,

and L, M, N, O, P, Q, the fecond,

fuch that A : B :: P : Q, B : C :: O : P,

C : D :: N : O, D : E :: M : N, E : F :: L : M;

the term "ex æquali in proportione perturbatâ feu inordinatâ" infers that

A : F :: L : Q.

BOOK V. PROP. XX. THEOR.

F there be three magnitudes, and other three, which, taken two and two, have the same ratio; then, if the first be greater than the third, the fourth shall be greater than the sixth; and if equal, equal; and if less, less.

Let ♥, ⌒, ■, be the first three magnitudes,

and ♦, ◇, ●, be the other three,

such that ♥ : ⌒ :: ♦ : ◇, and ⌒ : ■ :: ◇ : ●.

Then, if ♥ ⊏, =, or ⊐ ■, then will ♦ ⊏, =,

or ⊐ ●.

From the hypothesis, by alternando, we have

♥ : ♦ :: ⌒ : ◇,

and ⌒ : ◇ :: ■ : ●;

∴ ♥ : ♦ :: ■ : ● (B. 5. pr. 11);

∴ if ♥ ⊏, =, or ⊐ ■, then will ♦ ⊏, =,

or ⊐ ● (B. 5. pr. 14).

∴ If there be three magnitudes, &c.

BOOK V. PROP. XXI. THEOR.

F *there be three magnitudes, and other three which have the same ratio, taken two and two, but in a cross order; then if the first magnitude be greater than the third, the fourth shall be greater than the sixth; and if equal, equal; and if less, less.*

Let ▽, ▲, ■, be the first three magnitudes,

and ◆, ○, ●, the other three,

such that ▽ : ▲ :: ○ : ●, and ▲ : ■ :: ◆ : ○.

Then, if ▽ ⊏, =, or ⊐ ■, then

will ◆ ⊏, =, ⊐ ●.

First, let ▽ be ⊏ ■:

then, because ▲ is any other magnitude,

▽ : ▲ ⊏ ■ : ▲ (B. 5. pr. 8);

but ○ : ● :: ▽ : ▲ (hyp.);

∴ ○ : ● ⊏ ■ : ▲ (B. 5. pr. 13);

and because ▲ : ■ :: ◆ : ○ (hyp.);

∴ ■ : ▲ :: ○ : ◆ (inv.),

and it was shown that ○ : ● ⊏ ■ : ▲,

∴ ○ : ● ⊏ ○ : ◆ (B. 5. pr. 13);

BOOK V. PROP. XXI. THEOR.

∴ ● ⊐ ◆,

that is ◆ ⊏ ●.

Secondly, let ▼ = ■; then shall ◆ = ●.

For because ▼ = ■,

▼ : ▲ = ■ : ▲ (B. 5. pr. 7);

but ▼ : ▲ = ◇ : ● (hyp.),

and ■ : ▲ = ◇ : ◆ (hyp. and inv.),

∴ ◇ : ● = ◇ : ◆ (B. 5. pr. 11),

∴ ◆ = ● (B. 5. pr. 9).

Next, let ▼ be ⊐ ■, then ◆ shall be ⊐ ● ;

for ■ ⊏ ▼,

and it has been shown that ■ : ▲ = ◇ : ◆,

and ▲ : ▼ = ● : ◇;

∴ by the first case ● is ⊏ ◆,

that is, ◆ ⊐ ●.

∴ If there be three, &c.

BOOK V. PROP. XXII. THEOR. 193

F there be any number of magnitudes, and as many others, which, taken two and two in order, have the same ratio; the first shall have to the last of the first magnitudes the same ratio which the first of the others has to the last of the same.

N.B.—This is usually cited by the words "ex æquali," or "ex æquo."

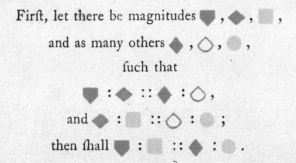

Let these magnitudes, as well as any equimultiples whatever of the antecedents and consequents of the ratios, stand as follows:—

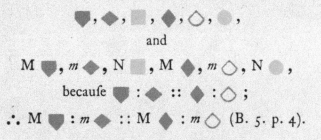

For the same reason

m ◆ : N ■ :: m ○ : N ● ;

and because there are three magnitudes,

BOOK V. PROP. XXII. THEOR.

M ♥, *m* ♦, N ■,

and other three, M ♦, *m* ○, N ●,

which, taken two and two, have the same ratio;

∴ if M ♥ ⊏, =, or ⊐ N ■

then will M ♦ ⊏, =, or ⊐ N ●, by (B. 5. pr. 20);

and ∴ ♥ : ■ :: ♦ : ● (def. 5).

Next, let there be four magnitudes, ♥, ♦, ■, ♦,

and other four, ○, ●, ■, ▲,

which, taken two and two, have the same ratio,

that is to say, ♥ : ♦ :: ○ : ●,

♦ : ■ :: ● : ■,

and ■ : ♦ :: ■ : ▲,

then shall ♥ : ♦ :: ○ : ▲ ;

for, because ♥, ♦, ■, are three magnitudes,

and ○, ●, ■, other three,

which, taken two and two, have the same ratio;

therefore, by the foregoing case, ♥ : ■ :: ○ : ■,

but ■ : ♦ :: ■ : ▲ ;

therefore again, by the first case, ♥ : ♦ :: ○ : ▲ ;

and so on, whatever the number of magnitudes be.

∴ If there be any number, &c.

BOOK V. PROP. XXIII. THEOR.

F *there be any number of magnitudes, and as many others, which, taken two and two in a cross order, have the same ratio; the first shall have to the last of the first magnitudes the same ratio which the first of the others has to the last of the same.*

N.B.—This is usually cited by the words "*ex æquali in proportione perturbatâ;*" or "*ex æquo perturbato.*"

∴ M ▽ : M ∪ :: ◇ : ● (B. 5. pr. 11);

and because ∪ : ■ :: ◆ : ◇ (hyp.),

∴ M ∪ : m ■ :: ◆ : m ◇ (B. 5. pr. 4);

then, because there are three magnitudes,

M ▽, M ∪, m ■,

and other three, M ◆, m ◇, m ●,

which, taken two and two in a crofs order, have the fame ratio;

therefore, if M ▽ ⊏, =, or ⊐ m ■,

then will M ◆ ⊏, =, or ⊐ m ● (B. 5. pr. 21),

and ∴ ▽ : ■ :: ◆ : ● (B. 5. def. 5).

Next, let there be four magnitudes,

▽, ∪, ■, ◆,

and other four, ◇, ●, ■, ▲,

which, when taken two and two in a crofs order, have the fame ratio; namely,

▽ : ∪ :: ■ : ▲,

∪ : ■ :: ● : ■,

and ■ : ◆ :: ◇ : ●,

then fhall ▽ : ◆ :: ◇ : ▲.

For, becaufe ▽, ∪, ■ are three magnitudes,

BOOK V. PROP. XXIII. THEOR. 197

and ●, ■, ▲, other three,

which, taken two and two in a cross order, have the same ratio,

therefore, by the first case, ⬇ : ■ :: ● : ▲,

but ■ : ◆ :: ◇ : ●,

therefore again, by the first case, ⬇ : ◆ :: ◇ : ▲ ;

and so on, whatever be the number of such magnitudes.

∴ If there be any number, &c.

BOOK V. PROP. XXIV. THEOR.

IF *the first has to the second the same ratio which the third has to the fourth, and the fifth to the second the same which the sixth has to the fourth, the first and fifth together shall have to the second the same ratio which the third and sixth together have to the fourth.*

∴ If the first, &c.

BOOK V. PROP. XXV. THEOR.

F *four magnitudes of the same kind are proportionals, the greatest and least of them together are greater than the other two together.*

Let four magnitudes, ♥ + ⌒, ■ + ♦, ⌒, and ♦, of the same kind, be proportionals, that is to say,

♥ + ⌒ : ■ + ♦ :: ⌒ : ♦,

and let ♥ + ⌒ be the greatest of the four, and consequently by pr. A and 14 of Book 5, ♦ is the least; then will ♥ + ⌒ + ♦ be ⊐ ■ + ♦ + ⌒;
because ♥ + ⌒ : ■ + ♦ :: ⌒ : ♦,

∴ ♥ : ■ :: ♥ + ⌒ : ■ + ♦ (B. 5. pr. 19),
but ♥ + ⌒ ⊐ ■ + ♦ (hyp.),

∴ ♥ ⊐ ■ (B. 5. pr. A);
to each of these add ⌒ + ♦,

∴ ♥ + ⌒ + ♦ ⊐ ■ + ⌒ + ♦.

∴ If four magnitudes, &c.

DEFINITION X.

When three magnitudes are proportionals, the first is said to have to the third the duplicate ratio of that which it has to the second.

For example, if A, B, C, be continued proportionals, that is, A : B :: B : C, A is said to have to C the duplicate ratio of A : B ;

$$\text{or } \frac{A}{C} = \text{the square of } \frac{A}{B}.$$

This property will be more readily seen of the quantities ar^2, ar, a, for $ar^2 : ar :: ar : a$;

$$\text{and } \frac{ar^2}{a} = r^2 = \text{the square of } \frac{ar^2}{ar} = r,$$

or of a, ar, ar^2 ;

$$\text{for } \frac{a}{ar^2} = \frac{1}{r^2} = \text{the square of } \frac{a}{ar} = \frac{1}{r}.$$

DEFINITION XI.

When four magnitudes are continual proportionals, the first is said to have to the fourth the triplicate ratio of that which it has to the second; and so on, quadruplicate, &c. increasing the denomination still by unity, in any number of proportionals.

For example, let A, B, C, D, be four continued proportionals, that is, A : B :: B : C :: C : D ; A is said to have to D, the triplicate ratio of A to B ;

$$\text{or } \frac{A}{D} = \text{the cube of } \frac{A}{B}.$$

BOOK V. DEFINITION XI.

This definition will be better understood, and applied to a greater number of magnitudes than four that are continued proportionals, as follows :—

Let ar^3, ar^2, ar, a, be four magnitudes in continued proportion, that is, $ar^3 : ar^2 :: ar^2 : ar :: ar : a$,

then $\dfrac{ar^3}{a} = r^3 =$ the cube of $\dfrac{ar^3}{ar^2} = r$.

Or, let ar^5, ar^4, ar^3, ar^2, ar, a, be six magnitudes in proportion, that is

$ar^5 : ar^4 :: ar^4 : ar^3 :: ar^3 : ar^2 :: ar^2 : ar :: ar : a$,

then the ratio $\dfrac{ar^5}{a} = r^5 =$ the fifth power of $\dfrac{ar^5}{ar^4} = r$.

Or, let a, ar, ar^2, ar^3, ar^4, be five magnitudes in continued proportion; then $\dfrac{a}{ar^4} = \dfrac{1}{r^4} =$ the fourth power of $\dfrac{a}{ar} = \dfrac{1}{r}$.

DEFINITION A.

To know a compound ratio :—

When there are any number of magnitudes of the same kind, the first is said to have to the last of them the ratio compounded of the ratio which the first has to the second, and of the ratio which the second has to the third, and of the ratio which the third has to the fourth; and so on, unto the last magnitude.

For example, if A, B, C, D, be four magnitudes of the same kind, the first A is said to have to the last D the ratio compounded of the ratio of A to B, and of the ratio of B to C, and of the ratio of C to D ; or, the ratio of

A to D is said to be compounded of the ratios of A to B, B to C, and C to D.

And if A has to B the same ratio which E has to F, and B to C the same ratio that G has to H, and C to D the same that K has to L; then by this definition, A is said to have to D the ratio compounded of ratios which are the same with the ratios of E to F, G to H, and K to L. And the same thing is to be understood when it is more briefly expressed by saying, A has to D the ratio compounded of the ratios of E to F, G to H, and K to L.

In like manner, the same things being supposed; if M has to N the same ratio which A has to D, then for shortness sake, M is said to have to N the ratio compounded of the ratios of E to F, G to H, and K to L.

This definition may be better understood from an arithmetical or algebraical illustration; for, in fact, a ratio compounded of several other ratios, is nothing more than a ratio which has for its antecedent the continued product of all the antecedents of the ratios compounded, and for its consequent the continued product of all the consequents of the ratios compounded.

Thus, the ratio compounded of the ratios of
$$2:3,\ 4:7,\ 6:11,\ 2:5,$$
is the ratio of $2 \times 4 \times 6 \times 2 : 3 \times 7 \times 11 \times 5$,
or the ratio of $96 : 1155$, or $32 : 385$.

And of the magnitudes A, B, C, D, E, F, of the same kind, A : F is the ratio compounded of the ratios of
$$A:B,\ B:C,\ C:D,\ D:E,\ E:F;$$
for $A \times B \times C \times D \times E : B \times C \times D \times E \times F$,
or $\frac{A \times B \times C \times D \times E}{B \times C \times D \times E \times F} = \frac{A}{F}$, or the ratio of A : F.

BOOK V. PROP. F. THEOR.

ATIOS *which are compounded of the same ratios are the same to one another.*

Let A : B :: F : G,
B : C :: G : H,
C : D :: H : K,
and D : E :: K : L.

Then the ratio which is compounded of the ratios of A : B, B : C, C : D, D : E, or the ratio of A : E, is the same as the ratio compounded of the ratios of F : G, G : H, H : K, K : L, or the ratio of F : L.

For $\dfrac{A}{B} = \dfrac{F}{G}$,

$\dfrac{B}{C} = \dfrac{G}{H}$,

$\dfrac{C}{D} = \dfrac{H}{K}$,

and $\dfrac{D}{E} = \dfrac{K}{L}$;

$\therefore \dfrac{A \times B \times C \times D}{B \times C \times D \times E} = \dfrac{F \times G \times H \times K}{G \times H \times K \times L}$,

and $\therefore \dfrac{A}{E} = \dfrac{F}{L}$,

or the ratio of A : E is the same as the ratio of F : L.

The same may be demonstrated of any number of ratios so circumstanced.

Next, let A : B :: K : L,
B : C :: H : K,
C : D :: G : H,
D : E :: F : G.

Then the ratio which is compounded of the ratios of A : B, B : C, C : D, D : E, or the ratio of A : E, is the same as the ratio compounded of the ratios of K : L, H : K, G : H, F : G, or the ratio of F : L.

For $\dfrac{A}{B} = \dfrac{K}{L}$,

$\dfrac{B}{C} = \dfrac{H}{K}$,

$\dfrac{C}{D} = \dfrac{G}{H}$,

and $\dfrac{D}{E} = \dfrac{F}{G}$;

$\therefore \dfrac{A \times B \times C \times D}{B \times C \times D \times E} = \dfrac{K \times H \times G \times F}{L \times K \times H \times G}$,

and $\therefore \dfrac{A}{E} = \dfrac{F}{L}$,

or the ratio of A : E is the same as the ratio of F : L.

∴ Ratios which are compounded, &c.

BOOK V. PROP. G. THEOR.

F several ratios be the same to several ratios, each to each, the ratio which is compounded of ratios which are the same to the first ratios, each to each, shall be the same to the ratio compounded of ratios which are the same to the other ratios, each to each.

$$
\begin{array}{|ccccccc|}
\hline
A & B & C & D & E & F & G & H \quad\quad P \; Q \; R \; S \; T \\
a & b & c & d & e & f & g & h \quad\quad V \; W \; X \; Y \; Z \\
\hline
\end{array}
$$

If $A:B :: a:b$ and $A:B :: P:Q$ $a:b :: V:W$
$C:D :: c:d$ $C:D :: Q:R$ $c:d :: W:X$
$E:F :: e:f$ $E:F :: R:S$ $e:f :: X:Y$
and $G:H :: g:h$ $G:H :: S:T$ $g:h :: Y:Z$

then $P:T = V:Z$.

For $\dfrac{P}{Q} = \dfrac{A}{B} = \dfrac{a}{b} = \dfrac{V}{W}$,

$\dfrac{Q}{R} = \dfrac{C}{D} = \dfrac{c}{d} = \dfrac{W}{X}$,

$\dfrac{R}{S} = \dfrac{E}{F} = \dfrac{e}{f} = \dfrac{X}{Y}$,

$\dfrac{S}{T} = \dfrac{G}{H} = \dfrac{g}{h} = \dfrac{Y}{Z}$;

and $\therefore \dfrac{P \times Q \times R \times S}{Q \times R \times S \times T} = \dfrac{V \times W \times X \times Y}{W \times X \times Y \times Z}$,

and $\therefore \dfrac{P}{T} = \dfrac{V}{Z}$,

or $P:T = V:Z$.

∴ If several ratios, &c.

BOOK V. PROP. H. THEOR.

F a ratio which is compounded of several ratios be the same to a ratio which is compounded of several other ratios; and if one of the first ratios, or the ratio which is compounded of several of them, be the same to one of the last ratios, or to the ratio which is compounded of several of them; then the remaining ratio of the first, or, if there be more than one, the ratio compounded of the remaining ratios, shall be the same to the remaining ratio of the last, or, if there be more than one, to the ratio compounded of these remaining ratios.

$$\boxed{\begin{array}{c} A\ B\ C\ D\ E\ F\ G\ H \\ P\ Q\ R\ S\ T\ X \end{array}}$$

Let $A:B$, $B:C$, $C:D$, $D:E$, $E:F$, $F:G$, $G:H$, be the first ratios, and $P:Q$, $Q:R$, $R:S$, $S:T$, $T:X$, the other ratios; also, let $A:H$, which is compounded of the first ratios, be the same as the ratio of $P:X$, which is the ratio compounded of the other ratios; and, let the ratio of $A:E$, which is compounded of the ratios of $A:B$, $B:C$, $C:D$, $D:E$, be the same as the ratio of $P:R$, which is compounded of the ratios $P:Q$, $Q:R$.

Then the ratio which is compounded of the remaining first ratios, that is, the ratio compounded of the ratios $E:F$, $F:G$, $G:H$, that is, the ratio of $E:H$, shall be the same as the ratio of $R:X$, which is compounded of the ratios of $R:S$, $S:T$, $T:X$, the remaining other ratios.

BOOK V. PROP. H. THEOR.

Because $\dfrac{A \times B \times C \times D \times E \times F \times G}{B \times C \times D \times E \times F \times G \times H} = \dfrac{P \times Q \times R \times S \times T}{Q \times R \times S \times T \times X}$,

or $\dfrac{A \times B \times C \times D}{B \times C \times D \times E} \times \dfrac{E \times F \times G}{F \times G \times H} = \dfrac{P \times Q}{Q \times R} \times \dfrac{R \times S \times T}{S \times T \times X}$,

and $\dfrac{A \times B \times C \times D}{B \times C \times D \times E} = \dfrac{P \times Q}{Q \times R}$,

$\therefore \dfrac{E \times F \times G}{F \times G \times H} = \dfrac{R \times S \times T}{S \times T \times X}$,

$\therefore \dfrac{E}{H} = \dfrac{R}{X}$,

$\therefore E : H = R : X.$

\therefore If a ratio which, &c.

BOOK V. PROP. K. THEOR.

F there be any number of ratios, and any number of other ratios, such that the ratio which is compounded of ratios, which are the same to the first ratios, each to each, is the same to the ratio which is compounded of ratios, which are the same, each to each, to the last ratios—and if one of the first ratios, or the ratio which is compounded of ratios, which are the same to several of the first ratios, each to each, be the same to one of the last ratios, or to the ratio which is compounded of ratios, which are the same, each to each, to several of the last ratios—then the remaining ratio of the first; or, if there be more than one, the ratio which is compounded of ratios, which are the same, each to each, to the remaining ratios of the first, shall be the same to the remaining ratio of the last; or, if there be more than one, to the ratio which is compounded of ratios, which are the same, each to each, to these remaining ratios.

$$
\begin{array}{c}
h\ k\ m\ n\ s \\
A\,B,\ C\,D,\ E\,F,\ G\,H,\ K\,L,\ M\,N,\quad a\ b\ c\ d\ e\ f\ g \\
O\,P,\ Q\,R,\ S\,T,\ V\,W,\ X\,Y,\quad h\ k\ l\ m\ n\ p \\
a\ b\ c\ d\quad e\quad f\ g
\end{array}
$$

Let $A:B$, $C:D$, $E:F$, $G:H$, $K:L$, $M:N$, be the first ratios, and $O:P$, $Q:R$, $S:T$, $V:W$, $X:Y$, the other ratios;

and let $A:B = a:b$,
$C:D = b:c$,
$E:F = c:d$,
$G:H = d:e$,
$K:L = e:f$,
$M:N = f:g$.

BOOK V. PROP. K. THEOR.

Then, by the definition of a compound ratio, the ratio of $a:g$ is compounded of the ratios of $a:b, b:c, c:d, d:e, e:f, f:g$, which are the same as the ratio of $A:B, C:D, E:F, G:H, K:L, M:N$, each to each.

Also, $O:P = h:k,$
$Q:R = k:l,$
$S:T = l:m,$
$V:W = m:n,$
$X:Y = n:p.$

Then will the ratio of $h:p$ be the ratio compounded of the ratios of $h:k, k:l, l:m, m:n, n:p$, which are the same as the ratios of $O:P, Q:R, S:T, V:W, X:Y$, each to each.

∴ by the hypothesis $a:g = h:p$.

Also, let the ratio which is compounded of the ratios of $A:B, C:D$, two of the first ratios (or the ratios of $a:c$, for $A:B = a:b$, and $C:D = b:c$), be the same as the ratio of $a:d$, which is compounded of the ratios of $a:b$, $b:c, c:d$, which are the same as the ratios of $O:P$, $Q:R, S:T$, three of the other ratios.

And let the ratios of $h:s$, which is compounded of the ratios of $h:k, k:m, m:n, n:s$, which are the same as the remaining first ratios, namely, $E:F, G:H, K:L$, $M:N$; also, let the ratio of $e:g$, be that which is compounded of the ratios $e:f, f:g$, which are the same, each to each, to the remaining other ratios, namely, $V:W$, $X:Y$. Then the ratio of $h:s$ shall be the same as the ratio of $e:g$; or $h:s = e:g$.

For $\dfrac{A \times C \times E \times G \times K \times M}{B \times D \times F \times H \times L \times N} = \dfrac{a \times b \times c \times d \times e \times f}{b \times c \times d \times e \times f \times g}$,

E E

210 BOOK V. PROP. K. THEOR.

and $\frac{O \times Q \times S \times V \times X}{P \times R \times T \times W \times Y} = \frac{h \times k \times l \times m \times n}{k \times l \times m \times n \times p}$,

by the composition of the ratios;

$\therefore \frac{a \times b \times c \times d \times e \times f}{b \times c \times d \times e \times f \times g} = \frac{h \times k \times l \times m \times n}{k \times l \times m \times n \times p}$ (hyp.),

or $\frac{a \times b}{b \times c} \times \frac{c \times d \times e \times f}{d \times e \times f \times g} = \frac{h \times k \times l}{k \times l \times m} \times \frac{m \times n}{n \times p}$,

but $\frac{a \times b}{b \times c} = \frac{A \times C}{B \times D} = \frac{O \times Q \times S}{P \times R \times T} = \frac{a \times b \times c}{b \times c \times d} = \frac{h \times k \times l}{k \times l \times m}$;

$\therefore \frac{c \times d \times e \times f}{d \times e \times f \times g} = \frac{m \times n}{n \times p}$.

And $\frac{c \times d \times e \times f}{d \times e \times f \times g} = \frac{h \times k \times m \times n}{k \times m \times n \times s}$ (hyp.),

and $\frac{m \times n}{n \times p} = \frac{e \times f}{f \times g}$ (hyp.),

$\therefore \frac{h \times k \times m \times n}{k \times m \times n \times s} = \frac{ef}{fg}$,

$\therefore \frac{h}{s} = \frac{e}{g}$,

$\therefore h : s = e : g$.

\therefore If there be any number, &c.

* Algebraical and Arithmetical expositions of the Fifth Book of Euclid are given in Byrne's Doctrine of Proportion; published by WILLIAMS and Co. London. 1841.

BOOK VI.
DEFINITIONS.

I.

ECTILINEAR figures are said to be similar, when they have their several angles equal, each to each, and the sides about the equal angles proportional.

II.

Two sides of one figure are said to be reciprocally proportional to two sides of another figure when one of the sides of the first is to the second, as the remaining side of the second is to the remaining side of the first.

III.

A straight line is said to be cut in extreme and mean ratio, when the whole is to the greater segment, as the greater segment is to the less.

IV.

The altitude of any figure is the straight line drawn from its vertex perpendicular to its base, or the base produced.

BOOK VI. PROP. I. THEOR.

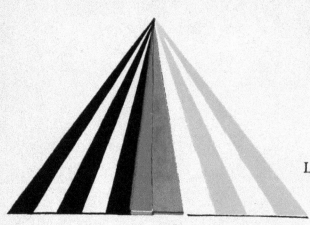

 RIANGLES and parallelograms having the same altitude are to one another as their bases.

Let the triangles ▲ and ▲ have a common vertex, and their bases ▬ and ▬ in the same straight line.

Produce ▬▬ both ways, take successively on ▬ produced lines equal to it; and on ▬ produced lines successively equal to it; and draw lines from the common vertex to their extremities.

The triangles ▲ thus formed are all equal to one another, since their bases are equal. (B. 1. pr. 38.)

∴ ▲ and its base are respectively equimultiples of ▲ and the base ▬.

BOOK VI. PROP. I. THEOR. 23

In like manner ▲ and its base are respectively equimultiples of ▲ and the base ——.

∴ If m or 6 times ▲ ⊏=⊐ or n or 5 times ▲ then m or 6 times —— ⊏=⊐ or n or 5 times ——, m and n stand for every multiple taken as in the fifth definition of the Fifth Book. Although we have only shown that this property exists when m equal 6, and n equal 5, yet it is evident that the property holds good for every multiple value that may be given to m, and to n.

∴ ▲ : ▲ :: —— : —— (B. 5. def. 5.)

Parallelograms having the same altitude are the doubles of the triangles, on their bases, and are proportional to them (Part 1), and hence their doubles, the parallelograms, are as their bases. (B. 5. pr. 15.)

Q. E. D.

BOOK VI. PROP. II. THEOR.

F a straight line ▬▬ be drawn parallel to any side ▪▪▪▪▪▪▪▪ of a triangle, it shall cut the other sides, or those sides produced, into proportional segments.

And if any straight line ▬▬ divide the sides of a triangle, or those sides produced, into proportional segments, it is parallel to the remaining side ▪▪▪▪▪▪▪▪.

PART I.

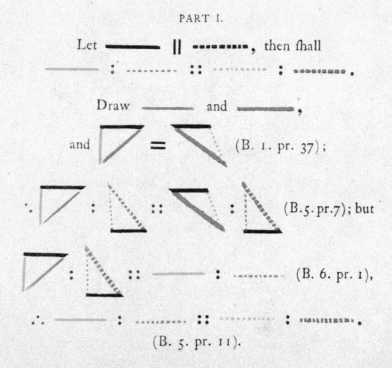

(B. 5. pr. 11).

BOOK VI. PROP. II. THEOR. 215

PART II.

Let —— : ······ :: ——— : ·······.
then —— ∥ ········.

Let the same construction remain,

because —— : ······ :: ◿ : ◿ ⎫
⎬ (B. 6. pr. 1);
and ······ : ······ :: ◸ : ◿ ⎭

but —— : ······ :: ——— : ······ (hyp.),

∴ ◿ : ◸ :: ◸ : ◿ (B. 5. pr. 11.)

∴ ◿ = ◸ (B. 5. pr. 9);

but they are on the same base ········, and at the same side of it, and

∴ —— ∥ ········ (B. 1. pr. 39).

Q. E. D.

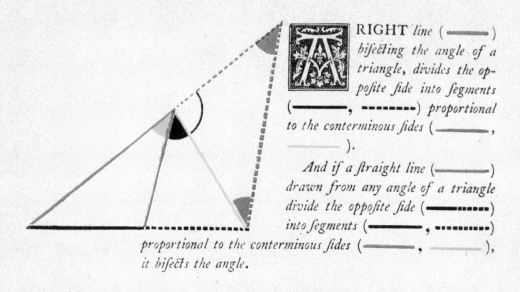

A RIGHT line (———) bisecting the angle of a triangle, divides the opposite side into segments (———, ------) proportional to the conterminous sides (———, ———).

And if a straight line (———) drawn from any angle of a triangle divide the opposite side (———-----) into segments (———, ----------) proportional to the conterminous sides (———, ———), it bisects the angle.

PART I.

Draw ---------- ∥ ———, to meet ----------;

then, ◢ = ◣ (B. 1. pr. 29);

∴ ◢ = ◣ ; but ◢ = ◣, ∴ ◢ = ◣,

∴ ---------- = ——— (B. 1. pr. 6);

and because ——— ∥ ----------,

---------- : ——— :: ---------- : ———
(B. 6. pr. 2);

but ---------- = ———;

∴ ——— : ——— :: ---------- : ———
(B. 5. pr. 7).

BOOK VI. PROP. III. THEOR.

PART II.

Let the same construction remain,

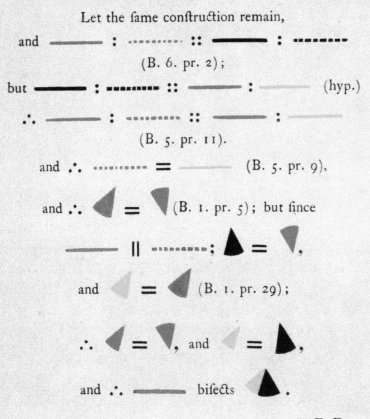

Q. E. D.

BOOK VI. PROP. IV. THEOR.

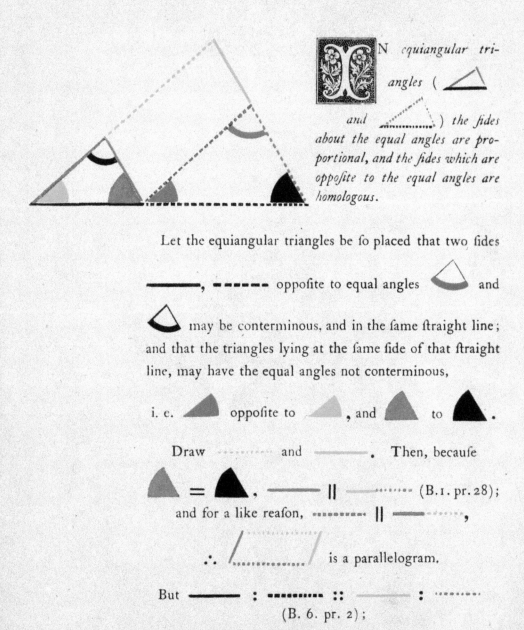

IN equiangular triangles (▲ and ▲) the sides about the equal angles are proportional, and the sides which are opposite to the equal angles are homologous.

Let the equiangular triangles be so placed that two sides ———, ------- opposite to equal angles ◠ and ◠ may be conterminous, and in the same straight line; and that the triangles lying at the same side of that straight line, may have the equal angles not conterminous, i. e. ▲ opposite to ▲, and ▲ to ▲.

Draw ------- and ———. Then, because ▲ = ▲, ——— ‖ ------- (B. 1. pr. 28); and for a like reason, ------- ‖ ———,

∴ ⬜ is a parallelogram.

But ——— : ------- ∷ ——— : -------
(B. 6. pr. 2);

BOOK VI. PROP. IV. THEOR. 219

and since ─── = ─── (B. 1. pr. 34),
─── : ········ :: ─── : ········ ; and by alternation, ─── : ─── :: ········ : ········ (B. 5. pr. 16).

In like manner it may be shown, that
─── : ········ :: ─── : ········ ;
and by alternation, that
─── : ─── :: ········ : ········ ;
but it has been already proved that
─── : ─── :: ········ : ········ ,
and therefore, ex æquali,
─── : ─── :: ········ : ········
(B. 5. pr. 22),
therefore the sides about the equal angles are proportional, and those which are opposite to the equal angles are homologous.

Q. E. D.

BOOK VI. PROP. V. THEOR.

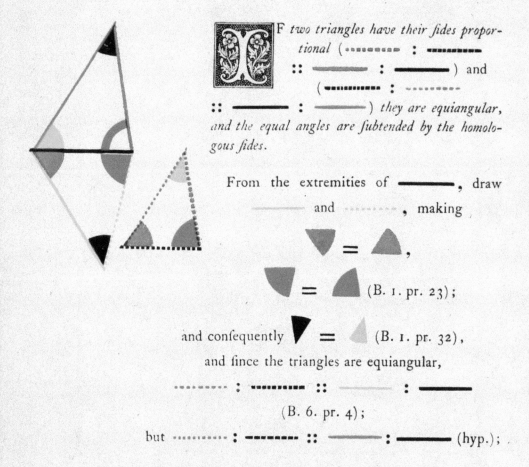

IF *two triangles have their sides proportional* (▬▬▬ : ▬▬▬ :: ▬▬▬ : ▬▬▬) *and* (▬▬▬ : ▬▬▬ :: ▬▬▬ : ▬▬▬) *they are equiangular, and the equal angles are subtended by the homologous sides.*

From the extremities of ▬▬▬, draw ▬▬▬ and ▬▬▬, making

▼ = ▲,

▼ = ▲ (B. 1. pr. 23);

and consequently ▼ = ▲ (B. 1. pr. 32),

and since the triangles are equiangular,

▬▬▬ : ▬▬▬ :: ▬▬▬ : ▬▬▬

(B. 6. pr. 4);

but ▬▬▬ : ▬▬▬ :: ▬▬▬ : ▬▬▬ (hyp.);

∴ ▬▬▬ : ▬▬▬ :: ▬▬▬ : ▬▬▬,

and consequently ▬▬▬ = ▬▬▬ (B. 5. pr. 9).

In the like manner it may be shown that

▬▬▬ = ▬▬▬ .

BOOK VI. PROP. V. THEOR. 221

Therefore, the two triangles having a common base ———, and their sides equal, have also equal angles opposite to equal sides, i. e.

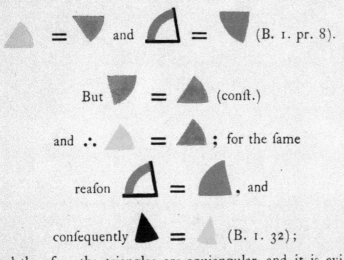 (B. 1. pr. 8).

and therefore the triangles are equiangular, and it is evident that the homologous sides subtend the equal angles.

Q. E. D.

BOOK VI. PROP. VI. THEOR.

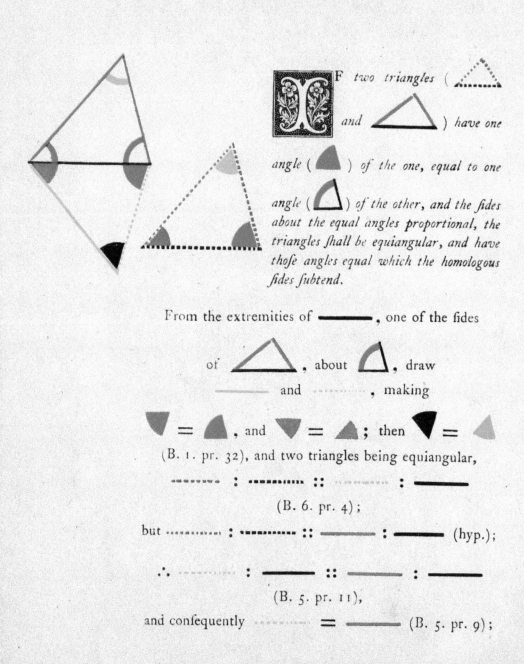

IF two triangles (▵ and ▵) have one angle (◣) of the one, equal to one angle (◿) of the other, and the sides about the equal angles proportional, the triangles shall be equiangular, and have those angles equal which the homologous sides subtend.

From the extremities of ———, one of the sides of ▵, about ◿, draw ——— and ········, making

▼ = ▲, and ▼ = ▲; then ▼ = ▲

(B. 1. pr. 32), and two triangles being equiangular,

········ : ········ :: ········ : ———

(B. 6. pr. 4);

but ········ : ········ :: ——— : ——— (hyp.);

∴ ········ : ——— :: ——— : ———

(B. 5. pr. 11),

and consequently ········ = ——— (B. 5. pr. 9);

BOOK VI. PROP. VI. THEOR. 223

∴ △ = ▽ in every respect.
(B. 1. pr. 4).

But ▼ = ▲ (const.),

and ∴ △ = ▲ ; and

since also ◁ = ◂ .

△ = ◂ (B. 1. pr. 32);

and ∴ △ and △ are equiangular, with their equal angles opposite to homologous sides.

Q. E. D.

BOOK VI. PROP. VII. THEOR.

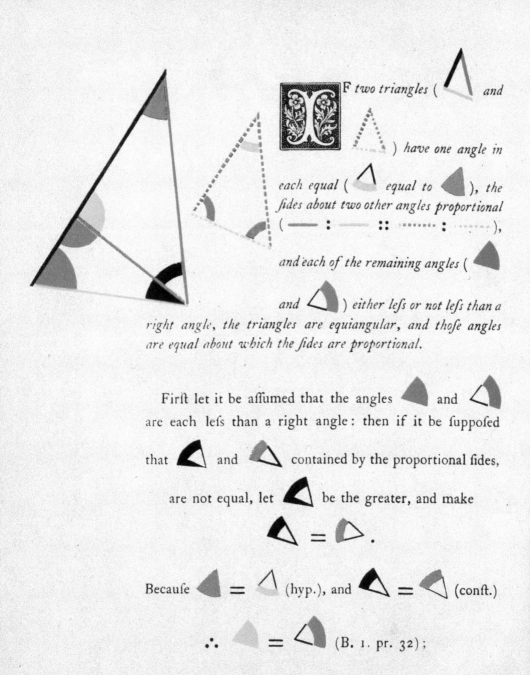

IF two triangles (▲ and ▲) have one angle in each equal (△ equal to ◢), the sides about two other angles proportional (—— : ⋯⋯ :: ⋯⋯ : ⋯⋯), and each of the remaining angles (◢ and △) either less or not less than a right angle, the triangles are equiangular, and those angles are equal about which the sides are proportional.

First let it be assumed that the angles ◢ and △ are each less than a right angle: then if it be supposed that ◢ and △ contained by the proportional sides, are not equal, let ◢ be the greater, and make

◢ = ◢.

Because ◢ = △ (hyp.), and ◢ = ◁ (const.)

∴ ◢ = △ (B. 1. pr. 32);

BOOK VI. PROP. VII. THEOR. 225

∴ —— : —— :: ······· : ······· (B. 6. pr. 4),

but —— : —— :: ······· : ······· (hyp.)

∴ —— : —— :: —— : —— ;

∴ —— = —— (B. 5. pr. 9),

and ∴ ▲ = ▲ (B. 1. pr. 5).

But ▲ is less than a right angle (hyp.)

∴ ▲ is less than a right angle; and ∴ ▲ must be greater than a right angle (B. 1. pr. 13), but it has been proved = △ and therefore less than a right angle, which is absurd. ∴ ◁ and ◁ are not unequal;

∴ they are equal, and since ◁ = △ (hyp.)

∴ ◁ = △ (B. 1. pr. 32), and therefore the triangles are equiangular.

But if ▲ and ◁ be assumed to be each not less than a right angle, it may be proved as before, that the triangles are equiangular, and have the sides about the equal angles proportional. (B. 6. pr. 4).

Q. E. D.

BOOK VI. PROP. VIII. THEOR.

I N a right angled triangle (), if a perpendicular (——) be drawn from the right angle to the opposite side, the triangles (,) on each side of it are similar to the whole triangle and to each other.

Because = (B. 1. ax. 11), and

common to and ;

= (B. 1. pr. 32);

∴ and are equiangular; and consequently have their sides about the equal angles proportional (B. 6. pr. 4), and are therefore similar (B. 6. def. 1).

In like manner it may be proved that is similar to ; but has been shewn to be similar to ; ∴ and are similar to the whole and to each other.

Q. E. D.

BOOK VI. PROP. IX. PROB.

FROM *a given straight line* (━ ┄) *to cut off any required part.*

From either extremity of the given line draw ━━┄┄ making any angle with ━┄ ; and produce ┄━ till the whole produced line ━━▬ contains ━━ as often as ━┄ contains the required part.

Draw ━━, and draw ┄┄ ∥ ━.

━ is the required part of ━ ┄.

For since ┄ ∥ ━

━ : ┄ :: ━ : ┄

(B. 6. pr. 2), and by composition (B. 5. pr. 18);

━ : ━ :: ┄ : ━ ;

but ━━ contains ━━ as often as ━┄ contains the required part (const.);

∴ ━ is the required part.

Q. E. D.

BOOK VI. PROP. X. PROB.

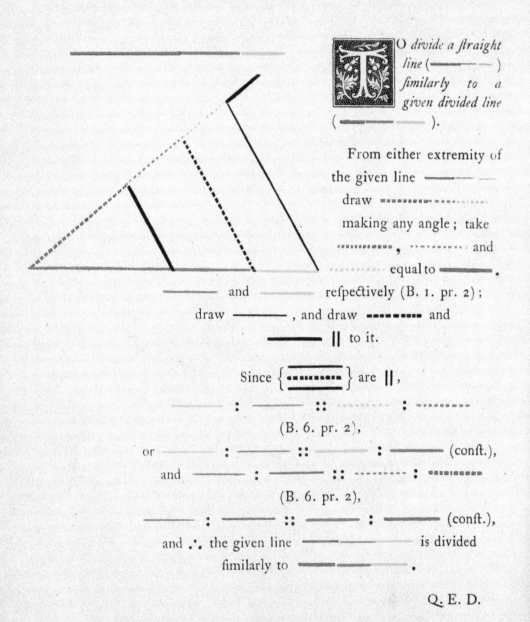

To divide a straight line (———— ————) similarly to a given divided line (———— ————).

From either extremity of the given line ———— ———— draw ·········· ·········· making any angle; take ·········· , ·········· and ·········· equal to ————, ———— and ———— respectively (B. 1. pr. 2); draw ————, and draw ········· and ———— ∥ to it.

Since { ========== } are ∥,

———— : ———— :: ·········· : ··········
(B. 6. pr. 2),
or ———— : ———— :: ———— : ———— (conft.),
and ———— : ———— :: ········ : ········
(B. 6. pr. 2),
———— : ———— :: ———— : ———— (conft.),
and ∴ the given line ———— ———— is divided fimilarly to ———— ————.

Q. E. D.

BOOK VI. PROP. XI. PROB.

TO *find a third proportional to two given straight lines* (——— *and* ———).

At either extremity of the given line ——— draw ------ making an angle; take ······· = ———, and draw ———;

make ········· = ———, and draw ········· ∥ ———; (B. 1. pr. 31.)

——— is the third proportional to ——— and ———.

For since ——— ∥ ·········,

∴ ——— : ········ :: ········ : ———
(B. 6 pr. 2);

but ········ = ········ = ——— (conſt.);

∴ ——— : ——— :: ——— : ———.
(B. 5. pr. 7).

Q. E. D.

BOOK VI. PROP. XII. PROB.

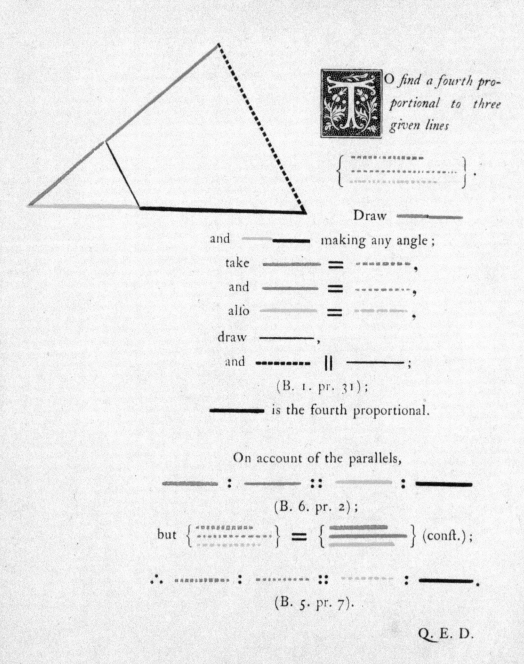

To find a fourth proportional to three given lines

{ ▃▃▃▃ }.

Draw ▃▃▃
and ▃▃▃ making any angle;
take ▃▃▃ = ▃▃▃,
and ▃▃▃ = ▃▃▃,
also ▃▃▃ = ▃▃▃,
draw ▃▃▃,
and ▃▃▃ ∥ ▃▃▃;
(B. 1. pr. 31);
▃▃▃ is the fourth proportional.

On account of the parallels,

▃▃▃ : ▃▃▃ :: ▃▃▃ : ▃▃▃

(B. 6. pr. 2);

but { ▃▃▃ } = { ▃▃▃ } (conſt.);

∴ ▃▃▃ : ▃▃▃ :: ▃▃▃ : ▃▃▃.

(B. 5. pr. 7).

Q. E. D.

BOOK VI. PROP. XIII. PROB.

TO find a mean proportional between two given straight lines { ▭▭ }.

Draw any straight line ▬▬,
make ▬▬ = ▭▭,
and ▬▬ = ▭▭; bisect ▬▬:
and from the point of bisection as a centre, and half the line as a radius, describe a semicircle ◠.

draw ▬▬ ⊥ ▬▬:

▬▬ is the mean proportional required.

Draw ▬▬ and ▭▭.

Since ◢ is a right angle (B. 3. pr. 31),
and ▬▬ is ⊥ from it upon the opposite side,
∴ ▬▬ is a mean proportional between ▬▬ and ▬▬ (B. 6. pr. 8),
and ∴ between ▭▭ and ▭▭ (const.).

Q. E. D

BOOK VI. PROP. XIV. THEOR.

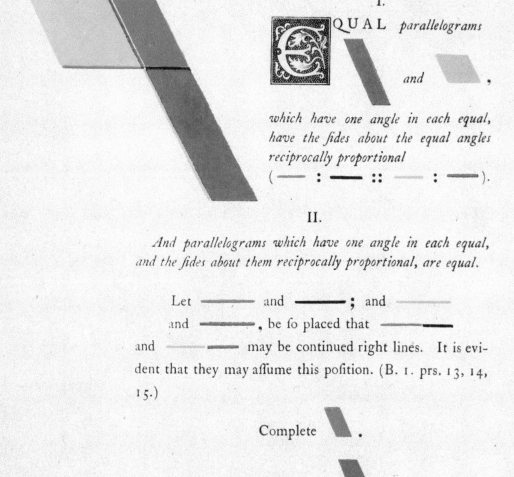

I.

EQUAL *parallelograms* ▰ and ▰, which have one angle in each equal, have the sides about the equal angles reciprocally proportional (── : ── :: ── : ──).

II.

And parallelograms which have one angle in each equal, and the sides about them reciprocally proportional, are equal.

Let ── and ──; and ── and ──, be so placed that ── and ── may be continued right lines. It is evident that they may assume this position. (B. 1. prs. 13, 14, 15.)

Complete ▰.

Since ▰ = ▰;

∴ ▰ : ▰ :: ▰ : ▰ (B. 5. pr. 7.)

BOOK VI. PROP. XIV. THEOR. 233

∴ ▬▬ : ▬▬ :: ▬▬ : ▬▬
(B. 6. pr. 1.)

The same construction remaining:

▬▬ : ▬▬ :: { ▭ : ▰ (B. 6. pr. 1.)
 ▬ : ▬ (hyp.)
 ▰ : ▰ (B. 6. pr. 1.) }

∴ ▭ : ▰ :: ▰ : ▰ (B. 5. pr. 11.)

and ∴ ▭ = ▰ (B. 5. pr. 9).

Q. E. D.

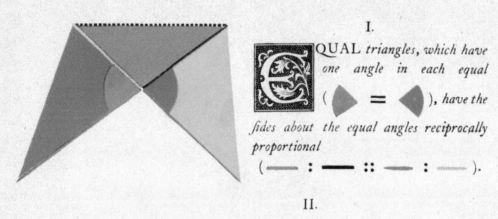

I.

EQUAL *triangles, which have one angle in each equal* (▶ = ◀), *have the sides about the equal angles reciprocally proportional*
(—— : — :: — : ——).

II.

And two triangles which have an angle of the one equal to an angle of the other, and the sides about the equal angles reciprocally proportional, are equal.

I.

Let the triangles be so placed that the equal angles ▶ and ◀ may be vertically opposite, that is to say, so that ——— and ——— may be in the same straight line. Whence also ——— and ——— must be in the same straight line. (B. 1. pr. 14.)

Draw, then

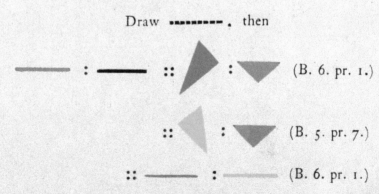

—— : — :: ▲ : ▼ (B. 6. pr. 1.)

:: ◀ : ▼ (B. 5. pr. 7.)

:: —— : —— (B. 6. pr. 1.)

BOOK VI. PROP. XV. THEOR.

∴ ▬▬ : ▬▬ :: ▬▬ : ▬▬
(B. 5. pr. 11.)

II.

Let the same construction remain, and

◀ : ▼ :: ▬▬ : ▬▬ (B. 6. pr. 1.)

and ▬▬ : ▬▬ :: ◀ : ▼ (B. 6. pr. 1.)

But ▬▬ : ▬▬ :: ▬▬ : ▬▬ , (hyp.)

∴ ◀ : ▼ :: ◀ : ▼ (B. 5. pr. 11);

∴ ◀ = ◀ (B. 5. pr. 9.)

Q. E. D.

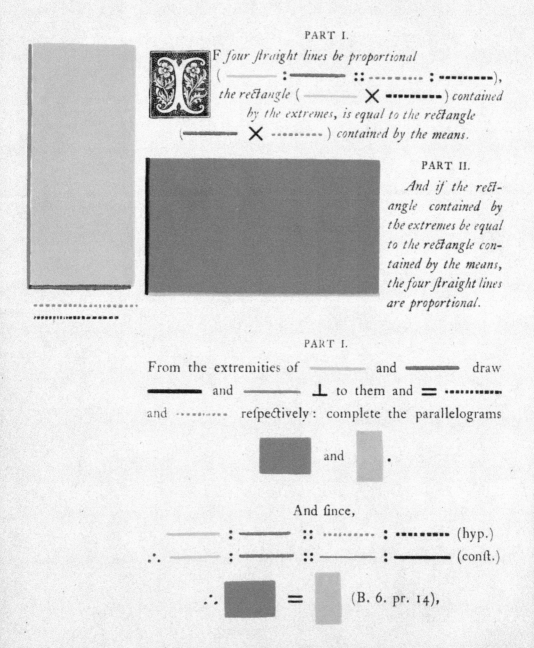

PART I.

IF *four straight lines be proportional* (———— : ———— :: ········· : ··········), *the rectangle* (———— ✕ ··········) *contained by the extremes, is equal to the rectangle* (———— ✕ ··········) *contained by the means.*

PART II.

And if the rectangle contained by the extremes be equal to the rectangle contained by the means, the four straight lines are proportional.

PART I.

From the extremities of ———— and ———— draw ———— and ———— ⊥ to them and = ··········
and ·········· respectively: complete the parallelograms ▬ and ▬.

And since,

———— : ———— :: ·········· : ·········· (hyp.)

∴ ———— : ———— :: ———— : ———— (const.)

∴ ▬ = ▬ (B. 6. pr. 14),

BOOK VI. PROP. XVI. THEOR. 237

that is, the rectangle contained by the extremes, equal to the rectangle contained by the means.

PART II.

Let the same construction remain; because

▪▪▪▪▪▪▪ = ———— , ■ = ▪

and ———— = ▪▪▪▪▪▪ .

∴ ———— : ———— :: ———— : ————

(B. 6. pr. 14).

But ———— = ▪▪▪▪▪▪ ,

and ———— = ▬▬▬▬ (const.)

∴ ———— : ———— :: ▪▪▪▪▪▪ : ▪▪▪▪▪▪

(B. 5. pr. 7).

Q. E. D.

BOOK VI. PROP. XVII. THEOR.

PART I

F three ſtraight lines be proportional (——— : ——— :: ——— : ———) the rectangle under the extremes is equal to the ſquare of the mean.

PART II.

And if the rectangle under the extremes be equal to the ſquare of the mean, the three ſtraight lines are proportional.

PART I.

Aſſume ——— = ———, and
ſince ——— : ——— :: ——— : ———,
then ——— : ——— :: ——— : ———,
∴ ——— × ——— = ——— × ———
(B. 6. pr. 16).

But ——— = ———,
∴ ——— × ——— = ——— × ———,
or = ———2; therefore, if the three ſtraight lines are proportional, the rectangle contained by the extremes is equal to the ſquare of the mean.

PART II.

Aſſume ——— = ———, then
——— × ——— = ——— × ———,
∴ ——— : ——— :: ——— : ———
(B. 6. pr. 16), and
∴ ——— : ——— :: ——— : ———.

Q. E. D.

BOOK VI. PROP. XVIII. THEOR.

N a given straight line (———)
to construct a rectilinear figure
similar to a given one ()
and similarly placed.

Resolve the given figure into triangles by
drawing the lines ──────── and ────────.

At the extremities of ─────── make

▲ = △ and ◗ = ◖ :

again at the extremities of ─────── make ◀ = ◀

and ◀ = ◀ : in like manner make

◣ = ▽ and ▶ = ▶.

Then is similar to .

It is evident from the construction and (B. 1. pr. 32) that
the figures are equiangular; and since the triangles

△ and △ are equiangular; then by (B. 6. pr. 4),

─── : ─── :: ──────── : ───
and ─── : ─── :: ─── : ────────.

BOOK VI. PROP. XVIII. THEOR.

Again, because 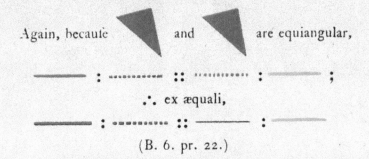 and are equiangular,

────── : ·········· :: ·········· : ────── ;

∴ ex æquali,

────── : ────── :: ────── : ──────

(B. 6. pr. 22.)

In like manner it may be shown that the remaining sides of the two figures are proportional.

∴ by (B. 6. def. 1.)

 is similar to

and similarly situated; and on the given line ──────.

Q. E. D.

BOOK VI. PROP. XIX. THEOR.

SIMILAR *triangles* (▲ and ▲) are to one another in the duplicate ratio of their homologous sides.

Let ▲ and ▲ be equal angles, and ▬▬ and ▬▬ homologous sides of the similar triangles ▲ and ▲ and on ▬▬ the greater of these lines take ▬▬ a third proportional, so that

▬▬ : ▬▬ :: ▬▬ : ▬▬ ;

draw ▬▬.

▬▬ : ▬▬ :: ▬▬ : ▬▬

(B. 6. pr. 4);

∴ ▬▬ : ▬▬ :: ▬▬ : ▬▬

(B. 5. pr. 16, alt.),

but ▬▬ : ▬▬ :: ▬▬ : ▬▬ (const.),

∴ ▬▬ : ▬▬ :: ▬▬ : ▬▬ conse-

242 BOOK VI. PROP. XIX. THEOR.

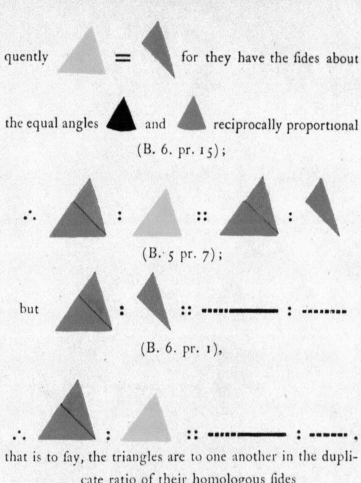

that is to say, the triangles are to one another in the duplicate ratio of their homologous sides ——— and ······——— (B. 5. def. 11).

Q. E. D.

BOOK VI. PROP. XX. THEOR. 243

IMILAR polygons may be divided into the same number of similar triangles, each similar pair of which are proportional to the polygons; and the polygons are to each other in the duplicate ratio of their homologous sides.

Draw ——— and ·········, and ——— and ---------, resolving the polygons into triangles. Then because the polygons are similar,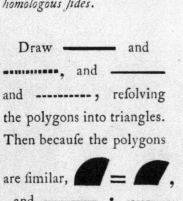

∴ ▲ and ▲ are similar, and ◂ = ◂ (B. 6. pr. 6);

but ◆ = ◆ because they are angles of similar polygons; therefore the remainders ▲ and ▲ are equal; hence ▬▬ : ········ :: --------- : ·········, on account of the similar triangles,

244 BOOK VI. PROP. XX. THEOR.

and ······· : ——— ∷ ········ : ———,

on account of the similar polygons,

∴ ········ : ——— ∷ ········· : ———,

ex æquali (B. 5. pr. 22), and as these proportional sides contain equal angles, the triangles ▲ and ▲ are similar (B. 6. pr. 6).

In like manner it may be shown that the triangles ▼ and ▼ are similar.

But ▲ is to ▲ in the duplicate ratio of ········· to ·········· (B. 6. pr. 19), and ▲ is to ▲ in like manner, in the duplicate ratio of ········· to ··········;

∴ ▲ : ▲ ∷ ▲ : ▲,

(B. 5. pr. 11);

Again ▲ is to ▲ in the duplicate ratio of ——— to ———, and ▼ is to ▼ in

BOOK VI. PROP. XX. THEOR. 245

the duplicate ratio of ▬▬▬ to ▬▬▬.

and as one of the antecedents is to one of the confequents, fo is the fum of all the antecedents to the fum of all the confequents; that is to fay, the fimilar triangles have to one another the fame ratio as the polygons (B. 5. pr. 12).

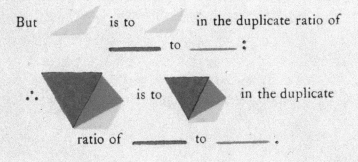

Q. E. D

RECTILINEAR figures (▲ and ▲) which are similar to the same figure () are similar also to each other.

Since ▲ and ▲ are similar, they are equiangular, and have the sides about the equal angles proportional (B. 6. def. 1); and since the figures ▲ and ▲ are also similar, they are equiangular, and have the sides about the equal angles proportional; therefore ▲ and ▲ are also equiangular, and have the sides about the equal angles proportional (B. 5. pr. 11), and are therefore similar.

<div align="right">Q. E. D.</div>

BOOK VI. PROP. XXII. THEOR.

PART I.

IF *four straight lines be proportional* (━━ : ━━ :: ━━ : ━━), *the similar rectilinear figures similarly described on them are also proportional.*

PART II.

And if four similar rectilinear figures, similarly described on four straight lines, be proportional, the straight lines are also proportional.

PART I.

Take ┄┄┄ a third proportional to ━━ and ━━, and ┄┄┄ a third proportional to ━━ and ━━ (B. 6. pr. 11);

since ━━ : ━━ :: ━━ : ━━ (hyp.),

━━ : ┄┄┄ :: ━━ : ┄┄┄ (const.)

∴ ex æquali,

━━ : ┄┄┄ :: ━━ : ┄┄┄ ;

but :: ━━ : ┄┄┄

(B. 6. pr. 20),

and ⬡ : ⬡ :: ━━ : ┄┄┄ ;

BOOK VI. PROP. XXII. THEOR.

∴ ▲ : ▲ :: ⬢ : ⬡

(B. 5. pr. 11).

PART II.

Let the same construction remain:

▲ : ▲ :: ⬢ : ⬡ (hyp.),

∴ ━━ : ┈┈ :: ━━ : ┈┈ (const.)

and ∴ ━━ : ━━ :: ━━ : ━━ .

(B. 5. pr. 11).

Q. E. D.

BOOK VI. PROP. XXIII. THEOR.

EQUIANGULAR *parallel-ograms* (▰ and ▰) *are to one another in a ratio compounded of the ratios of their sides.*

Let two of the sides ──── and ──── about the equal angles be placed so that they may form one straight line.

Since ▼ + ◗ = ◠,

and ◢ = ▼ (hyp.),

◢ + ◗ = ◠,

and ∴ ──── and ──── form one straight line (B. 1. pr. 14);

complete ▰.

Since ▰ : ▰ :: ──── : ──── (B. 6. pr. 1),

and ▰ : ▰ :: ──── : ──── (B. 6. pr. 1),

▰ has to ▰ a ratio compounded of the ratios of ──── to ────, and of ──── to ────.

Q. E. D.

BOOK VI. PROP. XXIV. THEOR.

IN any parallelogram (▱) the parallelograms (▱ and ▱) which are about the diagonal are similar to the whole, and to each other.

As ▱ and ▱ have a common angle they are equiangular; but because ——— ∥ ———

△ and △ are similar (B. 6. pr. 4),

∴ ——— : ——— :: ——— : ———;

and the remaining opposite sides are equal to those,

∴ ▱ and ▱ have the sides about the equal angles proportional, and are therefore similar.

In the same manner it can be demonstrated that the parallelograms ▱ and ▱ are similar.

Since, therefore, each of the parallelograms ▱ and ▱ is similar to ▱, they are similar to each other.

Q. E. D.

BOOK VI. PROP. XXV. PROB.

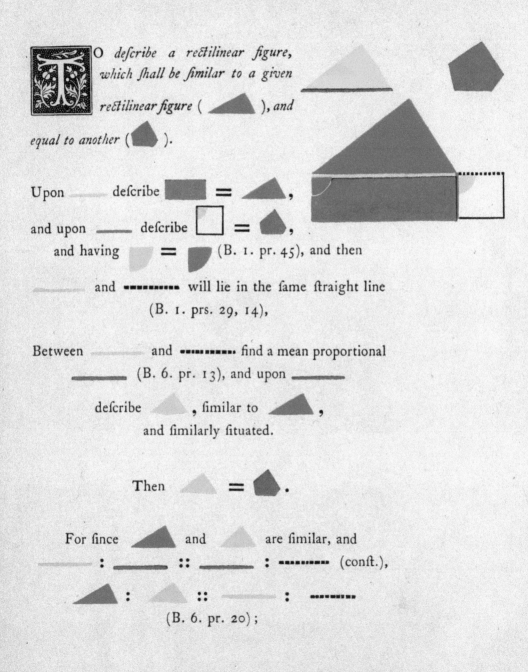

T O describe a rectilinear figure, which shall be similar to a given rectilinear figure (▲), and equal to another (⬟).

Upon ___ describe ▬ = ▲,

and upon ___ describe ☐ = ⬟,

and having ◖ = ◗ (B. 1. pr. 45), and then

___ and ••••••• will lie in the same straight line (B. 1. prs. 29, 14),

Between ___ and ••••••• find a mean proportional ___ (B. 6. pr. 13), and upon ___

describe ▲, similar to ▲, and similarly situated.

Then ▲ = ⬟.

For since ▲ and ▲ are similar, and ___ : ___ :: ___ : ••••••• (const.),

▲ : ▲ :: ___ : ••••••• (B. 6. pr. 20);

but ■ : □ :: —— : ----- (B. 6. pr. 1);

∴ ▲ : ▲ :: ■ : □ (B. 5. pr. 11);

but ▲ = ■ (conft.),

and ∴ ▲ = □ (B. 5. pr. 14);

and □ = ⬠ (conft.); confequently,

▲ which is fimilar to ▲ is alfo = ⬠.

Q. E. D.

BOOK VI. PROP. XXVI. THEOR.

IF *similar and similarly posited parallelograms* (▱ and ▱) *have a common angle, they are about the same diagonal.*

For, if possible, let ⌒ be the diagonal of ▱ and draw ─── ∥ ─── (B. 1. pr. 31).

Since ▱ and ▱ are about the same diagonal ⌒, and have ▱ common, they are similar (B. 6. pr. 24);

∴ ─── : ─── :: ─── : ───
but ─── : ─── :: ─── : ─── (hyp.),

∴ ─── : ─── :: ─── : ───,
and ∴ ─── = ─── (B. 5. pr. 9.),
which is absurd.

∴ ⌒ is not the diagonal of ▱ in the same manner it can be demonstrated that no other line is except ═══.

Q. E. D.

254 BOOK VI. PROP. XXVII. THEOR.

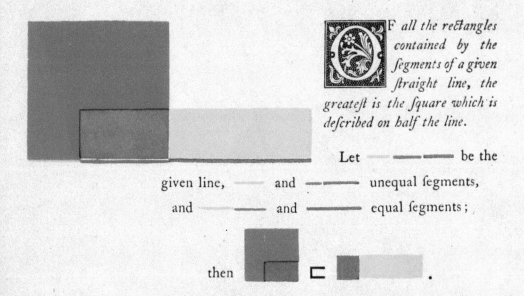

O F all the rectangles contained by the segments of a given straight line, the greatest is the square which is described on half the line.

Let ——— be the given line, — and ——— unequal segments, and — and — equal segments; then ▪ ⊏ ▬ .

For it has been demonstrated already (B. 2. pr. 5), that the square of half the line is equal to the rectangle contained by any unequal segments together with the square of the part intermediate between the middle point and the point of unequal section. The square described on half the line exceeds therefore the rectangle contained by any unequal segments of the line.

Q. E. D.

BOOK VI. PROP. XXVIII. PROB.

O *divide a given straight line* (┄┄━━) *so that the rectangle contained by its segments may be equal to a given area, not exceeding the square of half the line.*

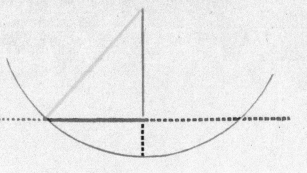

Let the given area be = ┄┄┄┄ ².

Bisect ┄┄━━━, or

make ┄━━ = ┄┄┄┄;

and if ┄━━ ² = ┄┄┄┄ ²,

the problem is solved.

But if ┄┄━━ ² ≠ ┄┄┄┄ ², then

must ┄━━ ⊐ ┄┄┄┄ (hyp.).

Draw ━━ ⊥ ┄━━ = ┄┄┄┄;

make ━━━┄┄ = ┄┄━━ or ┄┄┄┄;

with ━━━┄┄ as radius describe a circle cutting the given line; draw ━━━ .

Then ┄┄ ✕ ━━┄┄ + ━━ ² = ┄━━ ²

(B. 2. pr. 5.) = ━━━ ².

But ━━ ² = ━━ ² + ━━ ²

(B. 1. pr. 47);

BOOK VI. PROP. XXVIII. PROB.

∴ ⸺ × ⸺ + ⸺²
= ⸺² + ⸺²,
from both, take ⸺²,
and ⸺ × ⸺ = ⸺².

But ⸺ = ⸺ (conſt.),
and ∴ ⸺ is ſo divided
that ⸺ × ⸺ = ⸺².

Q. E. D.

BOOK VI. PROP. XXIX. PROB.

O *produce a given straight line* (━━ ┄┄), *so that the rectangle contained by the segments between the extremities of the given line and the point to which it is produced, may be equal to a given area, i. e. equal to the square on* ━━.

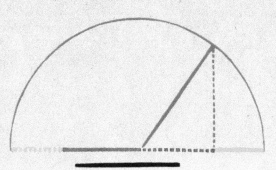

Make ━━ = ┄┄, and
draw ┄┄ ⊥ ┄┄ = ━━;
draw ━━; and
with the radius ━━, describe a circle
meeting ━━ produced.

Then ━━ × ━━ + ┄┄² =
━━² (B. 2. pr. 6.) = ━━².

But ━━² = ┄┄² + ┄┄² (B. 1. pr. 47.)

∴ ━━ × ━━ + ┄┄² =
┄┄² + ┄┄²,
from both take ┄┄²,
and ━━ × ━━ = ┄┄²;
but ┄┄ = ━━,
∴ ┄┄² = the given area.

<div style="text-align:right">Q. E. D.</div>

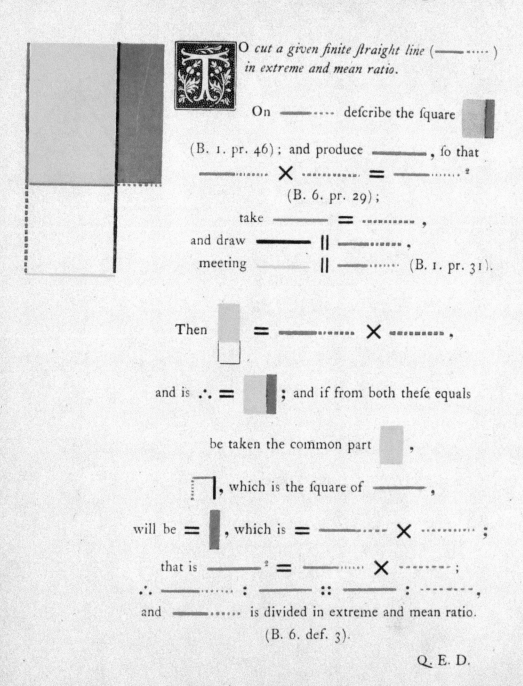

BOOK VI. PROP. XXXI. THEOR.

IF any similar rectilinear figures be similarly described on the sides of a right angled triangle (), the figure described on the side (▬▬▬) subtending the right angle is equal to the sum of the figures on the other sides.

From the right angle draw ▬▬ perpendicular to ▬▬▬;

then ▬▬ : ▬▬ :: ▬▬ : ▬▬
(B. 6. pr. 8).

∴ ▬▬ : ▬▬ :: ▬▬ : ▬▬
(B. 6. pr. 20).

but ▬▬ : ▬▬ :: ▬▬ : ▬▬
(B. 6. pr. 20).

Hence ▬▬ + ▬▬ : ▬▬
:: ▬▬ + ▬▬ : ▬▬ ;

but ▬▬ + ▬▬ = ▬▬ ;

and ∴ ▬▬ + ▬▬ = ▬▬ .

Q. E. D.

BOOK VI. PROP. XXXII. THEOR.

IF two triangles (▲ and ▲), have two sides proportional (—— : —— :: ······ : ········), and be so placed at an angle that the homologous sides are parallel, the remaining sides (—— and ······) form one right line.

Since —— ∥ ········,

▲ = ▼ (B. 1. pr. 29);

and also since —— ∥ ········,

▼ = ▲ (B. 1. pr. 29);

∴ ▲ = ▲ ; and since

—— : —— :: ······ : ······ (hyp.),

the triangles are equiangular (B. 6. pr. 6);

∴ ▲ = △ :

but ▲ = ▼ ;

∴ ▲ + ▼ + △ = ▲ + ▲ + ▲ =

◐ (B. 1. pr. 32), and ∴ —— and ········ lie in the same straight line (B. 1. pr. 14).

Q. E. D.

BOOK VI. PROP. XXXIII. THEOR.

IN equal circles (◯, ◯), angles, whether at the centre or circumference, are in the same ratio to one another as the arcs on which they stand (▲ : ◢ :: — : —); so also are sectors.

Take in the circumference of ◯ any number of arcs —, —, &c. each = —, and also in the circumference of ◯ take any number of arcs ⋯, ⋯, &c. each = ⋯, draw the radii to the extremities of the equal arcs.

Then since the arcs —, —, —, &c. are all equal, the angles ▲, ◢, ◣, &c. are also equal (B. 3. pr. 27);

∴ ▲ is the same multiple of ◢ which the arc ⌣ is of —; and in the same manner ◭ is the same multiple of ◢, which the arc ⋯ is of the arc —.

BOOK VI. PROP. XXXIII. THEOR.

Then it is evident (B. 3. pr. 27),

∴ ◢ : ◢ :: — : —— , (B. 5. def. 5), or the angles at the centre are as the arcs on which they stand; but the angles at the circumference being halves of the angles at the centre (B. 3. pr. 20) are in the same ratio (B. 5. pr. 15), and therefore are as the arcs on which they stand.

It is evident, that sectors in equal circles, and on equal arcs are equal (B. 1. pr. 4; B. 3. prs. 24, 27, and def. 9). Hence, if the sectors be substituted for the angles in the above demonstration, the second part of the proposition will be established, that is, in equal circles the sectors have the same ratio to one another as the arcs on which they stand.

<div style="text-align: right;">Q. E. D.</div>

BOOK VI. PROP. A. THEOR. 263

IF *the right line* (⋯⋯), *bisecting an external angle* ◣ *of the triangle* ◸ *meet the opposite side* (▬▬) *produced, that whole produced side* (▬▬▬), *and its external segment* (⋯⋯) *will be proportional to the sides* (▬▬⋯ *and* ▬▬), *which contain the angle adjacent to the external bisected angle.*

For if ▬▬ be drawn ∥ ⋯⋯,

then ◗ = ◁, (B. 1. pr. 29);

= ◣, (hyp.),

= ◖, (B. 1. pr. 29);

and ∴ ⋯⋯ = ▬▬, (B. 1. pr. 6),

and ▬▬⋯ : ▬▬ :: ▬▬⋯ : ⋯⋯,
(B. 5. pr. 7);

But also,

▬▬⋯ : ⋯⋯ :: ▬▬⋯ : ▬▬⋯.
(B. 6. pr. 2);

and therefore

▬▬⋯ : ▬▬⋯ :: ▬▬⋯ : ▬▬.
(B. 5. pr. 11).

Q. E. D.

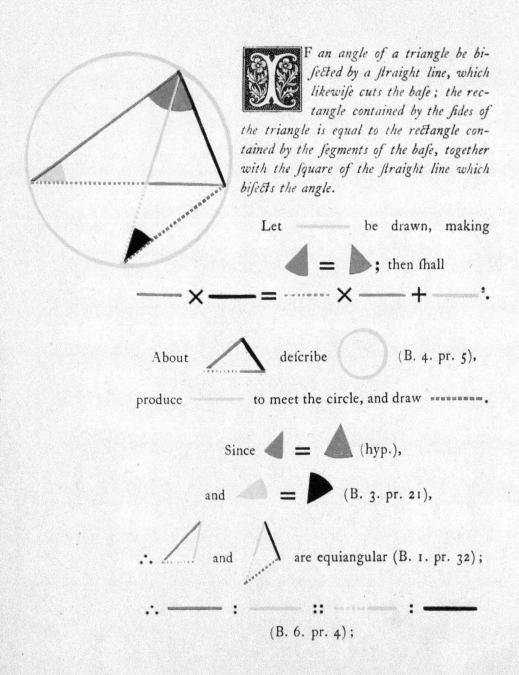

IF an angle of a triangle be bisected by a straight line, which likewise cuts the base; the rectangle contained by the sides of the triangle is equal to the rectangle contained by the segments of the base, together with the square of the straight line which bisects the angle.

Let ———— be drawn, making ◀ = ▶ ; then shall

———— × ———— = ······· × ———— + ————² .

About △ describe ○ (B. 4. pr. 5),

produce ———— to meet the circle, and draw ········· .

Since ◀ = ▲ (hyp.),

and ◁ = ▶ (B. 3. pr. 21),

∴ △ and △ are equiangular (B. 1. pr. 32);

∴ ———— : ———— :: ········ : ————
(B. 6. pr. 4);

BOOK VI. PROP. B. THEOR.

∴ —— × —— = —— × ——
(B. 6. pr. 16.)

= —— × —— + ——.
(B. 2. pr. 3);

but —— × —— = —— × ——
(B. 3. pr. 35);

∴ —— × —— = —— × —— + ——.

Q. E. D.

BOOK VI. PROP. C. THEOR.

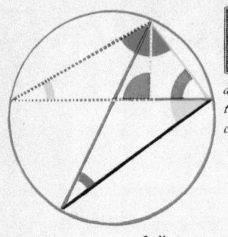

 F *from any angle of a triangle a straight line be drawn perpendicular to the base; the rectangle contained by the sides of the triangle is equal to the rectangle contained by the perpendicular and the diameter of the circle described about the triangle.*

From ⬟ of △
draw ⋯⋯ ⊥ ━━━; then
shall ┄┄ ✕ ━━━ = ⋯⋯ ✕ the
diameter of the described circle.

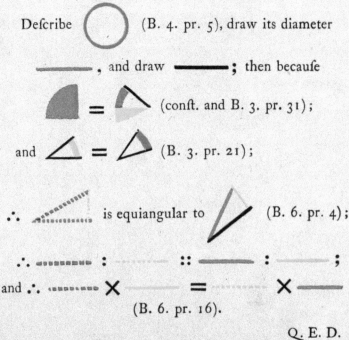

Describe ◯ (B. 4. pr. 5), draw its diameter
━━━, and draw ━━━; then because

◭ = ◭ (const. and B. 3. pr. 31);

and △ = △ (B. 3. pr. 21);

∴ ━━━ is equiangular to ◺ (B. 6. pr. 4);

∴ ┄┄ : ━━━ :: ━━━ : ⋯⋯ ;

and ∴ ┄┄ ✕ ━━━ = ⋯⋯ ✕ ━━━
(B. 6. pr. 16).

Q. E. D.

BOOK VI. PROP. D. THEOR.

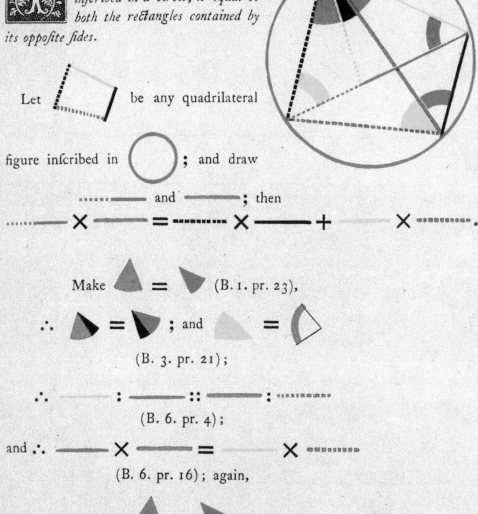

THE *rectangle contained by the diagonals of a quadrilateral figure inscribed in a circle, is equal to both the rectangles contained by its opposite sides.*

Let be any quadrilateral figure inscribed in ◯ ; and draw ┄┄── and ───; then

┄── × ─── = ┄┄── × ─── + ─── × ┄┄──.

Make ▲ = ▼ (B. 1. pr. 23),

∴ ◣ = ◤ ; and ▲ = ◗ (B. 3. pr. 21);

∴ ─── : ─── :: ─── : ┄┄── (B. 6. pr. 4);

and ∴ ─── × ─── = ─── × ┄┄── (B. 6. pr. 16); again,

because ▲ = ▼ (const.),

268 BOOK VI. PROP. D. THEOR.

and ∨ = ∨ (B. 3. pr. 21);

∴ ⋯⋯ : ⋯⋯ :: ——— : ———
(B. 6. pr. 4);

and ∴ ⋯⋯ × ——— = ⋯⋯ × ———
(B. 6. pr. 16);

but, from above,

——— × ——— = ——— × ⋯⋯ ;

∴ ⋯⋯ × ——— = ⋯⋯ × ——— + ——— × ⋯⋯
(B. 2. pr. 1.

Q. E. D.

THE END.

CHISWICK: PRINTED BY C. WHITTINGHAM.